art:21

John Baldessari

Cao Fei

Mary Heilmann

William Kentridge

Kimsooja

Jeff Koons

Florian Maier-Aichen

Paul McCarthy

Allan McCollum

Julie Mehretu

Doris Salcedo

Cindy Sherman

Yinka Shonibare MBE

Carrie Mae Weems

Interviews by
Susan Sollins

Edited by
Marybeth Sollins

Wesley Miller
Associate Curator

art:21

5

ART IN THE TWENTY-FIRST CENTURY

IN MEMORIAM

Dorothy Cullman

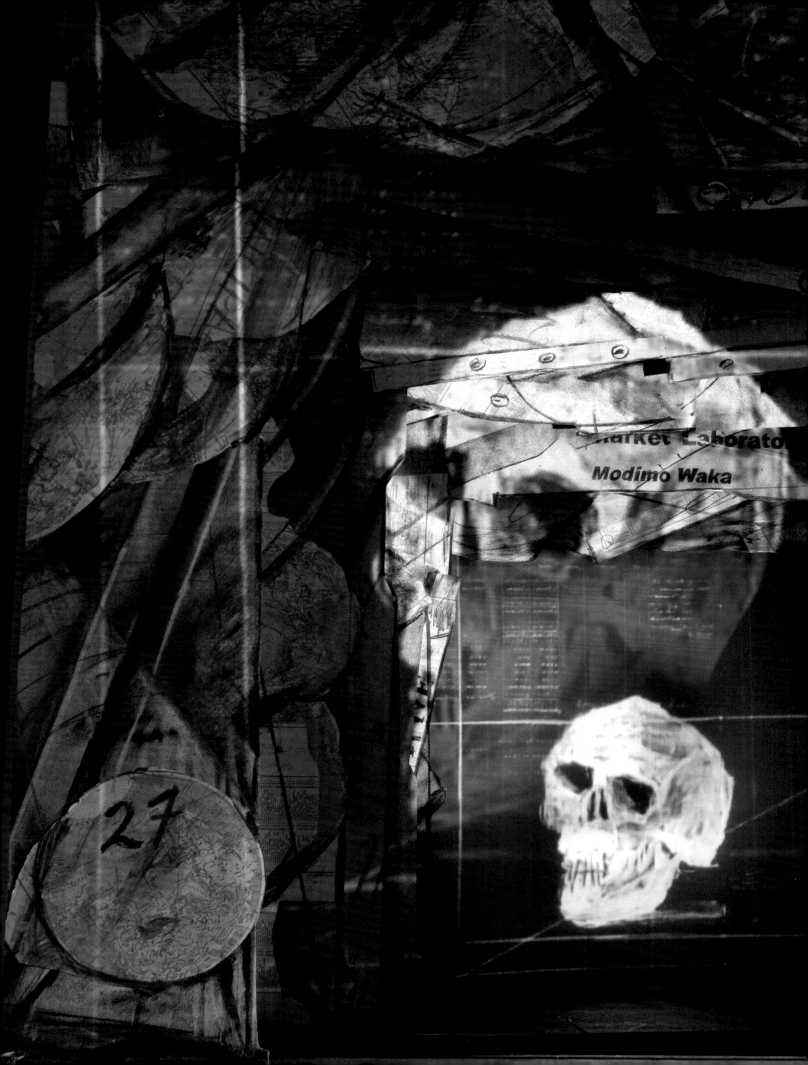

Contents

Acknowledgments

I prepare these acknowledgments with pleasure, in anticipation of this volume's publication and the broadcast of Season Five of *Art:21—Art in the Twenty-First Century.* I am grateful to Art21's extraordinary staff—Eve Moros Ortega, Sara Simonson, Wesley Miller, Beth Allen, Jessica Hamlin, Nick Ravich, Jonathan Munar, Marc Mayer, Kelly Shindler, Joe Fusaro, Larissa Nikola-Lisa, Katherine Payne, and Mary Cook—for all their contributions to Season Five. To Migs Wright, without whom our work would be much diminished, I owe my deep gratitude. I also owe special thanks to Allison Winshel and her colleagues at PBS; consulting directors Charles Atlas and Catherine Tatge; and all who worked with Art21 in the filming, editing, and production of Season Five, including David Howe, Ed Sherin, Lizzie Donahue, and Mark Sutton.

For the provision of images reproduced in this volume, I thank 303 Gallery; Alexander and Bonin; Blum & Poe; Friedrich Petzel Gallery; Hauser & Wirth; Jack Shainman Gallery; James Cohan Gallery; Kunstmuseen Krefeld; Lombard-Freid Projects; Marian Goodman Gallery; Metro Pictures; Museum of Contemporary Art, Chicago; New Museum; P.P.O.W Gallery; Pace Editions Inc.; Stephen Friedman Gallery; and The Project. I especially acknowledge Vera Alemani, Amy Lynn Baumann, Catherine Belloy, Colby Bird, Kajette Bloomfield, Paul Brewer, Ginger Cofield, Samantha Culp, Phil Curtis, Natalie Dembo, Jessica Eisenthal, Lea Freid, Alexandra Gaty, Rashell George, Simon Greenberg, Johan Jacobs, Sarah Kohn, Venus Lau, Amy Levin, Renée Martin, Carlin Mayer, Anne McIlleron, Brooke Mellen, Mariko Munro, Harmony Murphy, Oliver Newton, Marcie Paper, Katie Rashid, Heather Rasmussen, Christopher Rawson, Sara Rentz, Andre Ribuoli, Lauran Rothstein, Ann-Marie Rounkle, Karen Schoellkopf, Kim Schoenstadt, Kelsey Sundberg, Liane Thatcher, Kara Vander Weg, James Woodward, and Pamela Vander Zwan, all of whom assisted in compiling information for this volume. In addition, I thank Ahmed Amer, Paulo Padilha, Joaquin Perez, and Ken Yapelli for capturing the production stills from Art21 footage. Additional interviews for this volume were conducted by Susan Dowling, David Howe, Wesley Miller, Catherine Tatge, and Phil Tinari. Interview translation was provided by Xiaotong Wang; transcription was provided by Pat Casteel Transcripts and Transcript Associates, Inc.

The support and involvement of Marybeth Sollins, who created the text from my interviews with the artists, assisted me with the introduction, and edited this volume, has been invaluable. Her editorial skills, wisdom, and calm have made this book possible. To Russell Hassell, the designer who has applied his magical touch and talent to create this fifth splendid Art21 publication, I extend affectionate gratitude and admiration. Once again, he has designed a book that mirrors Art21's spirit and philosophy. Wesley Miller and Jennifer Lee worked diligently with artists and galleries to select the images for the book and made important contributions in all phases of its production. We are grateful to them for their attention to myriad details.

To the artists in the series, I extend my grateful appreciation for their generous and open participation in the series and its ancillary education projects. To my steadfast friend Agnes Gund, and the entire Art21 Board of Trustees, I send heartfelt thanks for support and belief in this endeavor. In closing, I wish to acknowledge the extraordinary generosity of the Bagley Wright Fund for support of the production of this volume, and the individuals, foundations, corporations, and other funders of Season Five.

Susan Sollins
Executive Producer & Curator
Art21, Inc.

Introduction

I'm always interested in things that we don't call art— and I have to say, "Well, why not? What can I do to make this art?"
John Baldessari

As Alice B. Toklas remembered it, Gertrude Stein was nearing her last hours of life when she asked, "What is the answer?" Toklas was silent and did not respond, so Stein spoke again: "In that case, what is the question?" In telling the story afterward, Toklas caused the already mythic Stein to be remembered as one who might have been able to reveal the ultimate mysteries of life and death even in her penultimate moments as she continued to play her high-stakes game of the artist-thinker, volleying at Toklas the riposte to her own question. Apocryphal or not, the anecdote illuminates an essential quality of mind—the impulse to question—that is at the core of the words and stories of the artists included in this volume and in the television series of the same title. Like Stein, the artists profiled here break rules and find new ways to use vocabularies of form and language, albeit of visual form and visual language, in their quest for self-expression.

The "Baldessarian" question, "What can I do to make this art?" is addressed generation after generation by artists who are innovators rather than traditionalists. The responses to the question vary. But ambiguity and uncertainty are constants in artists' lives, and require them to engage in an open-ended, inquisitive search with no guarantee of answers. It is this state of being that seems to be a prerequisite for invention. Whether confronted by an empty canvas, a studio full of materials, or a body of finished work, the question, "Where do I go from here?" is resolved only through sustained and concentrated play with ideas, form, media, and materials over long periods of time. To follow an equivalent of the Yellow Brick Road wherever it leads, to be open to the destination *and* to what is encountered on the way, is essential. As William Kentridge says, "All the interesting work I've done always has been *against* ideas I've had. It's always in between the things I *thought* I was doing that the real work has happened. So, play is not so much about copying that, but trying to find the strategy to allow that to happen. . . . It's about not knowing what something means in advance."

For Cao Fei, not knowing what something means in advance might be considered intrinsic to her generation's world view. "Life itself for my generation is a dynamic and evolving process, and one does not need to organize or sort everything out in an orderly process. . . . Life is a blur; existence is chaotic," she says. A multiplicity of approaches—from interactive

plays, appropriation, and sampling to juxtaposition and assemblage—mirrors Cao Fei's openness to multiple vantage points from which to explore the theme of reality versus fantasy or dream. Whether using cosplay (costume role-play in which young people adopt cartoon characters as alter egos and sometimes even live their "real" lives in costume and character) or the virtual world of Second Life as vehicles for her work, Cao Fei questions whose— and which—world is "real."

There is an intensity of engagement in the work, a kind of "high," at the core of art making and in the process of play from which it evolves. Reflecting on her propensity for working alone, Cindy Sherman says, "When I use myself I can play so that every single picture is different. . . . When I've experimented with . . . models, I'm frustrated at trying to capture . . . something I can't even articulate because I don't really know what it is I am looking for until I see it." At play, as she tries on the various accoutrements that enable transformation, the work becomes intuitive in a process that is not unlike that of Kentridge cutting shapes in paper and moving them around his work table or John Baldessari suddenly deciding to place dots over faces in appropriated images. For Sherman the end result is a photograph that leads us to understand that the camera lies and that everything photographed can be (and has been) manipulated. Truth and photographic imagery are not synonymous, and never have been. Florian Maier-Aichen's take on this idea reveals a fascinating combination of intuitively playful investigative approaches to his work within the constraints of the traditional system that defines his medium. He combines photography and drawing, importing fictional elements to images that

some might consider undeniable representations of truth. Instead of using the computer to over-produce images, he uses it to introduce imperfections that make the work more open-ended in meaning. "These are not scientific images that tend to be precise," he says. "They're photographs but they're also imaginations." Reflecting on his education, Maier-Aichen says, "What I learned was that sometimes you can do things wrong . . . the way you're not supposed to." Perhaps it is fitting to note that John Baldessari was Maier-Aichen's teacher. "Baldessari was breaking every rule that there was, so it was a huge encouragement for me to question things or standards a little more. It was okay to just go 'wrong'."

One of the principles of play, William Kentridge tells us, is that however much we distort and break things apart, we will try finally to reconstruct them to make sense of the world. For artists, this "making sense" requires diligence: study, analysis, interpretation and reinterpretation, association, collaboration, digging deep. This can be a messy process, one that might then demand an obverse action—the imposition of an organizational impulse based on rules, limits, or systems. Again, one reaches for a "Baldessarian" turn of phrase to illuminate the concept that following rules might actually spark creativity. A system, he says, is like a corral around an idea, "a corral that you can move—but not too much. And it's that limited movement that promotes creativity." Once devised, a system can serve as the core of thinking itself. Certainly, systemic speculation is fundamental to Allan McCollum's work, which grows out of a generative grammar of form, an investigation or questioning of structure, as if he were constantly building the world anew with billions of small

building blocks, each one unique and subtly different. Among the provocations we might encounter in McCollum's process and in his work is the challenge to question just how much we are willing to see and absorb of the infinitesimally small differences between objects (and people?) that make them unique.

The instinctive insights that come to the fore through play also enable experimentation and discovery. As a result, artists—like scientists—can explore. One step follows another through a process of investigation during which intuition and recognition play a powerful role in revealing new forms. Reflecting on her early work, Julie Mehretu recalls her efforts to make sense of who she was in her time, space, and political environment by using very rational techniques of mapping, charting, and architecture. "What is it that you're trying to communicate," Mehretu asked herself, ". . . why the language of abstraction?" But now, almost a decade later, the question is, "What is it that's evolving?" Most amazing, she says, is "when something happens in the work that, without expectation or desire in the impulse of making it, completely illuminates it. What I'm most interested in is how I allow . . . it to be free enough that it reveals itself to me."

Even as a child, Kimsooja imagined herself as an artist-philosopher, as one who would "give wisdom to the people." As she matured as an artist, she realized that indeed she had been engaging in both art and philosophy. "All the questions I had as an artist, personally or professionally, were always linked to life itself," she says. "I saw art in life and life in art. I couldn't separate one from the other." The circulative, performative practice of sewing, in essence a form of play and much like Julie Mehretu's impulse to make marks or Florian Maier-Aichen's to "scribble," led to an epiphany that resolved Kimsooja's quest to understand the inner structure of the world as much as the structure of the surfaces with which she interacted as an artist. "When I was putting a needle into the silky fabric, I had a kind of exhilarating feeling like my head was hit by a thunderbolt," she says. Sewing became more than a process for creating work. In an intuitive leap from the world of everyday activity, Kimsooja became the needle—a metaphor for transcendence.

It seems that play is a tool for exploring meaning and challenging rules while also serving as a medium for communication. Play can be collaborative or solitary. We learn as we play—especially in childhood, and thereafter when we allow ourselves to give over to it. Through play we engage with formal structures: rules and regulations can be adhered to or broken; dialogues—with oneself and others—ensue. Mary Heilmann works within a game-like structure (shaped canvas/abstraction) but also in the free-floating world of make-believe. "A body of work starts by daydreaming, imagining, looking at my own work, the work that's already around in the studio," she says. In acts of playful rethinking and reinvention, Heilmann morphs new work from old as she allows the ideas in the back of her head, as she describes it, to change as she works. It seems that she approaches each piece with unspoken questions. How can her personal backstory infuse abstraction? How can color and form express emotion? The fanciful titles of her pieces relate to internal narratives, in which personal meaning can be inserted into formal inquiry and sets of rules can dictate content or

form—or not. But most important, Heilmann tells us, is "communicating and having something like a conversation through the work." Likewise for Jeff Koons, who says, ". . . Whether you're looking at dance or listening to music or looking at a visual artist's work, you want gesture. You want the person to be in the moment to show you how far you can go, and the freedom of what that means. So the job of the artist is to make a gesture and really show people what their potential is. It's not about the object, and it's not about the image; it's about the viewer. That's where the art happens. The objects are absolutely valueless. But what happens inside the viewer—that's where the value is." There are countless examples of perfection of form and surface in Koons's work. The playfulness and sensuality that abound in the subject matter and entertain us also force us to look more closely. Are we not looking at a darker, deeper aspect of the artist's spontaneous and playful investigations? The questions he poses have to do with the nature of mortality, desire, power, and excess. Much like Carrie Mae Weems and Yinka Shonibare, discussed below, Koons uses beauty as a magnet to pull us into a conversation about difficult subjects.

Responsibility to the critical examination of ideas (and the concomitant challenge to accepted practices and norms, whether in life or art) is another thread that connects the artists presented here. This intellectual model leads inevitably to a questioning of the status quo—both aesthetic and sociopolitical—which exists outside the realm of form and structure and is enmeshed within an arena of content. Once inside that arena, the artist-thinker has no reason to hold back. For Carrie Mae Weems, who explores the lives and histories of African Americans in this country, inquiry is implicit in the subject matter, and highly charged. Why did this happen? How *could* it have happened? How best can I draw you, the viewer, into the frame to experience this conundrum and this horror? Beauty is the lure Weems uses to pull us into a discourse on controversial issues, as she also asks how she herself can enter the space of making the work. "What does the work need to feel like? What is it trying to do? . . . Have I posed this beauty for no real reason . . . or does it point to something that has deeper meaning that is more useful than beauty?" Even when she is not completely sure, she says, "at least I'm starting with a set of ideas and questions about entering that porthole." Like Weems, Yinka Shonibare MBE glories in beauty per se and also as a lure to engage viewers with the work and with ideas that they might not otherwise be willing to acknowledge or examine. To the same end, he revels in the use of theatrical devices that enable him to "travel into a different space" where he can deal with everyday issues but be transgressive. "All artists," he says, "are transgressive. My job is to challenge the status quo . . . to actually turn the system another way and see what happens if we look at it from that angle. I want people to see something different in the familiar." As he traverses the wavering boundary that separates insider and outsider, Shonibare queries authenticity. Comingling historical references to European art and society in his investigations of cultural identity and individual difference, he plays a provocative game of sometimes ambiguous, sometimes starkly obvious hide-and-seek that makes us take notice. Doris Salcedo's investigations center on the victims and perpetrators of wars and unfathomable atrocities, which have repeated themselves

"like one single unending event through the course of history." As a Third World artist, Salcedo gives us memories of catastrophes and acts of inhumanity that most of us have never witnessed or imagined and almost certainly may never have acknowledged or understood, for lack of having experienced the reality of her world. Salcedo does not force us to view the acts of atrocity to which her work refers. Rather, she makes us see them through visual metaphor and poetry. There is nothing playful in her contemplation of the history she addresses—but her inquiries plumb the deepest realms of intuition and creativity in order to find ways to convey that subject matter. Among the questions she asks are how form can hold meaning; how memory can be embedded in sculptural form; how materials can be transformed until they have metamorphosed from metaphor into "something else." She challenges our Eurocentric history of art and the impact of its "whiteness" on accepted standards of beauty, morality, and ethics. Revealing her musings about what kind of work she would make for an installation to be placed in Turbine Hall at Tate Modern (an enormous modernist space that tends to incite museum-goers to gaze upward with expressions of awe that she considers narcissistic), Salcedo says, "I wanted to . . . change that perspective, reverse it entirely, turn it upside down. . . . Instead of looking up you would have to look down as a way of seeing reality."

"My responsibility is to the idea and not to the audience," says Paul McCarthy, as he reflects on the unanswerable nature of an interviewer's questions about his work. "But it's the audience demanding a concise answer to why I'm doing this and what's my justification. It's as much an exploration as anything. I can't tell you why. The why and the answers to why are in the piece itself—in the work." There is constant interplay of ideas and processes in McCarthy's work. Describing the early stages of conceptualizing and constructing a sculpture, McCarthy remarks that his assistants "think they're making a sculpture. Then they begin to realize that what the sculpture is going to be doesn't exist at the end, but that it may exist anywhere in between, and they have no idea where that is." Uncertainty, ambiguity, and the interplay of ideas: "Some of it really is just about letting something go and finding something." As for his performances and video installations, and particularly *Piccadilly Circus,* McCarthy says, "I don't know whether I was looking for the truth. I was just building a piece. I was making a work of art, constructing something. It's a portrayal of absurdness, of an insanity. It's play. So it kind of teeters back and forth."

No matter what the subject at hand—history, revolution, apartheid, social upheaval, logic, power, metaphor, religion, or artifice, among others—the artists presented here know that art today mirrors a host of myriad influences, sources, and ideas. It serves no master, religion, or propaganda as it most often did in past centuries. Its making is serious beyond doubt even though that making evolves through sustained, open-ended play. Pragmatic and philosophical, these artists exemplify the artist-thinker role so clearly given voice in Gertrude Stein's supposed last words: "In that case, what is the question?" And so we return to John Baldessari: *I'm always interested in things that we don't call art—and I have to say, "Well, why not? What can I do to make this art?"*

Susan Sollins

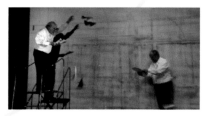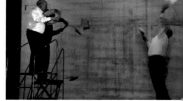

William Kentridge

Doris Salcedo

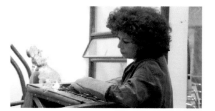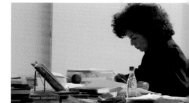

Carrie Mae Weems

Compassion

William Kentridge

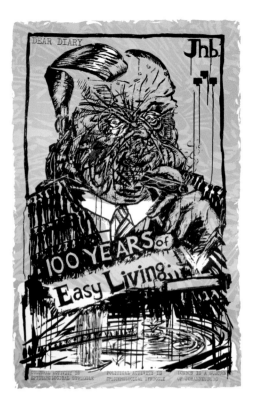

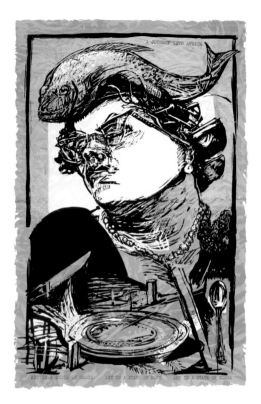

I grew up in a family that was very involved with the legal battles against apartheid, the great treason trials in the 1950s and early '60s which my father was involved with, and later with the legal resources center that my mother founded. It was very much a family in which one was aware of the anomaly of what South Africa was. So instead of it being natural (as it was to most young white South Africans in my classes) that whites had all the rights and black people didn't, I was fortunate growing up in a domestic situation in which it was made very clear that it was a completely unnatural as well as immoral and unjust circumstance.

The political interest in what happens in South Africa is very much part of the work. When I started working as an artist, one of the questions that seemed inescapable to me was how one finds an adequate way (whether it's adequate or not is open to debate) of not initially illustrating a society that one lives in, but allows what happens there to be part of the work, the vocabulary, and the raw material that is dealt with. Can one find an art which relates to politics, in which the same ambiguities and uncertainties that one finds when describing the rest of the world also exist in the political and social questions that one is depicting? That's not the norm in political art. Great Soviet political art at its key moment was complete optimism and certainty. The slogan—as something that in a few words could encompass a huge program, a huge human desire, a huge human sense of agency—becomes impossible. So, in light of the impossibility of that kind of certainty and optimism, what is the work that *can* be done that doesn't simply pretend that part of the world doesn't exist— that doesn't follow Clement Greenberg and say that the world is the canvas and that nothing exists beyond the canvas? It's not that I have found an answer, but it's a question that still intrigues me. I suppose the first promptings or proddings to work as an artist are still there and the questions haven't changed. One does the work and then tries to formulate a series of questions which one could possibly ask as a reason for the work. So it's always reverse engineering in terms of the ideas.

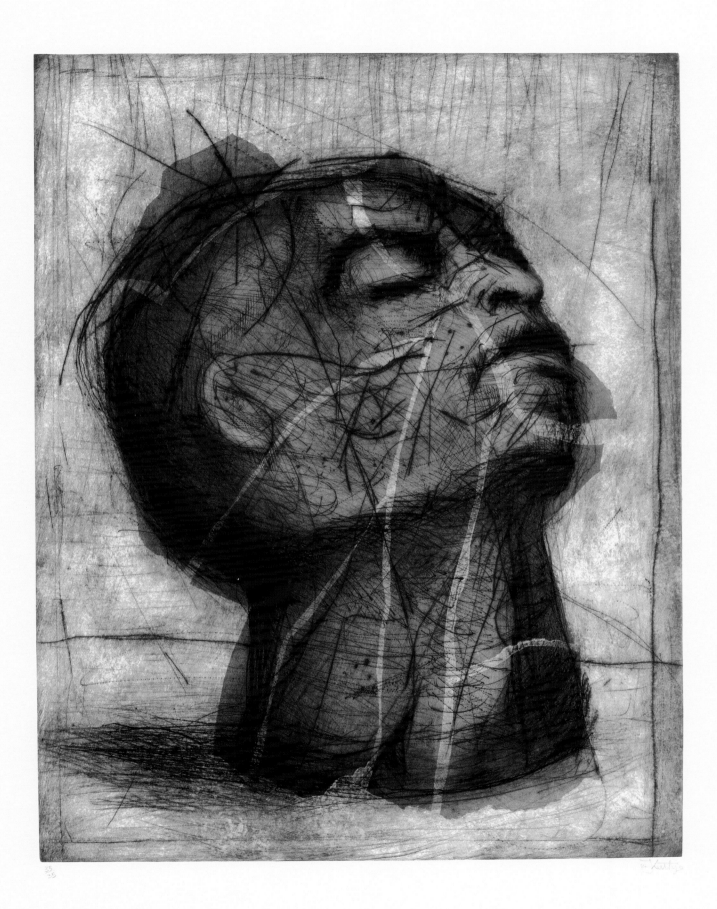

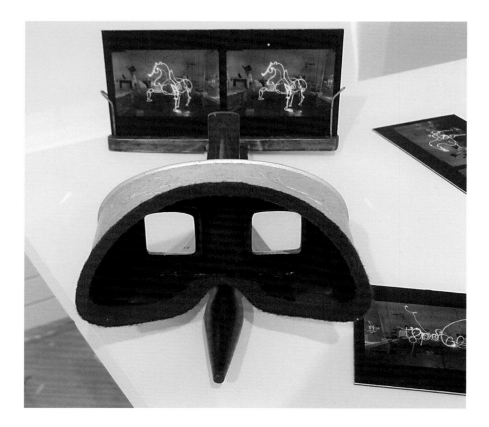

The work starts with the pleasure of putting pieces of paper together and turning them from pieces of paper into a woman—or taking lines that meander around a piece of plastic and turning them into a horse. That's the starting point. That's the pleasure and that's the need; that's the impulse. Very secondarily, you're saying, "Okay, having done that (A) can one find some justification for this activity, or is it just a kind of occupational therapy? Or (B) if it does interest people, if there are things in it that have emerged that echo other thoughts or raise other sets of associations, where do those come from and what is the nature of the work?" In other words, "What, in spite of myself, is there in the work which interests other people?" It's not that I'm saying I don't think the work has a meaning or a logic or a substance, but I'd be very wary (I'm always very wary) about putting that at the beginning rather than at the end of the process. The project is about doing the work and then seeing at the end what it is that you have made.

There are different cut-up pieces of paper here, but put them on top of another silhouette and suddenly they become a load that's being carried or something that's being pulled along. We absolutely want to make sense of the world in that way. That's one of the principles of play—that however much you distort and break things apart, in the end we will try to reconstruct them in some way to make sense of the world. I think that every child does it. It's fundamental. Take mis-hearings. When you mis-hear something, what does your brain immediately do? It immediately tries to find a possible meaning. So with my daughter, when she was four: I was telling her a story about a cat that was being chased by a dog in the garden. It ran through the cat flap and it was saved. She retold the story to her mother and said, "Daddy was telling a story about a cat, and it was chased by a dog, and the cat flapped its wings and it escaped." Flap was not a term that was understood. But what does the brain immediately do? It immediately says, "Okay, flap, flap, flap . . . ," and it not only constructs a meaning for it but it constructs a whole complicated scenario. You've got a flap; then you've got to have wings. So we are constantly constructing these complex worlds out of very vestigial clues. My work has been to try to find strategies to let that happen.

William Kentridge

ABOVE
Double Vision, 2007
Set of 8 stereoscopic cards, colophon wood box, and stereoscope, dimensions variable, each card 3½ x 7 inches
Edition of 25

OPPOSITE
Promised Land, from
Horse and Nose series, 2008
Tapestry weave with embroidery, 149³/₅ x 163⁴/₅ inches

Robert Motherwell paints a series of black shapes on a canvas. And those stay resolutely as black shapes. But allow them to move an inch and we'll suddenly start constructing all sorts of images. I suppose one of the arguments is that people say that's a mis-looking at abstract painting. And I'm saying that the desperation to hang onto abstraction—to say, "These are only black shapes of paper, that's all they are, they're forever just random black shapes of paper," is also not so much a misunderstanding (people *understand*) but a denial of what it is that we do. We see this optically as black shapes on the canvas. When you know it's going to turn into a horse you can recognize head and tail. Without that they're still black shapes on a field. But as soon as we absolutely recognize it as a quadruped, because there are four feet with a neck, a spine, a tail, and a head—and particularly once it moves—that's what we see. It's not about a generosity of viewing. It's about an inability *not* to do that. I think one does three things when looking. On the one hand, there's recognizing what the actual object is (black torn sheets of paper). Second, there's the inability not to see that in fact these turn into a horse. And third, which for me is the vital part, is the stepping back behind ourselves and understanding (A) that we're fooled—in other words, these *are* black pieces of paper—and (B) taking pleasure in constantly making sense of the world, even in fragments or inconsistencies which we push into a pattern. On the one hand, one could try very carefully to draw a silhouette of a horse. And if you're good at drawing it would be better and more accurate—and if you're good at animals, it would be even better. There are great portrait silhouette cutters who can cut a piece of paper and it will look like your silhouette perfectly—which I'm not good at, at all. But what I can do—but only as well as anybody else in the world can do— is recognize things as they appear. It's not that I'm better at recognizing eight pieces of paper as a horse than anyone else. What I do is allow myself the luxury of saying that this is going to be the way I'm going to spend months and years of my life, arranging stupid pieces of paper and then saying, "Ah, a horse!" every day as if it's something fresh.

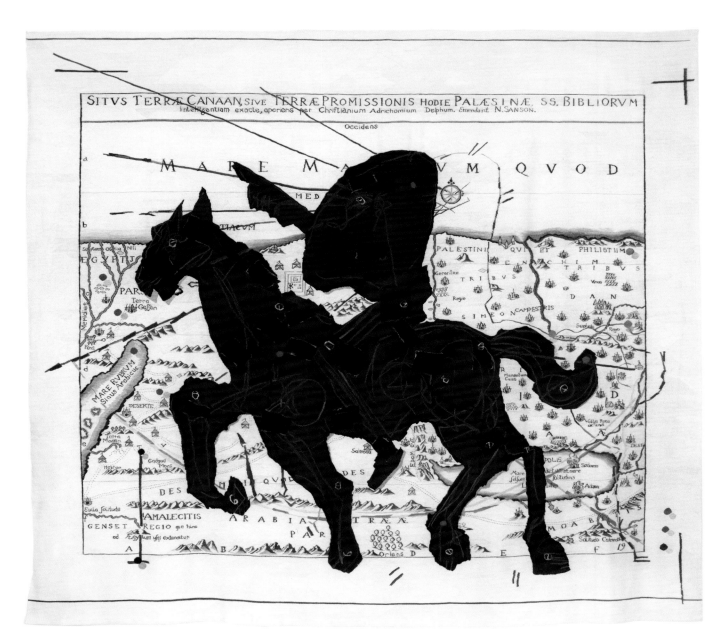

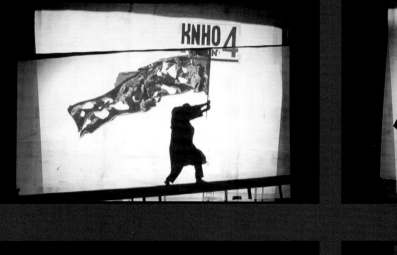
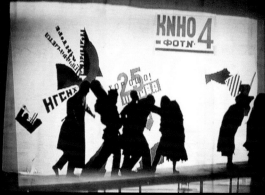

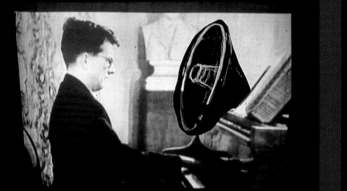
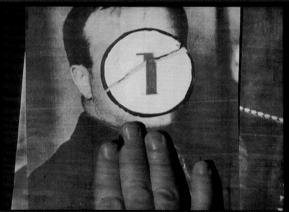

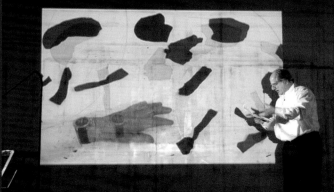

William Kentridge

The possibility of exploring something not known quite literally will lead to understanding that one can do things lightly and quickly without understanding deep motivations. It's not exactly frowned upon, but it's not the norm. For me it has always been very important. All the interesting work I've done has always been *against* ideas I've had. It's always in between the things I thought I was doing that the real work has happened. So play is not so much copying that, but trying to find the strategy to allow that to happen. It's about not knowing what something means in advance so that there's a possibility, if something emerges, to hang onto it and allow that to develop—allowing inauthentic origins of images and sequences. So something's done because it's going to solve a technical problem but, if it's done well, somewhere along the way may well be something that is of substantive mean-

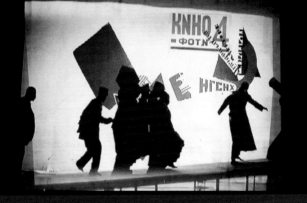

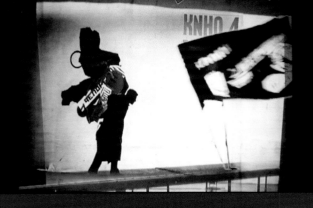

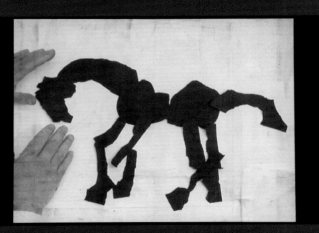

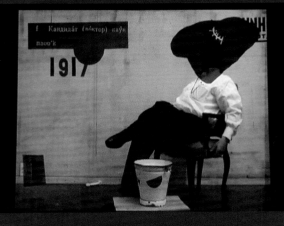

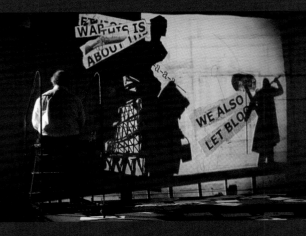

ing rather than technically useful at that moment. A lot of the work is like playing in the sense that there are simple rules. I can walk up and down inside the studio and film that and see what emerges. It starts off from what the actual activity in the studio is—a lot of pacing up and down—and it's playing with that. In other words, it's taking something that's real and saying, "If one extends it to absurdity, if one turns it on its head, if one does it in a

different way, what are the things that are revealed about that initial very straight-forward activity?" You could describe it as experimenting or improvisation.

The Sydney piece is a series of eight projections called *I am not me, the horse is not mine* (2008). You see all the projections at the same time. The soundtrack goes with the procession of people marching across the screen. The

text was edited as a kind of concrete poetry, over the music. Its timing, rhythm, and emphasis are a combination of how long images are on the screen, how long the words are on the screen, and what's happening in the music behind it. For me it became a very interesting piece—to think of a whole series of works which consist of soundtrack and text so your reading speed is determined by the editing and the music.

William Kentridge

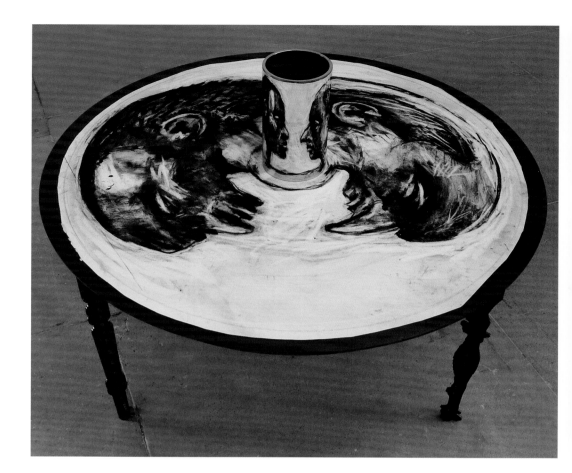

The anamorphic film, *What Will Come (has already come)* (2007), which is about the Italian-Ethiopian war of the 1930s, works on the principle that what is distorted in the projection gets corrected in the viewer's seeing of it in a mirror. So the distortion is the correction and the original is the distorted. One of the aspects of doing the film or the drawings was learning the grammar of the transformations that happen when you go from a flat surface to the curved mirror. So, for example, to draw a straight line is relatively complicated because every straight line is in fact a curve, whereas every straight line that you draw becomes a parabola. Looped telephone wires are very easy. You simply draw a series of straight lines on the drawing and then lines will loop themselves around the surface of the cylinder. If you want a straight line, you've got to calculate a not obvious curve on the sheet of paper. But it also means that suddenly a circle, which is very easy to draw on a flat surface with a compass, has to become quite a strange kidney bean-shaped object in order to appear as a circle on the mirror. I'm interested in machines that make you aware of the process of seeing and aware of what you do when you construct the world by looking. This is interesting in itself, but more as a broad-based metaphor for how we understand the world. So when you see the anamorphic drawing and its correction in the mirror, what you are very aware of is how your brain is constructing what appears to be a perfect circle when you know in fact it's not a perfect circle. It's a completely disgusting kidney shape. When you look through a stereoscopic viewer, you're aware that you have two completely flat images and that all that is happening is that your brain is constructing an illusion of three-dimensional depth. That's what we're doing all the time in the world. Our retinas are receiving flat images, and our brain combines the two images from our retinas into this illusion of coherent depth. And because we do it so well we believe that's what we're seeing. We believe we are simply seeing depth rather than constructing depth out of two flat images. So, again, it's both about the phenomenon and the wow factor—but more about the agency we have, whether we like it or not, to make sense of the world.

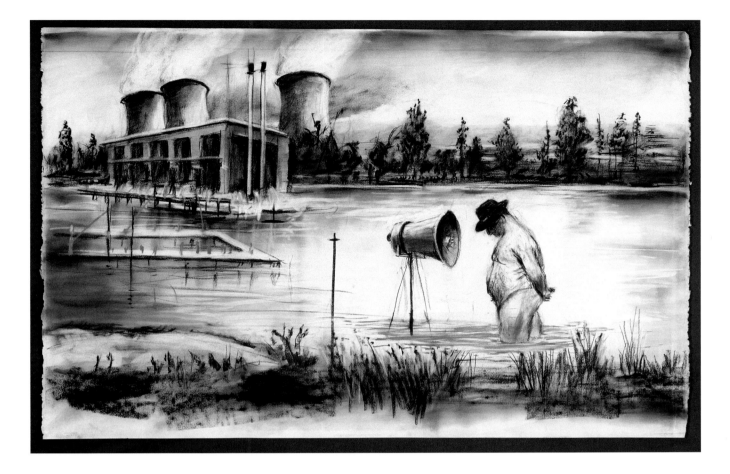

The first animated films I made were done on the basis of trying to get away from a program in which I could see my life heading out ahead of me (thirteen more solo exhibitions of charcoal drawings!). So I decided I had to do something that couldn't possibly fit into that context, that wasn't going to be in a gallery—something for my own interest and pleasure. The question I was asking myself was, "Can I do something that doesn't have to have a meaning, doesn't have to have a social purpose, doesn't have to fit into the politics of the liberation movement or any other kind of agitprop work, but will find its own meaning in the strange way of making an animated film with charcoal drawings?"

When I first did the films they were very separate from my activity of drawing, which was *art*. And when a curator came and said he wanted to show my films, I felt insulted and I refused. I said, "This is nonsense; they're not art, they're films. Here are the drawings, what's wrong with the drawings? Why don't you like the drawings? These are perfectly good drawings, what do you want the films for?" It took me a long time to understand that it was all right that film was the substantive work I was doing. That experience gave me a lot of confidence in the validity of working without a program, without the 'essay' being written in advance (which is to say, if you're at university, you write the essay, and if you're outside the university you write that even worse thing, the grant application). So I made a decision that I would never ever write a script, I would never write a storyboard, I would never ever write a proposal on the basis that even if I wrote them, the act of codifying like that somehow killed the project.

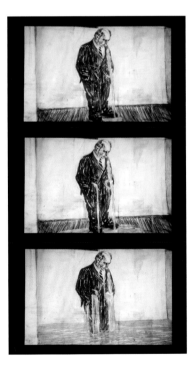

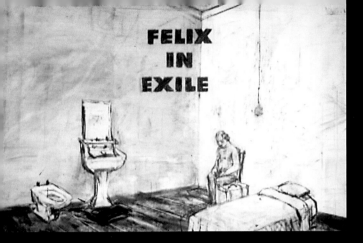
FELIX
IN
EXILE

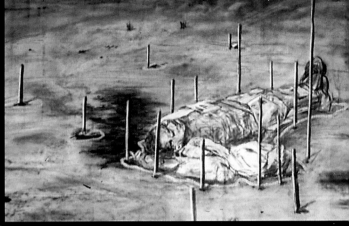

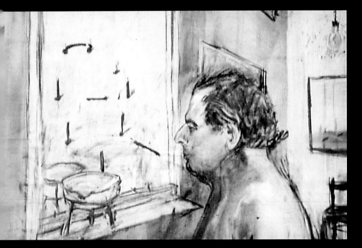

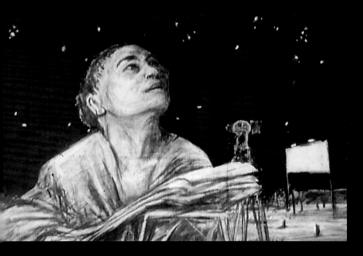

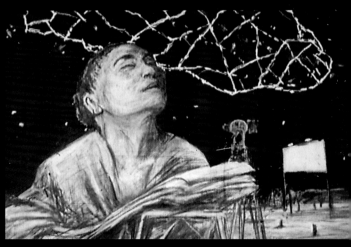

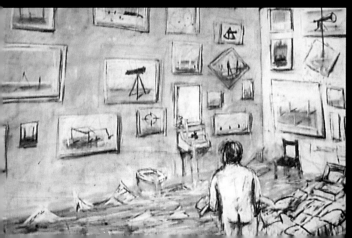

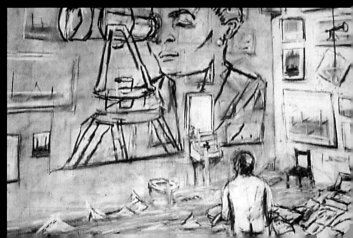

William Kentridge

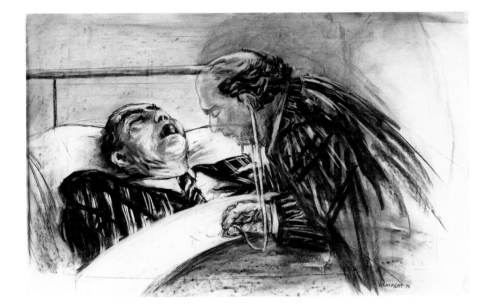

The films opened an enormous door because they gave me a sense that it was possible to work without a program in advance, without first having written a script—a sense that if you work conscientiously and hard, and there is something inside you that is of interest, you yourself will be the film, and the film will always be you. A lot of the work that I've done since then, even if it's not using that technique, has certainly used that strategy. It had to do with understanding that images and movement as well as static images are a key thing for me to be working on. The provisionality of drawings, the fact that they were going to be succeeded by the next stage of the drawing, was very good for someone who's bad at knowing when to commit something to being finished. Here the drawing would go on till the sequence finished in the film, and that would be the end of the drawing (understanding of the world as process rather than as fact). And somehow this technique and this medium allow that to come forward. There isn't a contradiction between what the medium itself seems to suggest and things that I'm actually interested in. Whereas when I tried to draw on a computer, its inner logic was very much at odds. The computer had to do with cloning, replication (things staying the same), and effect. You could put an effect that looked like charcoal animation onto the computer (aware of that not being a necessary part of the process, but a kind of decoration added on), whereas the *smudge* of a charcoal animation is not decoration. It's something you can't avoid; it's there whether you like it or not. I think one does think with one's hands. And that's why the keyboard is not a good place for me to think. Some people think very well on a keyboard. I need a kind of fidgeting of charcoal, scissors, or tearing, or something in my hands, as if there's a different brain that is controlling how that works.

There are lots of drawings that are about the need for comfort. I'm not sure if that's identical to compassion—about a 'taking' rather than a 'giving'. Maybe the depiction of it is a giving. In the activity of making work, there's a sense that if you spend a day or two days drawing an object or an image there's a sympathy towards that object embodied in the human labor of making the drawing. For me, there is something in the dedication to the image, whether it's Géricault painting guillotined heads or another shocking image. There's something about the hours of physically studying those heads and painting them that becomes a compassionate act even though you can tell that the artist is very cold-bloodedly and ghoulishly looking at disaster or using other people's pain as raw material for the work. That's what every artist does—use other people's pain as well as his own as raw material. So there is—if not a vampirishness—certainly an appropriation of other people's distress in the activity of being a writer or an artist. But there is also something in the activity of both—contemplating, depicting, and spending the time with it—which I hope as an artist redeems the activity from one of simple exploitation and abuse.

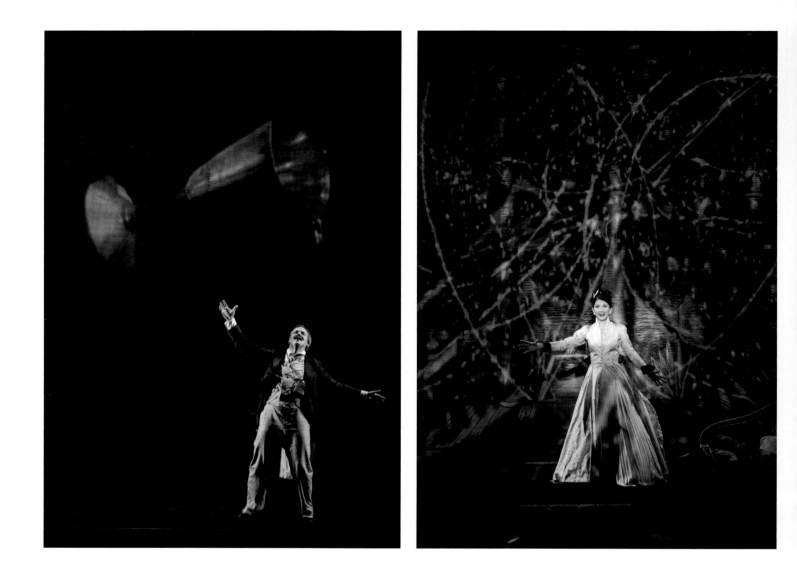

William Kentridge

It's the capacity for recognition that makes a difference between order and disorder in looking at visual images. And it's the vocabulary of recognizable images that we have inside us, which is completely vital to what it is to see. I don't really buy the idea that order and disorder are the same. On the one hand it's the pleasure of the optical illusion if you think you recognize what you're seeing but it's something completely different. But it's also about chaos, which we somehow force into a pattern of coherence in terms of how we have to make sense of the world. There's a kind of narrative drive—not a will to recognize but an inability *not* to recognize—that we are stuck with and saved by. It's always so with abstract painting, or even with music. You're not looking at it right or you're not listening to it right if you're seeing other things apart from the pure music or the pure shape. With music it's naturally complicated, but with shape you understand that to *not* see is a deformation—a kind of putting your eyes on a diet—trying to cut out part of what it is to be human, which is to take fragments and to complete them.

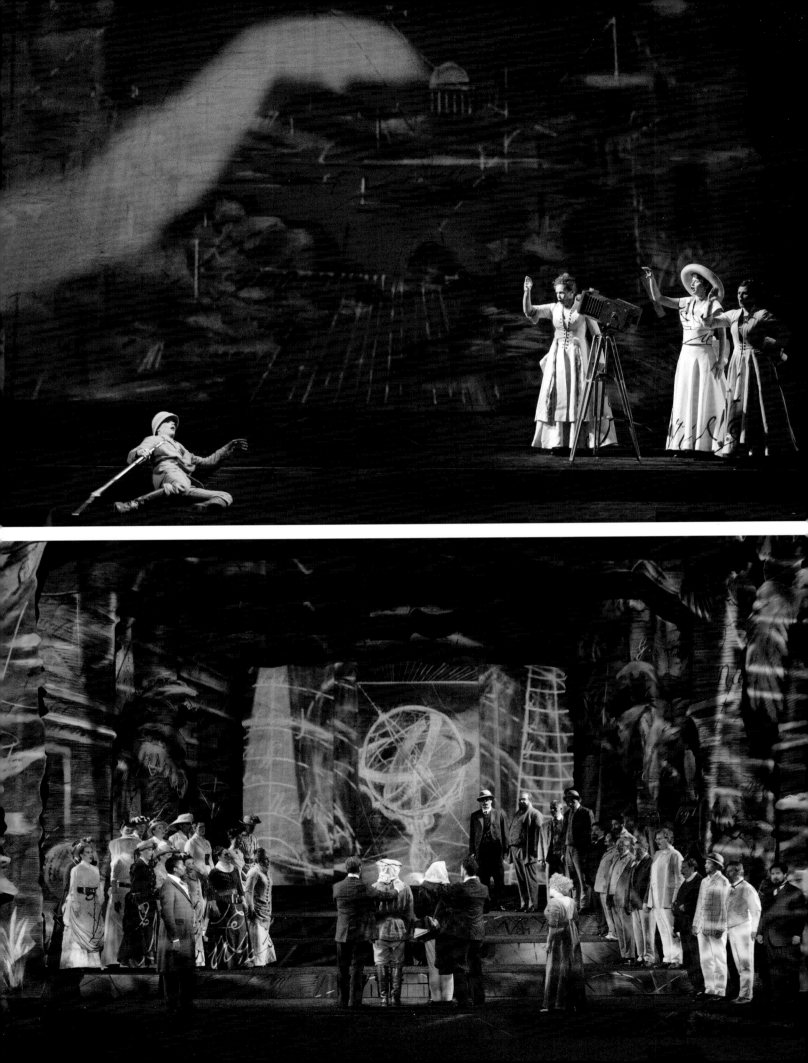

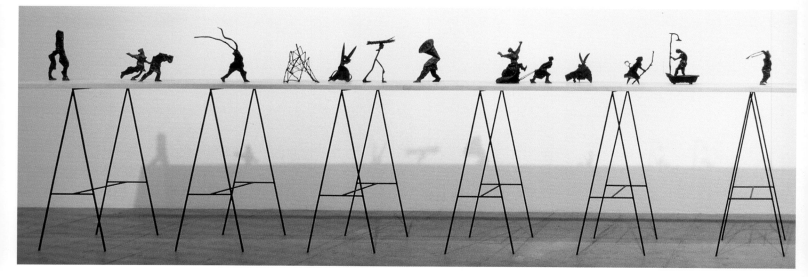

William Kentridge

ABOVE
Procession, detail, 1999–2000
Set of 26 bronze figures, dimensions
variable between 15¾ x 11 x 10³/₅
inches and 13 x 10 x 6⁷/₁₀ inches

OPPOSITE
Workshop for *The Nose*,
Johannesburg, 2008

There have been many iterations of porters and processions in my work. I suppose it's a response to physical labor being very much a part of who we still are. But it is also about processions that don't have endpoints. In other words, they start across the screen and the journey is to get from one side to the other. I think what's important for me is that uncertain ending. They're not definitely walking towards utopia at the other end of the screen, nor are there necessarily killing fields at the other end. But there's a sense of journeying, not knowing what's going to be at the other end, which seems to be an important part of where we are in the world now—whether it's a diaspora, whether it's refugees, whether it's voluntary migrations—that sense of shifting across to an uncertain end, in which there may be hope. This is not to say that there isn't hope (as a political category hope still exists and is very important). But the certainties of ending certainly don't seem possible.

When the Metropolitan Opera wanted me to do an opera, I spent a long time trying to find one that seemed appropriate. They suggested Shostakovich. I said yes to Shostakovich, but that the first prize for me would be his opera, *The Nose*. I wanted to do a twentieth-century opera, to do a project that has to do with the end of Russian modernism, and I was interested in looking back at places in which there had been an interest in working with political imagery. Gogol's story, *The Nose*, is an absurdist drama. It's got nothing to do with the calamities of the twentieth century. Nonetheless it depicts a world that is completely awry, in which the common logics no longer apply. And it's in that depiction of logic out of kilter and no longer adding up, which it does with great seriousness as all comedy has to, that it actually gets closest to revealing the dislocations in the world. I haven't seen it as a parable for our time, except in its form or its principles which have to do with learning from the absurd. But it's a story about the terrors of hierarchy. That's not a specifically South African phenomenon. At the moment I think it applies everywhere. But I suppose the real interest for me in the opera has to do with the self, with understanding that the self is so divided—which is emblematically shown by a nose that doesn't recognize its owner and is in conflict with itself. The body is in conflict with itself. And that's a way of understanding the world as fundamentally divided.

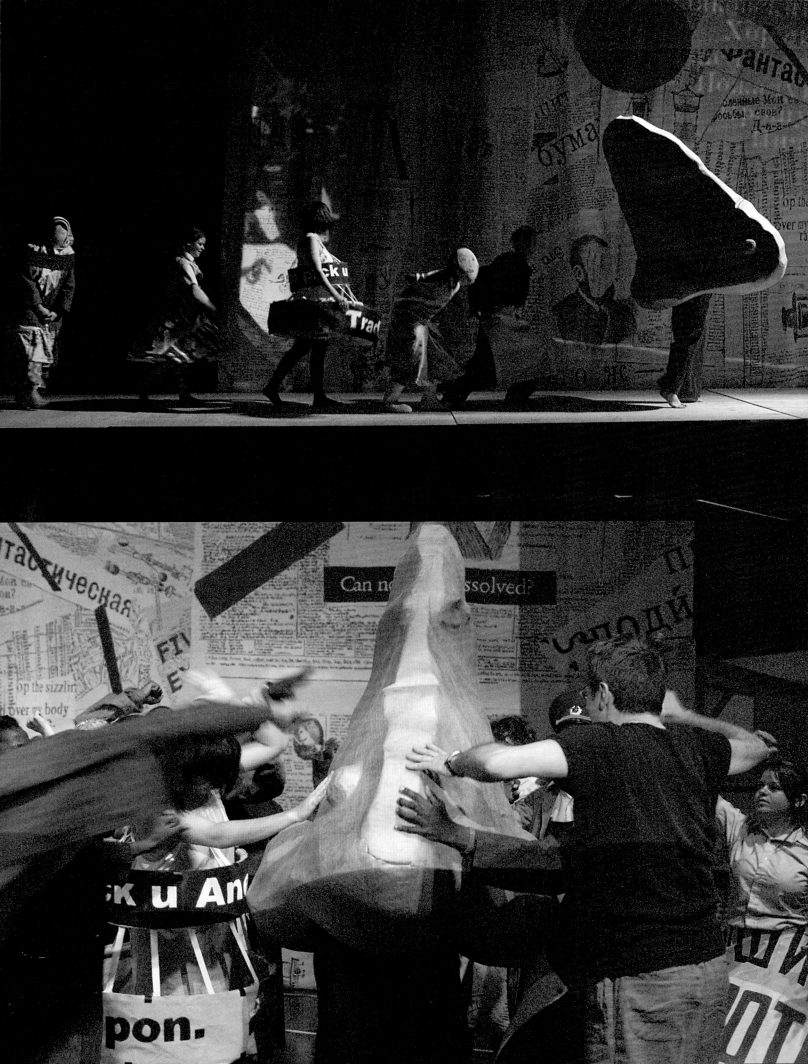

Doris Salcedo

BELOW
Noviembre 6 y 7, 2000
Installation at Palace of Justice,
Bogotá, Colombia

OPPOSITE
Acción de duelo
July 3, 2007
Installation at Plaza de Bolivar,
Bogotá, Colombia

We know in the Third World that rationality does not fix every problem. In the Third World we see things in a different way. You have to make your life out of chaos. You have to organize your life out of disorder. It's a vain attempt to make sense (and I want to emphasize the word *vain*). I don't think art has a possibility of providing aesthetic redemption. But I think we have to try. There's a beautiful quote from the Italian philosopher Giorgio Agamben. He says that when the victim gives account of his own ruin, life subsists even in the ruin. And I think that's our task, to make that subsist, not to allow that to be forgotten—to bring that to our present tense.

For me, the notion of duration—something that is not finished, a process going on—is very important. Also it is important for me to locate these pieces out of historical time. So the time for reflection is open for the viewer and for me, both. It is a very important aspect of the work—something that is happening, that remains happening, that will still be there . . . a condition that is timeless, that unfortunately repeats every day, that you cannot walk away from. It defines you from that moment when it happened. It defines the rest of your life. But since it is repeating constantly, endlessly happening, you have it there just suspended. And I think that time suspended is where we can really stop and think. There are many events happening every day, especially when you are living in a country like Colombia where catastrophe seems like one single unending event and one catastrophe erases a previous catastrophe, and so on. I think it is important to open this space of suspended time where you can think, where you can reflect on something that happened to one individual.

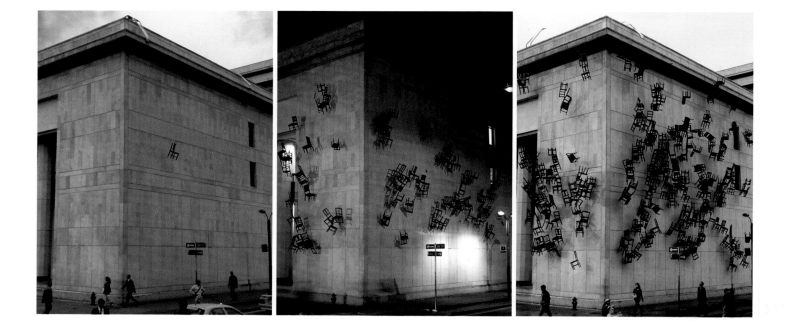

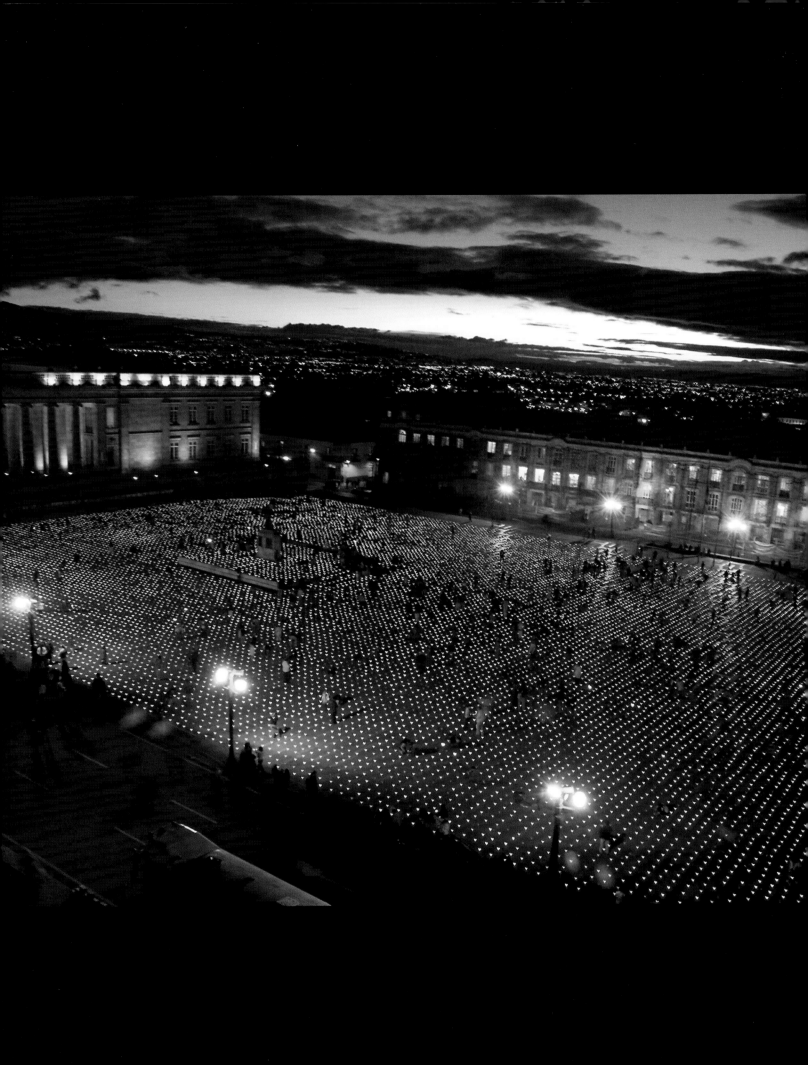

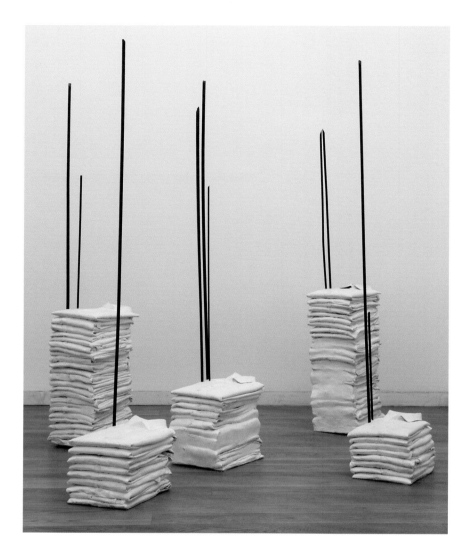

Doris Salcedo

LEFT
Untitled, 1988–90
Cloth shirts with plaster and steel
5 pieces: 66⅛ x 15 x 10¼ inches;
66⅛ x 13¾ x 9⅞ inches; 64⅜ x 13¾ x 10¼ inches;
65⅛ x 15 x 10 inches; 59½ x 14⅜ x 9⅝ inches
Collection of Banco de la República, Biblioteca
Luis Angel Arango, Bogotá, Colombia

OPPOSITE
Neither, 2004
Painted drywall and metal,
194½ x 291¼ x 590½ inches
Collection of Inhotim Centro de
Arte Contemporânea, Brumadinho,
Minas Gerais, Brazil

For many years, I've been talking to victims of violence. I used to travel to war zones in Colombia and interview people. After terrible events took place, I would go to the sites and interview people and gather objects. And my work was based on the words that the witnesses told me. So I used to think of myself as a secondary witness. The difference in the research that I'm currently doing is that I am no longer dealing with victims that are just victims. I'm dealing with victims that are perpetrators as well, so it's more complex.

But I guess it is essential to know that the artist is not making up things. As an artist I have a responsibility. I have to look at historical events and work with whatever material is given to me. I don't work based on imagination or fiction. The process of making a piece

for many artists, not just for me, is a sort of schizophrenic game where you try to put your center in the center of the person you are interviewing, the witness. And then you try to look at yourself and what you do from that perspective.

For years I kept files on concentration camps, both historical and contemporary. What interests me is the idea of a large portion of the population being excluded from civil rights—that you have people who are almost socially dead. That's what I'm researching. What does it mean to be socially dead? What does it mean to be alive and not be able to participate? Most of my pieces lately have been related to this issue. What also interests me is why we allow this to happen? What kind of society allows these events to take place in such a consistent manner? That's what

is really important. What is the political structure that allows this to happen, that allows us to do this to such a large portion of the population? There is a fragment of the population that exists on the borders of life, on the edges, on the epicenter of catastrophe. How do they live? When we talk about *underclass,* we have to know that it is a myth that is very useful to control a certain population. But at the same time, people that are under that horrible identity can be more. They can grow beyond the totality that is imposed on them. And I think art can do that—can show the splendor of a complete life. So I would like to show both sides—where there is a complete life under whatever circumstances and, on the other hand, what the circumstances and conditions are in which we force some people to live.

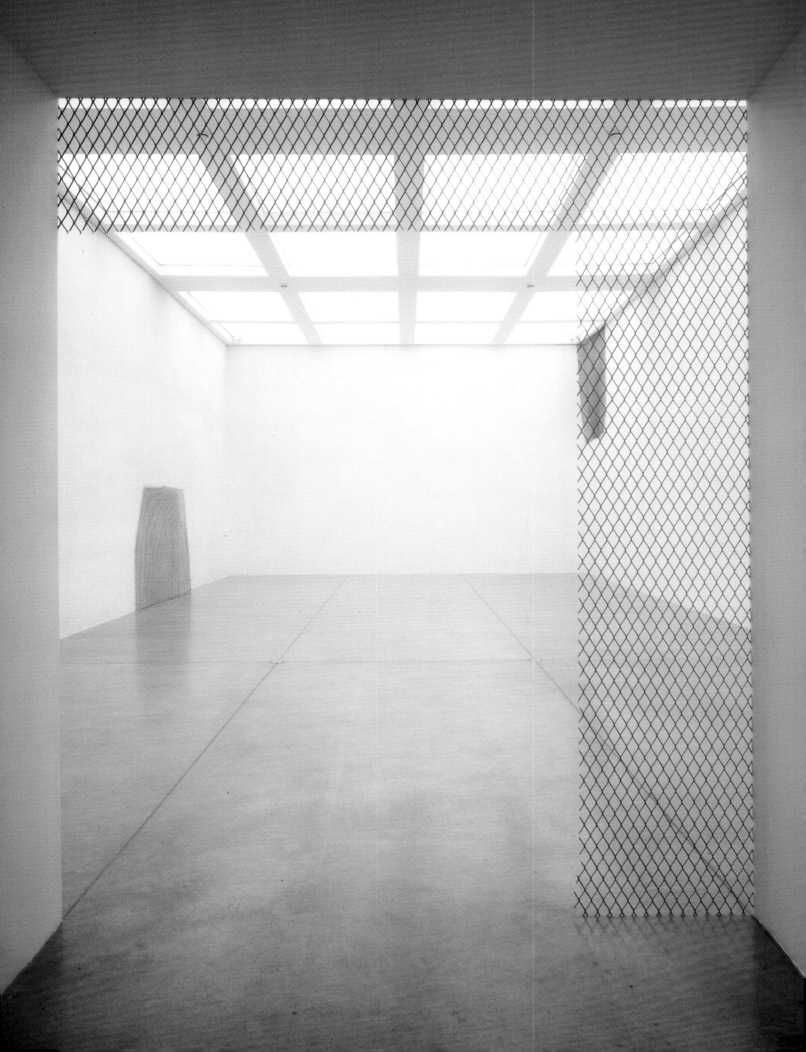

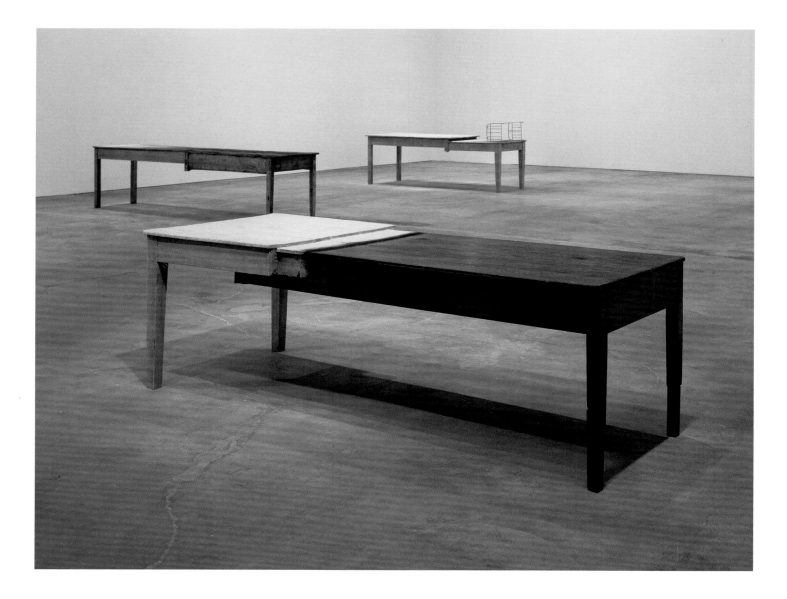

Doris Salcedo

ABOVE
Installation view of *Unland* at SITE Santa Fe, 1998
Front: *Unland*
the orphan's tunic, 1997
Wood, cloth, hair, and glue, 31½ x 96½ x 38½ inches
Collection of Fundación "la Caixa," Barcelona
Left: *Unland*
audible in the mouth, 1998
Wood, thread, and hair, 29½ x 124 x 31½ inches
Right: *Unland*
irreversible witness, 1995–98
Wood, cloth, metal, and hair, 44 x 98 x 35 inches
Collection of San Francisco Museum of Modern Art

OPPOSITE
Unland
the orpan's tunic, detail, 1997

The poet Paul Celan, quoting Georg Büchner, uses a very beautiful image: he says that he wishes he could be a Medusa's head to turn certain things into stone and gather people around that stone as though it were a great masterpiece. In a way that's what we do. Celan also says that the artist steps outside the human into a different terrain, the terrain of the inhuman, but looking always towards the human. I think that defines what I do and how I try to connect what I research with my work. For me, poetry is very important. I think it's the base of all art. Poetry is the art, and other words are just derivations of poetry. So for every single piece, I'm reading poetry. Celan's poetry is essential. He taught me what it meant to be an orphan, what it meant to be a poet in times such as his, in a labor camp, so that no matter what was done to him, still he was able to write poetry. He gave me the dimensions of the human soul, and that's what I needed to know. That's the way I want to see human beings. He taught me that life does not have only one side; it has many aspects. And, if you really look carefully, the opposite experience is embedded in what you see on the surface. Poetry is

something that you cannot use in every-day life, but—like the only aspect of our world that is not practical, that we cannot use, that is outside capitalism and consumer society—it is there in its extraordinary uselessness, which is exactly why it is poetic. Without it we would no longer be human. We would just be producing.

I remember a writer asking me where the title *Unland* (1998) came from. I said, "I took it from Paul Celan's poem." And that person scanned all the books and couldn't find it. Finally I remembered that I made it up (I couldn't feel that I was the author of that word). The process

of making *Unland* was insane because I was embroidering hair on wood—with a needle through wood. An insane gesture. An absurd gesture, demanding so much energy—a huge, absurd waste of energy—working with a team of fifteen people for three years, nonstop, on those pieces. So it reminded me of what Celan said: that it is only absurdity that shows the presence of the human. But the gesture was also related to the waste of lives here at the height of the paramilitary massacres in Colombia. I was referring to that as well. It was my way of showing how life could be wasted but, at the same time, that you

could build something that was poetic that could give testimony to the human presence and to the humanity of the victims, the fragility of life, and the brutality of power. *Unland* was about the impossibility of inhabiting a land, the impossibility of belonging and developing a life. As human beings, we all aspire to happiness. So it's that impossibility to which the title of that piece was referring. The title of *the orphan's tunic* is actually from Celan. I was interviewing children who had witnessed the killing of their parents and, as I said before, I learned from Celan what it means to be an orphan.

Doris Salcedo

RIGHT
Istanbul Project II, 2003
Piezo pigment on Hahnemühle
paper, 24½ x 37¼ inches
Edition of 35

OPPOSITE
Installation at 8th International
Istanbul Biennial, 2003

The Istanbul Biennial piece relates to an historical event. But that event had been forgotten, entirely forgotten. The people of the city did not make the direct connection, but it gave me the opportunity to bring many aspects alive, especially in a society where memories are repressed. I don't think it's important to know the event because humankind behaves pretty much the same way all over the world. I don't see differences between religions or culture. And so what I'm trying to get out of these pieces is that element that is common in all of us. And in a situation of war, we all experience it in much the same way, either as victim or perpetrator. So I'm not narrating a particular story. I'm just addressing experiences.

But what does it mean to 'destitute' one human being from humankind? I believe my role as an artist is to take that human being that has been expelled from the human condition and try to bring him or her back into the sphere of the human. That's why the works have to have a sacred element. If a human being is expelled from the human condition, the only way to reenter the human being into the sphere of the human is through the sacred. That's why images have to be perfect, entirely finished, and very well worked to be able to convey and address this idea. And I just don't want to relate it to the religious. For me, the sacred is the human.

I am not a solo singer. In my studio we are a chorus. One person could not produce such work; it is a collective effort. I work with architects—a team of architects that continuously gives me their creativity, their ideas, their input into the way that the pieces can be made and, even though I have a very precise idea of what I want, the kind of image I need. They are the ones that are making that image possible, building it in material. Each one has a role to play, and we respect each other's roles. It takes years anyway, with all their help. And I think that's very important, trying to change the role of an artist. The role of the artist has been overrated. It should be more humble. It has to be a collective effort at every level, because—especially for me, coming from the Third World—I cannot simply *use* somebody else's labor. That would destroy the sense of the piece if I were working from that perspective. No. We are all trying to understand something. The process leads us to make a piece, and the piece is a result of that process. I believe my work is also a collaboration with the witness, with the victims. I'm trying to understand, trying to make sense out of brutal acts, if that were possible. I know that's in vain, but I try to make sense out of this brutality.

Doris Salcedo

LEFT
La Casa Viuda I, 1992–94
Wood and fabric, 101½ x 15¼ x 23½ inches
Collection of Worcester Art Museum

OPPOSITE, TOP
Atrabiliarios, detail, 1992–93

OPPOSITE, BOTTOM
Atrabiliarios, 1992–93
Shoes, animal fiber, and surgical thread,
dimensions variable
Collection of the Pulitzer Foundation,
St. Louis, Missouri

La Casa Viuda (1992–94) is a very important work because it's related to forceful displacement. And I think that is the position I assume as an artist—that I don't have a fixed place, that I'm always being displaced. The work was an attempt to try to gather elements that were vanishing— that have been abandoned—and then create a site for it. As an artist I'm always moving myself continuously. I don't have a center. I assume the center of other people, moving from one condition to another, the condition of the slave or the condition of the immigrant. And because I don't have a place I can assume some-body else's and make a piece out of that. This work is not the kind of work where you develop an idea and it grows and changes. No. In my work, I'm always starting from zero. There's always a tabula rasa, and then a new piece will come. That's why there is no real visual relation between one piece and another.

When you are thinking of a piece, the piece tells you what to do, clearly, and you just have to do it. In *Atrabiliarios* (1992–93) I was researching several cases of people that had been disappeared. Finally I focused on one case—and I learned that in art everything is particular. The more particular and the more intimate you get, the more you can give in the piece. But at the same time, as I was working with each family, I was seeing that there was something really wrong about the victims, the families of the disappeared ones. They suffer in silence. I wanted to make that private pain into something public because it is not a private problem. It is a social problem. So I wanted to get that pain, the mourning that was in the sphere of

the private, into the sphere of the public. That's why I made many niches in one space, to convey the idea that it is a public problem that is happening to many, many people.

There are words that cannot be translated. *Atrabiliarios* is one of those words. It's a word that is no longer in common use; you don't hear it. It's a nineteenth-century word that was used in Colombia to refer to the behavior of people during the civil wars of the nineteenth century. And I was using it in an ambiguous way. It means 'people that are defiant' or of that temper. Those words are really weak. This is a very strong word in Spanish—and I was using it both in terms of the ones that had disappeared and the ones that had *been* disappeared.

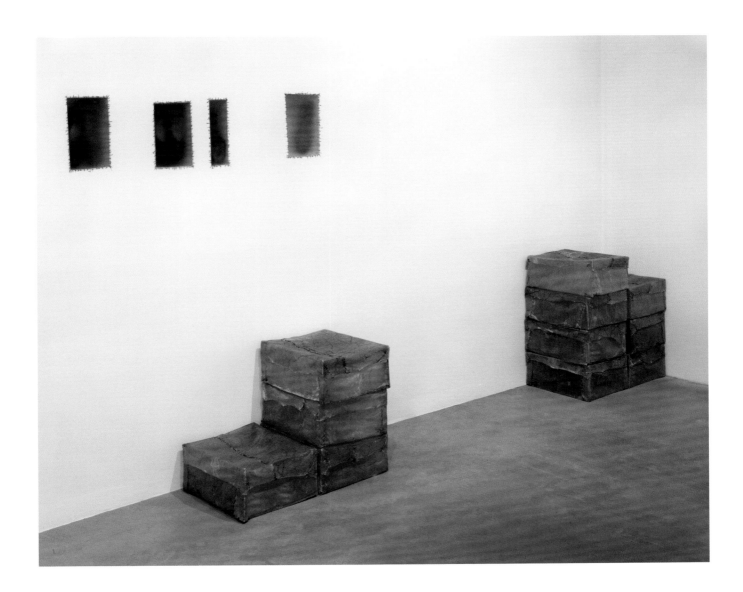

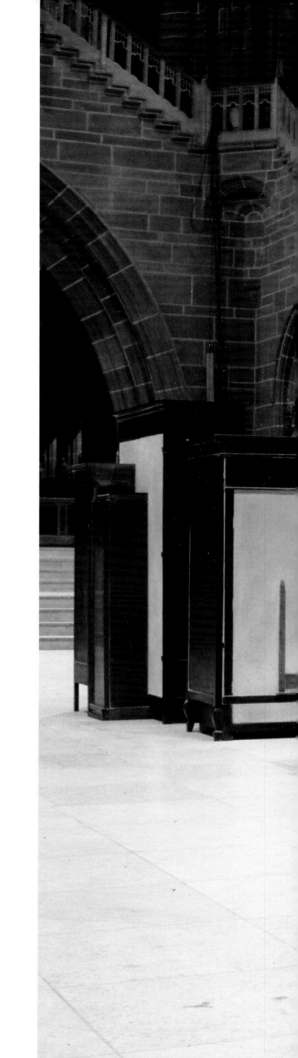

Doris Salcedo

Untitled works, 1999
Installation at the Anglican Cathedral, Liverpool
Trace, 1st Liverpool Biennial of Contemporary Art, 1999

Does compassion describe this work? I don't think so. In *Shibboleth* (2007) and other works, like *Neither* (2004), I wanted pieces that were quite crude, quite raw, in a straightforward way—pieces that had no cultural ornaments to alleviate the painful situation they are addressing. I don't think compassion was represented in those pieces. But as a reaction to what I'm presenting, somebody will feel compassion. In *Unland,* for example, it was clearly present. What I tried to do was to transform materials to the point where they are no longer metaphors but metamorphose into something else quite human and quite delicate—to talk of the fragility of human life and also the brutality of power. In order to do that I wanted to make a surface that was incredibly delicate and fragile, that can literally be destroyed if you just pull a little bit of the fabric that covers it. It's unbelievably fragile. And I think that would generate the idea of fear and compassion as the human response to a tragic event. In *Unland,* this takes place because it is the reality of the piece. It's fragility, vulnerability—not beauty. It is not beauty that interests me now. I believe that in fragility there is beauty. I believe that in other elements you can find beauty, but that's not my search; I'm not pursuing it. No. On many occasions my work has been described as the work that presents

the violence in my native Colombia. I don't think that's the case. I don't believe we own the intellectual property of violence; it's something that is unfortunately universal. I believe that narrows the work to a local aspect and limits its understanding. I don't need a visa to feel solidarity for people in other parts of the world. I don't think it is essential. What counts is to establish connections between difficult situations, terrible experiences, that are taking place all over the world and that show us that we're all the same, and that these differences that are created in terms of race or culture are fake. They are basically our way of constructing the image of the enemy. There's nothing real about it.

Once my work is finished, I'm not necessary any longer. My work has been done, I'm through. I'm finished. I need to leave the place, and I should not be there. The only moment when I get a great reward is in the moment when the piece is finished, when I feel that I haven't failed, that I have been able to address certain issues. That moment is extraordinary. I have half an hour or an hour of silent contemplation with the piece and there is a real communion with it. In that moment, the destroyed life of the victim shines forth and is part of my life and I can go on with that life. And that is quite extraordinary, that for a second I can think that that life was not lost.

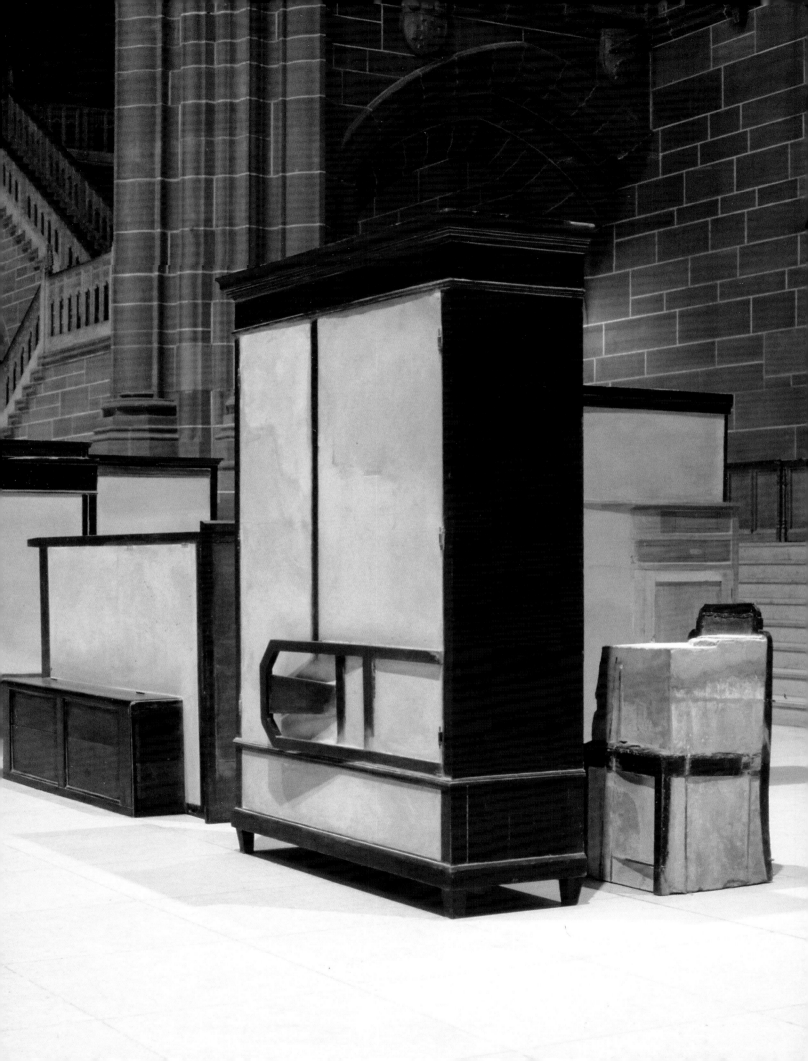

Doris Salcedo

RIGHT
Shibboleth, detail, 2007

OPPOSITE
Shibboleth, 2007
Installation at Turbine Hall, Tate Modern, London
Concrete and metal, 548 feet long

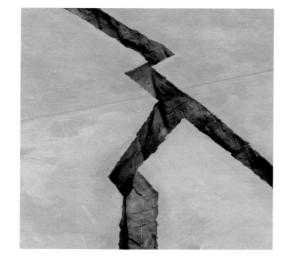

Shibboleth. When I went to visit Turbine Hall at Tate Modern, before I thought of this work, what struck me was the attitude of people who were there. They were amazed at the height. ("Wow, what an extraordinary space!") And I was thinking, "It's not that extraordinary. It's an industrial, modernist space." It's not like you are entering Hagia Sofia or you're in front of the pyramids in Egypt. I didn't think it was of that character, but people had that impression. And I thought it was unbelievably narcissistic. So what I wanted to do was to change that perspective, reverse it entirely, turn it upside down. Instead of looking up, you would have to look down as a way of seeing reality. I wanted to inscribe in this modernist, rationalist building an image that was somehow chaotic, that marked a negative space, because I believe there is a bottomless gap that divides humanity from inhumanity, or whites from nonwhites. I wanted to address that gap, which I thought was mainly perceived in the history of modernity. When you read the history of modernity, it is narrated only as a European event. So I wanted this history of racism to come out because I believe it's the untold dark side of the history of modernity. And that's why I wanted a crack to wreck the building, to intrude in the building, almost the same way a nonwhite immigrant intrudes in the sameness and consensus of white society.

Shibboleth is a word that I took from the Book of Judges in the Bible, which describes the war between two tribes of Israel, the Gileadites and the Ephraimites. The Ephraimites, who lost the war, were attempting to cross the Jordan River to escape. And, as they crossed, the Gileadites asked them to pronounce the word, shibboleth. They could not pronounce it like that; they pronounced it *sibboleth.* That pronunciation identified them as the enemy, as those who did not belong, and they were killed. The Bible described a huge massacre: 42,000 people were killed right there. So I use the word because I refer to the experience of racism, the experience of crossing borders, the experience of the immigrant. What is it to die, making this attempt at crossing a border? There's nothing new about the shibboleth. We all know the history of racism. What I wanted to do was to bring this into a museum because I believe art has played a very important role in generating and creating a standard of beauty and that the standard of humankind, of beauty, has been so restricted by art that it has left most of the inhabitants of this planet out of that description. So the love for classical art and classical beauty helped to create the idea that white human beings are not only beautiful, but that they are morally right—and that everything that could not fit into that image was considered deviant or morally wrong.

War is a tool to expel people from the human genre, from humankind. And I think that's the main event. There are civil wars going on everywhere, and these events are really shaping the way in which we live. War is very much embedded in our life, and that's what I'm trying to show in my work. My work is based not on my experience but on somebody else's, literally defined. That's where you get the connection with political violence, with war. And that's what really interests me. So I have focused on political violence, on forceful displacement, not in the large event but on the small individual and particular experience of a human being. I'm trying to extract that and put it in the work. Those experiences usually are not interesting for historians. The memory of anonymous victims is always being obliterated; I'm trying to rescue it. That's why my work does not *represent* something; it's simply a *hint* of something—trying to bring into our presence something subtle that is no longer here.

I feel that I am responsible for everything that happens and that I simply arrive too late. So the word that defines my work is *impotence.* I am completely impotent. I cannot give anybody back their father or their son. I cannot fix any problem. I cannot prevent a bombing. I can do nothing. I will never present the experience I'm trying to present in the proper way. As a person who lacks power, I face the ones who have power and who manipulate life constantly. From the perspective of one who lacks power, I look at the powerful ones and their deeds.

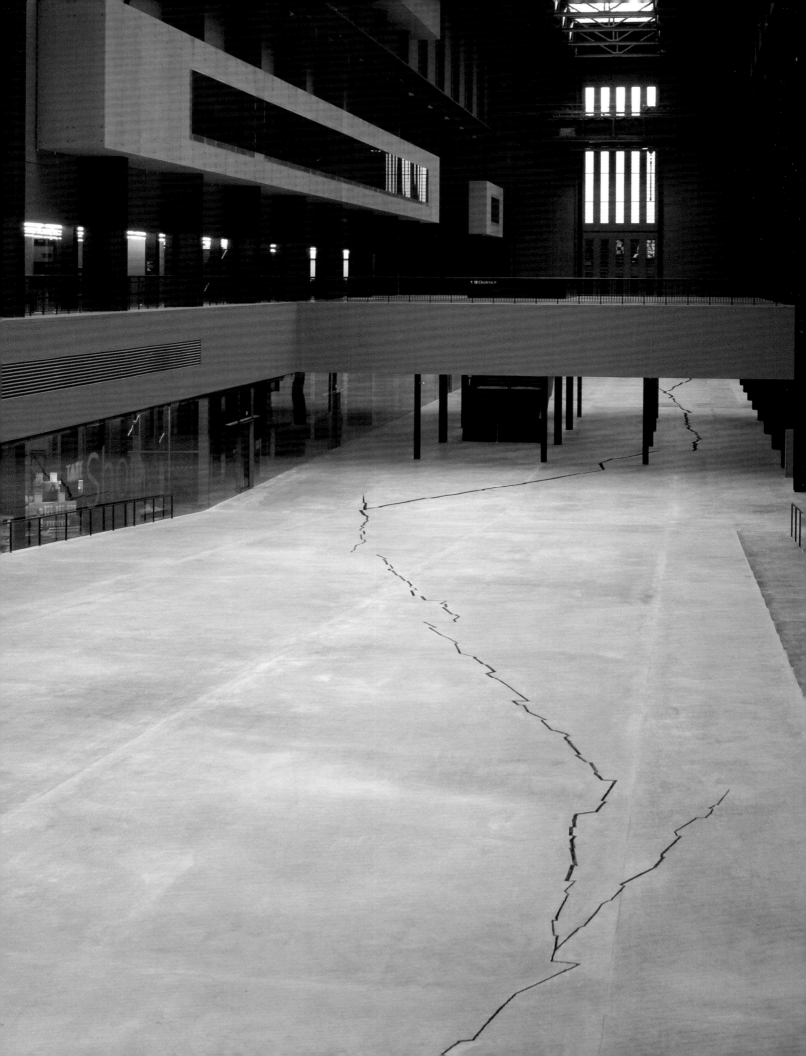

Carrie Mae Weems

My work just gets talked about in the narrowest possible way. I think that it's really so difficult: black woman photographer, Carrie Mae Weems. Yes, always yes, the work has absolutely touched on race. But there are so many avenues of exploration in the work, and I know that people haven't done their homework if that's the first thing that they talk about. There is the performative nature of my work. There are ideas about beauty, how beauty functions in the work. There is the idea of construction. And yet you can still slice through to get to the heart of the thing, the heart of the subject. I think this is really kind of wonderful, that all that stuff doesn't get in your way; it simply frames where we are. And the idea of framing, really a Renaissance idea, that the frame would carry the emblem that had to do with the profession of the person in the image, so the frame tells us who that person is.

There are all of those points that I think could be and should be explored in the work but, because we are so profoundly troubled by race and because we're so caught in the quagmire of race, my work has been stuck in the discourse around race and only that for a very long time.

A part of my work that interests me most and that I've come to understand more in recent years is that it's very important for me to really use this body as a barometer of a certain kind of knowledge—to take the personal risk of exposing my own body in a certain kind of way. I can't ask anybody else to do something that I don't do first myself. I have to know what it means to be naked and exposed first, and then I can ask you, perhaps, to participate with me. But I have to know the depths of the vulnerability first. And so most of the work really is very performative, and that is true almost from the very beginning.

ABOVE AND OPPOSITE
Untitled, from *Kitchen Table Series*, 1989–90
Set of 20 gelatin-silver prints, 28¼ x 28¼
inches each

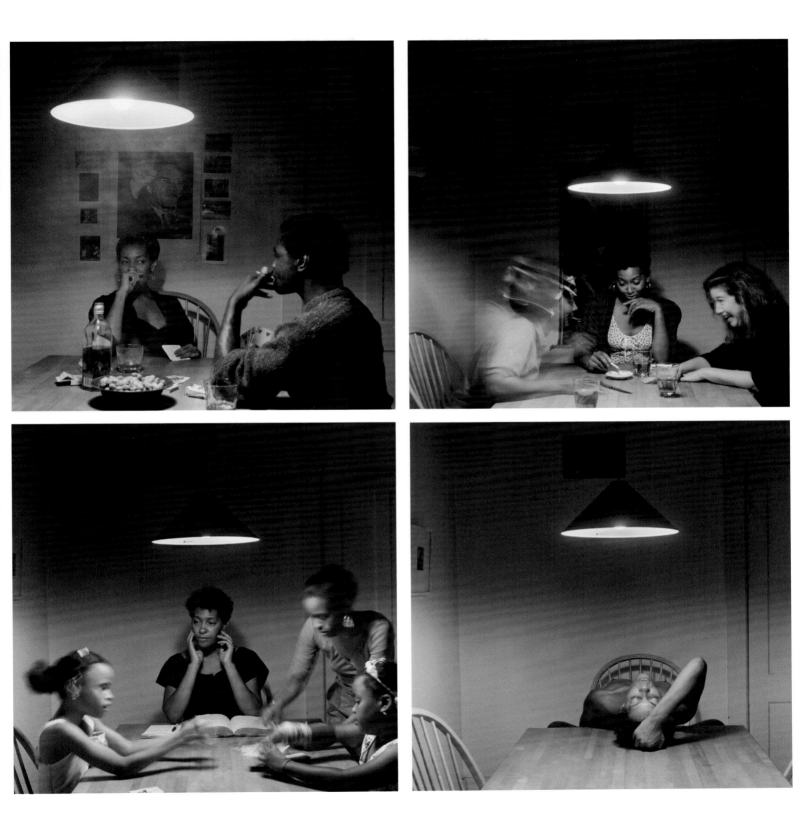

Carrie Mae Weems

I'm getting older. I think about this question of desirability, of being looked at. Who wants to look at this fifty-five-year-old woman? How much of myself do I need to expose at fifty-five, as opposed to when I was thirty-five? What are the risks that one takes at thirty-five that you *don't* take at fifty-five because the game has changed, the world has changed, *you've* changed? Putting yourself through certain kinds of paces has changed. Do I need to do that anymore? I'm not really sure—sometimes yes, sometimes no. This raises a very deep question about mature women and about how one looks at mature women. I think that recently there was a part of me that for a moment felt frayed and very vulnerable about revealing myself, and also concerned about who would be interested in looking, because

I'm making work that I'm hoping other people will look at, that I don't want people to turn away from. Will people turn away from me? Am I not the thing that causes them to look?

If we use beauty as the crutch, and I think that we often do, as a sort of gateway to exploring other kinds of issues, then I felt as though I was beginning to bump up against that wall in trying to figure out an authentic way (not a clever way, but an authentic way) of getting around that. And so some of the work that I'm working on now looks at just this idea of looking at older women in their sense of self, desirability, desire, their sense of compassion, but really looking at this aging body in a way that for the most part I don't think really gets looked at, examined, pictured, and imaged very often.

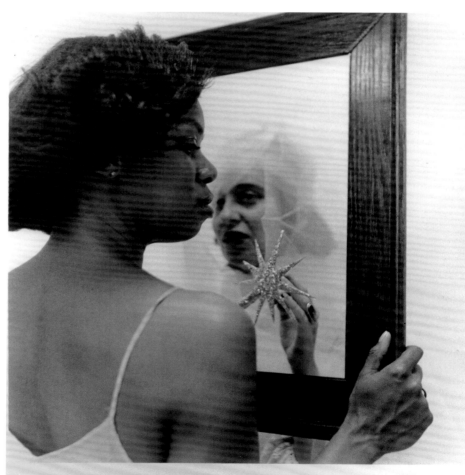

LOOKING INTO THE MIRROR, THE BLACK WOMAN ASKED,
"MIRROR, MIRROR ON THE WALL, WHO'S THE FINEST OF THEM ALL?"
THE MIRROR SAYS, "SNOW WHITE, YOU BLACK BITCH,
AND DON'T YOU FORGET IT!!!"

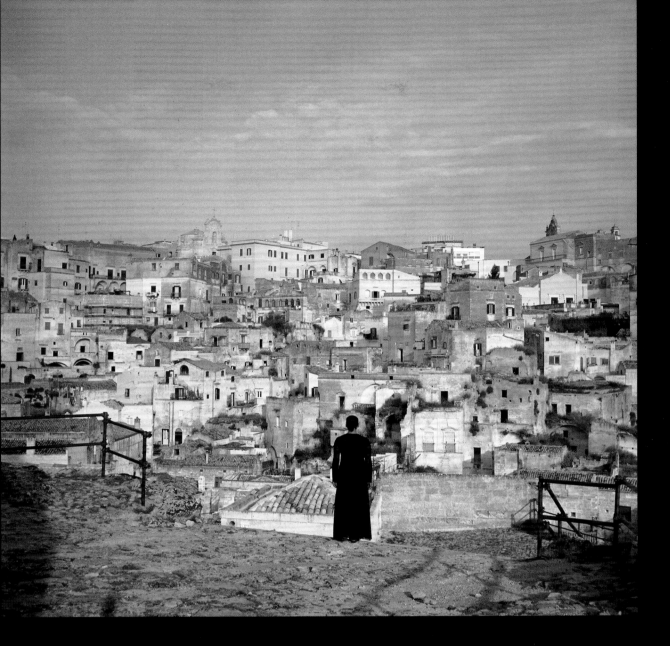

I spend a great deal of time thinking about what something looks like. It concerns me deeply. I'm very interested in how I map something, how I enter it—literally the porthole through which I can enter into the space of making the work. What does it need to have? What does it need to feel like? Conceptually, what is it trying to do? Even when I'm not completely sure, at least I'm starting with a set of ideas and questions about entering that porthole. And then, I'm always aware that I need to take somebody with me, that I don't want to experience any of this by myself. That's the experience of my romp through Rome. That experience has to be shared. My way

of sharing is to be as thoughtful as possible about how the entire thing is constructed so that you will enter this experience along with me, and so that there is something that we can share in contemplation of the sublime (which is sometimes very much about what the photographs are) and of confrontations of power (because I think that the work is about that as well). So if there is a beauty and elegance that allows my self and the viewer to be engaged, then I have a sense that you'll be more willing to enter the terrain and ask the difficult questions once you're there. I think a certain level of grace allows for the entry. It's sort of interesting that I work in

this really down and dirty way and yet the work is really quite exquisite. It's really nurtured and cared for and tender, but getting to it, doing it, is really sort of rough. I'm just interested, ultimately, in the emotional terrain—the beautiful surface and the emotional terrain—and that I get close to the emotion that I think the work is about and allow the viewer to experience at least some element of that along with me. Did I get close? That's the question that I'm always asking myself. And have I posed this beauty for no real reason? Is it just pretty or does it point to something that has deeper meaning, that is more useful than beauty?

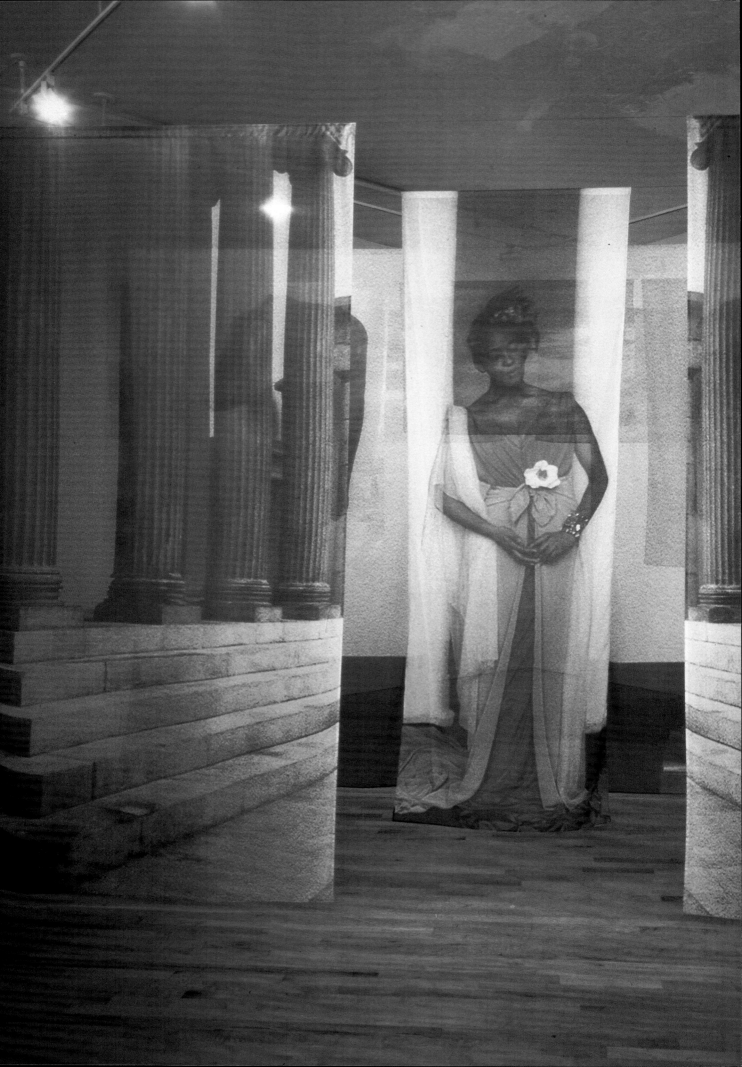

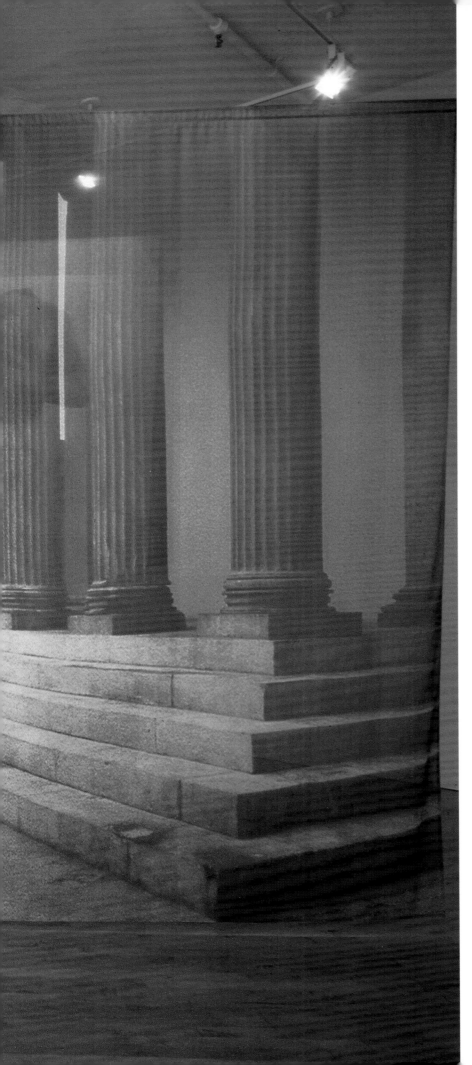

Carrie Mae Weems

LEFT
Ritual & Revolution, 1998
Installation view, P.P.O.W Gallery, New York

FOLLOWING PAGES
From Here I Saw What Happened and I Cried, 1995
Selections from set of 30 C-prints with sandblasted
text on glass, dimensions variable

There was a period of time when I just had to get off the wall. I just couldn't take it. I just didn't want to make one more 16 x 20 black-and-white photograph that was matted with the black frame around it. I needed a larger format for expressing certain kinds of ideas and a certain kind of work. So I started printing on cloth—on sheer, diaphanous cloth—and hanging those. There'd be rows and rows and rows of cloth with images printed on them, hanging in the gallery space. And often (because I love working with musicians, composers, and writers and poets) there would be a sound component as well, something that would hopefully envelop you in the space and something kinetic that you were aware of, no matter where you were, always another level of sound or voice or music or noise.

I've done several projects that looked at issues of appropriation and I've always thought that it was a legitimate use of material, though I can certainly understand that artists would be upset about that. So I've had to negotiate for the use of material. I've had controversies around my work, always, and I think it's actually really important. Harvard University was going to sue me at one point for using the images of slaves. And I thought "This is really fascinating. I think that you should sue me. This issue of who owns the rights to these images of slaves would be a very interesting thing to play out in public debate. You may be right legally, but I think that this is perhaps also a moral question. And maybe we might have to talk about the moral questions that surround your issue of copyright of these particular images." It was fascinating.

YOU BECAME A
SCIENTIFIC PROFILE

A NEGROID TYPE

AN ANTHROPOLOGICAL
DEBATE

& A PHOTOGRAPHIC SUBJECT

BORN WITH A VEIL
YOU BECAME
ROOT WORKER
JUJU MAMA
VOODOO QUEEN
HOODOO DOCTOR

BLACK AND TANNED
YOUR WHIPPED WIND
OF CHANGE HOWLED LOW
BLOWING ITSELF–HA–SMACK
INTO THE MIDDLE OF
ELLINGTON'S ORCHESTRA
BILLIE HEARD IT TOO &
CRIED STRANGE FRUIT TEARS

SOME SAID YOU WERE
THE SPITTING IMAGE
OF EVIL

YOU BECAME AN ACCOMPLICE

Carrie Mae Weems

My family is from the Mississippi Delta. So the idea of working in the fields is one that I know very well (and I worked in the fields until I was maybe fifteen, before I left home). I have done serious labor; I know what working in factories is and I've had a long history of work, union organizing, and all of that stuff. I come from a real working-class and political background.

Before my father died, I decided to take him to a sound studio because he loved to sing and I wanted to record him singing. And I wanted to do an oral history. So he starts talking about his life in Mississippi, and the farm that the family worked on. They were sharecroppers, just a step removed from the plantation system, picking cotton. And he talked about what it was like for him, what a day was like for him, how the cotton was weighed, how much he could pick, meeting my mother in a cotton field, making love to my mother for the first time at a cotton house. It's a very beautiful narrative, but it's a serious story—this complicated relationship of work, labor, war and aggression, and the market. My father is talking about what he does through the course of his life and he is simply a stand-in for millions of others who were part of the same system. So those ideas have been long-standing, and I suppose if I went back to the first real exploration of work, labor, and commerce it really begins with *Family Pictures and Stories* (1978–84).

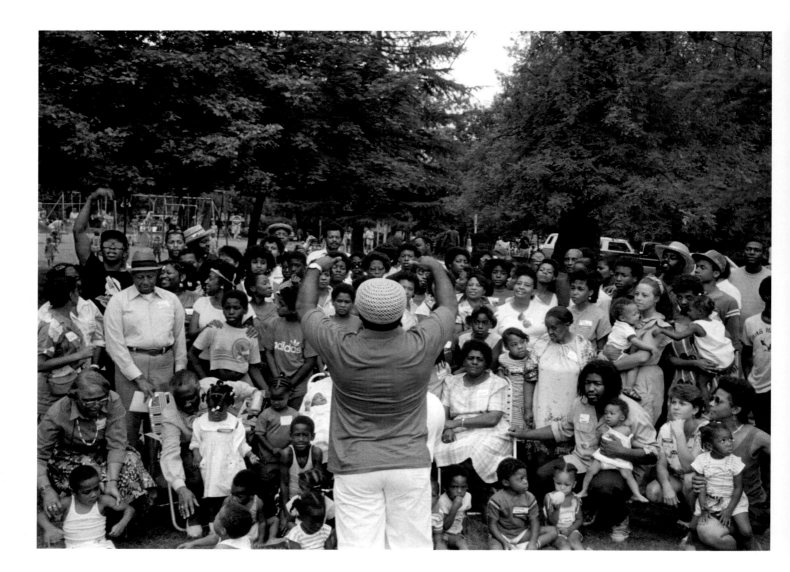

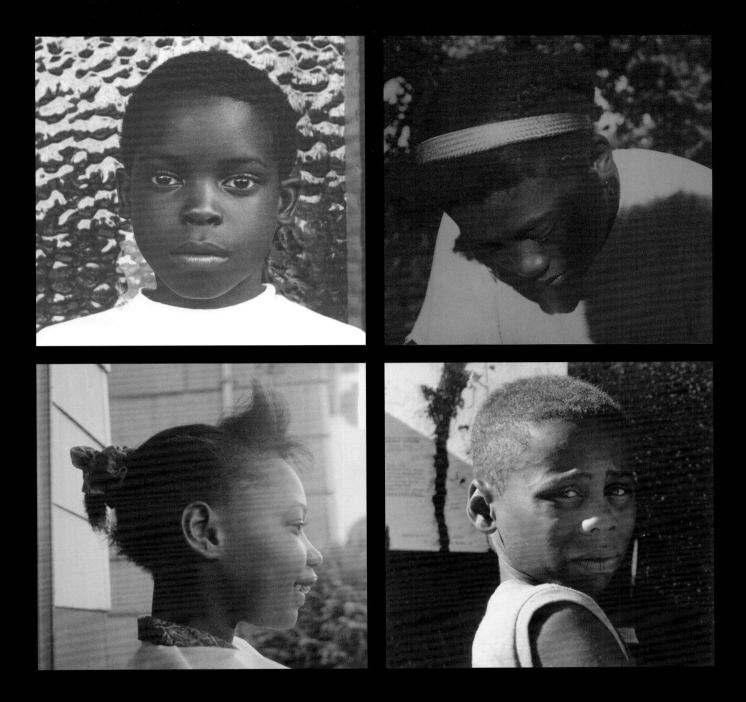

My grandfather was black and Jewish and Native American, which of course is not so much of an odd mix in Mississippi, because of the Seminoles. His mother was black and Native American and his father was Jewish, and of course he basically passed for white. My grandfather came to pick me up one day from school and the next day my girlfriend said, "What were you doing in the car with that white man?" And I said, "What white man?" And she said, "Carrie, the white man that picked you up right in front of the school." I said,

"That wasn't a white man; that was my grandfather." Of course that sort of set me thinking—that somebody would call my grandfather white, which just never quite occurred to me. And so a couple of days later, I was sitting in the living room, looking at him while he was at the table doing his books. I got off the couch and I walked over to him. I draped my arm around his neck and then I sort of wiggled my way into his lap and put my arms around his neck, and I leaned over and said, "Papa, what are you?" And he said,

"I'm human just like you." And when I was four or five I can remember my father sitting me in his lap and saying, "Carrie, you are the equal to anybody, black, brown, green, yellow. You are their equal and you can do anything." To have that sort of human spirit, to be brought up with that, set me very early in life on a really good path, always looking for the best in humankind. It didn't matter if you were white or black or Chinese or Mexican. What mattered was that you were a good person.

Carrie Mae Weems

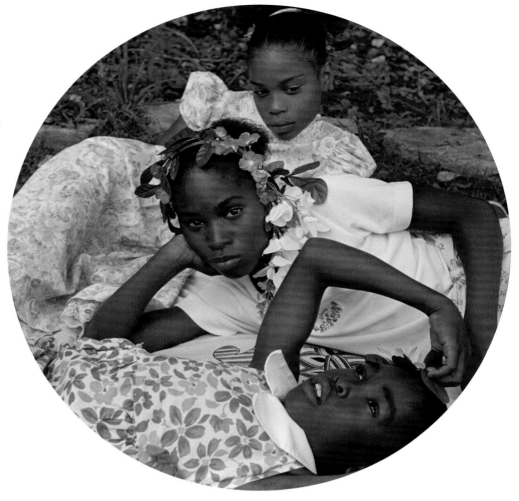

The wonderful initial influences on my work? They were the great photographers of the twentieth century, all those people that John Szarkowski rolled out for us: Garry Winogrand, Tom Roma, Todd Papageorge, and the earlier ones—Cartier-Bresson and Walker Evans. Evans and Robert Frank were two that I started to really pay attention to because they really understood something that I wanted to be close to, that there was a way of describing and approaching the world that I deeply admired. I thought that Evans moved with a great deal of compassion, but with his own extraordinary vision of how to define things, how using the camera and light to illuminate could really describe in a very specific kind of way. I love that. It was probably Roy DeCarava, an American photographer who was working at the same moment, who nailed it for me and who was doing very much what Evans was doing—both of them realizing

that they were working out of a deep cultural resonance. On the one hand, Evans was using everything from zone five to zone ten, and DeCarava was using everything from zone five to zero. So you had incredible cool whites of Evans and deep and rich blacks with DeCarava. They were both trying to do something that was culturally definitive—moving through aesthetic territory, and emotional, cultural, and visionary territory—which I thought was really kind of remarkable. I've always been very interested that nobody else has ever really talked about this as a way of examining the different ways in which photography was to take root in the United States or, for that matter, in other places. You know . . . how do we use light to describe the essence of ourselves? I think it was an enormous idea. You can't use the same kind of light registry for African-Americans that you do for white people. White people really do look better in zone

five or four. Black people really do look better in zone five or six. It becomes very mechanical in a way. There's a wonderful book, *In Praise of Shadows,* by Jun'ichiro Tanizaki, that has to do with the way in which light is culturally used. For the Japanese and the Chinese, the way a shaft of light falls to illuminate the pot that's sitting on the table is one sort of aesthetic dimension and idea. On the other hand, there is that German, Brechtian sort of idea where that light is so brilliant, bright, hard, and brash that nothing can hide from it. Absolutely nothing is escapable in that realm of light, and everything is there to be analyzed and examined. These are ideas that have been very, very interesting to me, and I think about them often. I think about the way that Brecht uses light. I think about the way DeCarava uses light. I think about the way that Beckett thinks about light.

How do *I* think about light? I can say that I'm influenced and I'm aware of the

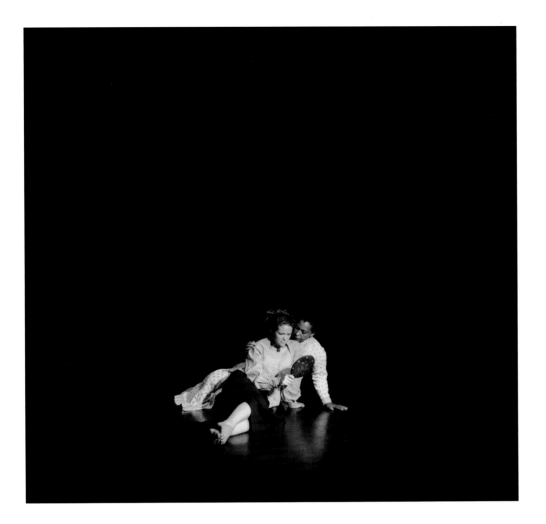

possibilities, but I never do anything that's German-like. I just don't look at the world through that particular lens. That's not the way I process the world and move through the world. But it is a cross between two points of reference, between someone like a DeCarava, on the one hand, and Evans on the other. I'm sort of swimming, navigating what's in between, and maybe that's appropriate because visually I swing between those things, too. I'm not simply describing African-American culture. I'm really involved with other levels of description that move across several different kinds of categories. On the one hand, I might be interested in what's happening in gender with men and women, black and white and Asian, and maybe I'm interested in questions of globalism and class. That might take me some place else. Rome took me to Rome, not to Mozambique, right? So what you do in a place like Rome is something that's different than what you

would do in a place like Mozambique. Because I'm interested in a number of different categories, I've been allowed to work across them aesthetically in a sort of unique way, yet always knowing that *this* work is made by *this* particular artist. It's not just the way I engage the subject, but it's also the kind of equipment that I use. My old Rollei, my distance from the subject, my way of constructing the frame is a thing that I am probably more concerned with than the zone systems that are much more about breaking down color.

And there are ideas about compassion— what you sacrifice for compassion, what you give up, what you choose not to live with so that you can express that. But we all sacrifice something for our compassion in some way. We're giving up something so that something else larger can happen, so that something bigger than *you* can take place. Sometimes we sacrifice our

families. Sometimes we sacrifice other levels of interpersonal communication so that we have that larger relationship with questions that move and shape the world. And so (and I don't think that I'm being naïve or sentimental or dramatic about it) I think that I've sacrificed an enormous amount of interpersonal comfort to pursue aspects of compassion, to pursue them, to look at them and to say, "Yes, I will step up to this. I want this too. And if I want this in this time, in this moment, then certain things have to be sacrificed (because I don't know how to do it all)." Sometimes you sacrifice too much. You find yourself out on a limb and not knowing really quite how to get back down the tree. But it's the space that you're in because you have taken the risk. I'm not unaware of the sacrifices and, at times, whom your compassion hurts. It's not all moving in one direction. It's complicated, as the work is complicated.

Carrie Mae Weems

One of the reasons the exhibition, *Constructing History: A Requiem to Mark the Moment* (2008), came about was in actually dealing with the issue of appropriation. I didn't want to have to appropriate anybody's material; I just wanted to revisit this history. And so I thought, "I have to make it myself and I have to make it in my own way. I have to rise above all of those restrictions and make something that I really want to make—giving a nod to all of those photographers who have come before me."

I've spent a very long time digging in the complex soil of race and racism. I've spent so much time looking at it, thinking about it, troubled over it, obsessed by it. And it still matters to me in a profound way. I really do wonder about this new moment that we're in—what it might mean to have an African-American man become the president of the United States—particularly given that the lives of black people in the United States have been shattered in an extraordinary way. That's simply the truth of the matter—that the brutal effect of racism on blacks, on people of color, but on African-Americans particularly, has been astounding. It's horrific what has happened to us here, and I know that it still matters and will always matter to me. Yet I know that somehow I have to also free myself from the yoke of it, from the despair of it—that somehow I have to put that aside for the moment because there are indeed other parts of life and other parts of my existence that also really matter, that need to be explored, and that to a certain extent allow me to retool and face the horror of what has happened with renewed energy and renewed understanding and possibility.

I knew that *Requiem* was going to be really demanding, and I wanted to concentrate on building the image and allowing myself the room to do that without trying to wear six different hats. I just didn't want to tax myself in that way. What was important was to find the appropriate stand-ins who could physically deliver in the way that I thought might be important and necessary. And for the first time I discovered another body and a type that understood gesture and movement in a certain way—and there are literally photographs that I have where I couldn't quite tell if it was she or I standing in that photograph. It's like, "Oh, wait a minute, is that *me?*" It was really wonderful to discover that, yes, actually I can have somebody stand in not just for me but for the archetype that I'm trying to get across.

Recapping the last forty years of my own life—beginning with 1968 and ending with 2008, and all those amazing and horrific things, assassinations, brutal acts—has implications and great significance for all of us. Now, part of that can be closed for me. I've gone back and I've revisited those assassinations, the civil rights movement. I have looked at it in any number of ways through any number of pieces. And for me this piece, while certainly not perfect, is a very interesting place to pause. It's beautifully articulated—both the video and the twenty photographs that accompany it. It's compassionate but not sentimental, because there is nothing sentimental about reviewing the assassination of King or Evers, or the Kennedys, Bob or John. There's something really tough about it, and I'm happy that I was able to move across that emotional terrain and say, "If I can just finish this, if I can cap this part of my life off, I think I might be able to move forward." And maybe we've all reached a kind of threshold and a new gateway to pass through. I think that Obama's election offers us another way of imagining ourselves as a people and as Americans. And maybe it's in that juncture that I could begin to imagine that all the horrific things that have happened to black people are reconciled through this one swift act. Do you understand what I'm trying to get at? That all of this has not been in vain; that indeed there are some other ways to *be*—and that maybe it really points to the declining significance of race. And so what we're really up against is not so much race any more as the main issue that needs to be negotiated, but rather the question of class that needs to be more illuminated. Race and class have always, for me, been deeply linked.

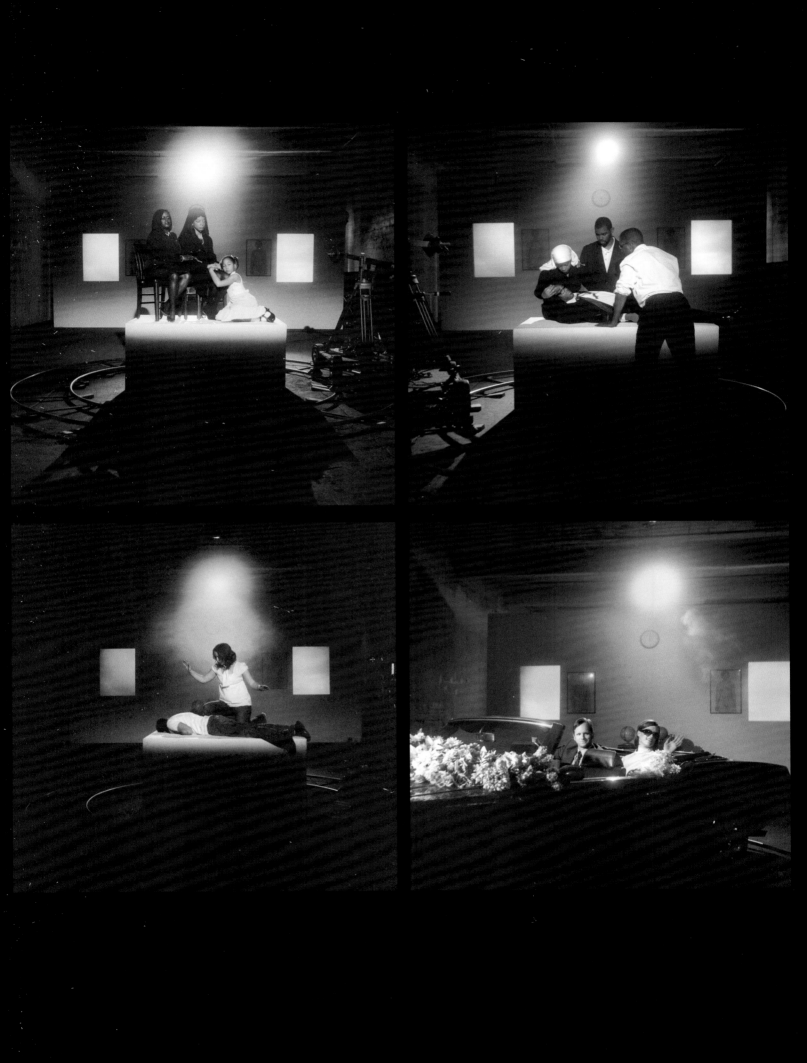

Cao Fei

Mary Heilmann

Jeff Koons

Florian Maier-Aichen

 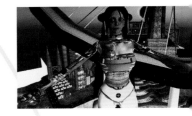

Fantasy

 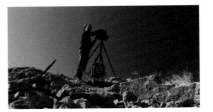 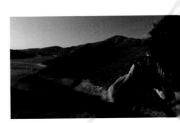

Cao Fei

It goes without saying that my generation has grown up in a fluid and mobile environment where cultures mix and diverge. For example, when I was little I would go out and learn street dance. Later I fell in love with hip-hop music. But I am still a girl who grew up in Guangzhou. Cultural hybridity is deeply rooted in my upbringing and it is reflected in my early theatrical works, including *Rabid Dogs* (2002). In fact, all my work reflects a diverse assortment of cultural layers. Life itself for my generation is a dynamic and evolving process, and one does not need to organize or sort everything out in an orderly way. So when it comes to shooting hip-hop scenes, I tend to do it naturally. And, when you want to express this kind of hybrid complexity, you rely on the use of interactive plays and applications, appropriation, juxtaposition, and assemblage. It's like the notion of sampling in hip-hop, mixing all kinds of things together. Life is a blur; existence is chaotic.

As for the relationship between my works and music it started probably with the influx of MTV and its accompanying culture. It was around the late 1980s and early '90s when China was first exposed to foreign pop culture. In my teenage years I watched lots of foreign music videos. In music videos, 'visuality', montage, music, and image are all blended together into a single process. The influence this left on me was that music and text can certainly enjoy a very close relationship. If I had grown up just reading—focusing on the written word—or if I had been into photography or still images—I would probably be a very different person than I am now. My way of thinking would have been totally different. But the idea of sound and image working together naturally affected the way I choose to express myself. Perhaps music takes the place of some narrative and feeling, or even replaces the role of narration. This is why in my hip-hop projects, or even in the factory scenes of *Whose Utopia* (2006), or in Second Life, music becomes a very emotional part of the work.

Cao Fei

OPPOSITE, ABOVE
Golden Fighter (COSPlayers Series), 2004
Digital C-print, 29¼ x 39¼ inches

OPPOSITE, BELOW
A Mirage (COSPlayers Series), 2004
Digital C-print, 29¼ x 39¼ inches

ABOVE
Ah Ming at Home (COSPlayers Series), 2004
Digital C-print, 29¼ x 39¼ inches

After my first hip-hop project I started working on *COSPlayers* (2004). Neither cosplay nor hip-hop is native to China; neither one originated here. But when we experience cosplay, or when we use it, you feel that it has become indigenous and original. We translate cosplay into Chinese as role playing. It comes from a generation of young people influenced by cartoon culture within the framework of Asian culture as a whole. Individuals come to be known for their imitation of one or another cartoon character. Even in real life they put themselves into the cartoon characters' roles, giving up their real identity to act out the characters, so much so that they let the characters replace themselves in their everyday lives and routines. It's a new kind of role reversal, which reflects the younger generation's discontent with

their actual roles in real life. The fact that they choose these fictional characters indicates their disillusionment and the gap between the generations. Each has its own world and its own assumptions.

The theme of reality versus dream is present throughout my work. Setting plays an important role. I was fascinated by the absurd and wacky scenery in and around the Pearl River Delta. When I was working as an art director, I would often go out and scout for outdoor settings, but along the way would come across ruined scenes dispersed throughout the perfect city and its suburbs. Those places left a deep impression on me. They are very typical of the area. For instance, there is a leopard on the green grass. There is a zebra. In the background there is a city. But all around there are ruins.

In *Whose Utopia* there is an avatar-like element, with factory workers role-playing their fantasies. The theme of reality versus dream and fantasy is present throughout my works. And I think that settings or surrounding backgrounds have a profound influence on characters and how they relate to each other. So when I first got the invitation from Siemens Corporation to create a work my first thought was that this might be a good opportunity to shoot inside a factory. This is usually very difficult. At that time the topic of the Pearl River Delta as the factory of the world was still out there. I felt that I had to get a firm grasp of the whole picture, to go behind the scenes in the factory and discover something about the essence and soul of the place, before plunging into the creative process. Every artist has a different approach to working on a project. What I had in mind was to discover some of the inherent problems in the system. When the work finally came out, some Western viewers reacted by saying how much they hate the idea of the world's factory, the exploitation of multinational capital, and the poor treatment of workers it so often entails. But I don't think *Whose Utopia* is about this. It's not an exposé, nor is it about political correctness. Rather, it attempts to look at and examine a particular kind of reality from multiple angles—how workers are on the lookout for the opportunity to survive; where they are now versus the kinds of dreams they have; their experiences growing up; their nostalgia or memory of their hometowns, their traditional Chinese families, their life experiences living inland, and how they migrated into urban life; and their hopes and aspirations for the future. These are the main issues.

Cao Fei

ABOVE
Whose Utopia, 2006
Video stills, high definition single-channel color video with sound, 20 min

OPPOSITE, ABOVE
My Future is Not a Dream 04, 2006
Digital C-print, 47¼ x 59 inches

OPPOSITE, BELOW
My Future is Not a Dream 02, 2006
Digital C-print, 47¼ x 59 inches

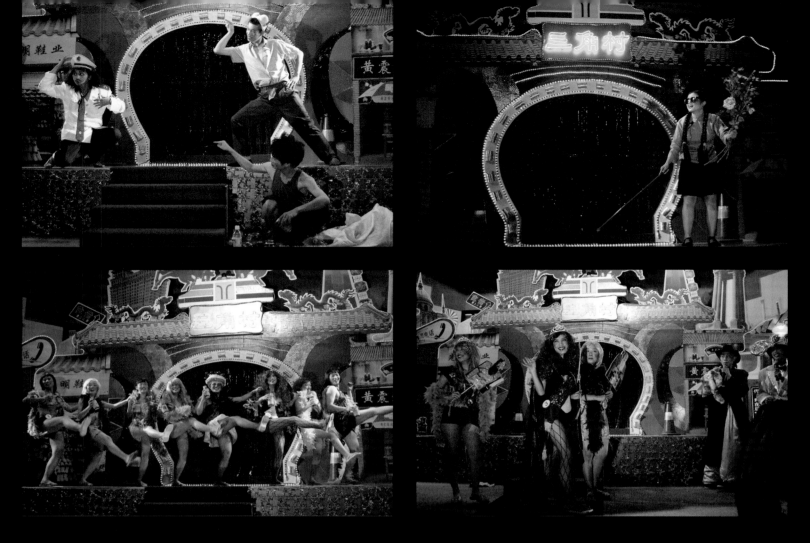

Cao Fei

PRD Anti-Heroes, 2006
Video stills
Multimedia opera, single-channel color
video with sound, 2 hr 22 min

In 2005, when I was working on *PRD Anti-Heroes* (2006), it was a crucial moment in China. By that time there had already been a lot of discussion about the Pearl River Delta and the subject was open for argument and debate. After that, the whole Delta issue began to cool down. So at that time I felt a need for a summing-up—and I think my work covers all of the issues. It summarizes my years of observation and experience. There is a transitional relationship between *Whose Utopia* and *PRD Anti-Heroes*—that is, how to shift from a real-life drama to a theatrical arena. But both share a common theatrical thread. I remember reading a very obscure book many years ago—a novel,

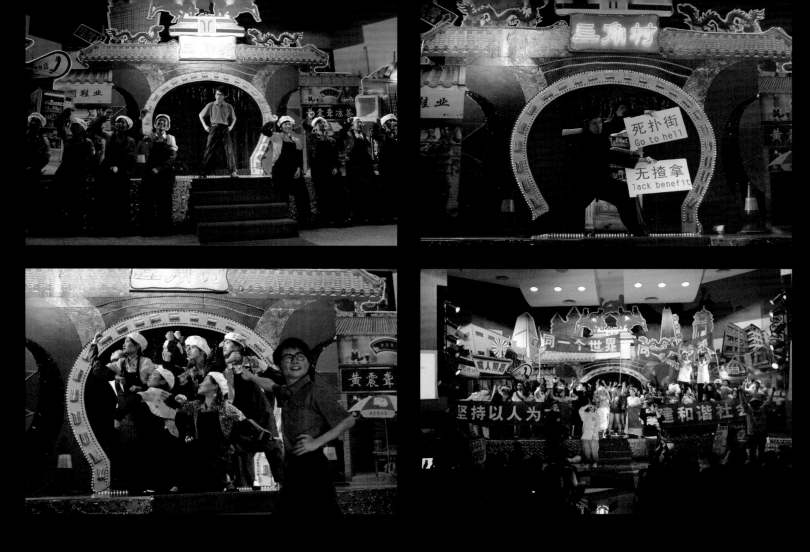

but a very ordinary one. It was about the pre-liberation era (pre-1949), a chaotic period in southern China. Each district of Guangzhou had its own militia, a whole small-scale army, and their own territories, and so on. There were all these small-time warlords, in a very unofficial and chaotic state. Each had his own camp of followers vying for their own interests and advantages. It was fascinating—very real and vivid. But this whole situation belonged only to unofficial history, outside the mainstream. So I started thinking about the artistic mainstream in China, and its mainstream heroes. But I deliberately blurred the two categories of heroes. *PRD Anti-Heroes* is full of

ordinary individuals and also some real heroes from the Pearl River Delta region. I mixed their identities together and assigned the new roles of anti-heroes to all of them. The concept of hero carries more positive connotations. Anti-hero, on the other hand, is not a completely derogatory term. An anti-hero has a more folksy and wild way of doing things. He is not likely to follow the social norms, though he may be more committed to some kind of loyalty and sense of brotherhood. There is something more human in these characters. Anti-heroes are often recognized for their accomplishments outside the official ideology, regardless of their personalities or flaws.

Cao Fei

i.Mirror by China Tracy (AKA: Cao Fei Second Life Documentary Film), 2007
Video stills
Second Life documentary film, single-channel
color video with sound, 28 min

My Second Life documentary, *i.Mirror* (2007), has a feminine perspective. It is very different from my works in the past because, here, I really allow myself to enter my own work—whereas when I worked on *COSPlayers* and *Whose Utopia* I tried to be very objective—to be an observer and to adopt an overview in order to look at and examine the facts and life of the world. I first learned about Second Life around 2006. A colleague told me that he was buying land in an online game. I was curious, wondering how one could do that, and I made a mental note to see what on earth this whole business was all about. So I went online and downloaded the software right away. Subsequently, I opened an account for China Tracy, my avatar. At the time no one had commissioned me to do this project. But I started to get really interested in Second Life. I was absolutely enthralled and spellbound by it from the beginning, when I registered the username China Tracy, to the time when I popped into this virtual world. The whole process was totally captivating and riveting. By the time I was invited to participate in the China Pavilion at the Venice Biennale, I had already been thinking that the virtual world could somehow be brought into the commission. So I began to explore the possibility of a collaborative undertaking between Second Life and the China Pavilion. I threw myself into this project, going on an adventurous journey into unknown territory to explore and wander day in and day out for about half a year, and eventually I came up with the production, *i.Mirror*.

I was simply following the traditional Chinese convention of naming when I chose the name for my avatar. China is the surname, and I picked Tracy as the given name because Tracy is a very ordinary American girl's name. My motive was simple. I just wanted to enter the virtual world with an ordinary person's perspective to see what was happening there. In the beginning I was working with the pre-designed personas that a new Second Life user can choose in constructing his or her avatar. They were pretty standard, so I picked the one that looked most Chinese. But she was not really good-looking. Once you go into Second Life you can make changes on your own. So eventually I started making all the adjustments I needed to give her a more modern look. The process took several stages, including adjustments of her skin tone. I spent a lot of money buying her skin, her eyes, her figure, and even her sex organs. It was a process of trying to make her perfect, step by step. But aside from tweaking my avatar, I think that I spent more time exploring and traveling in this virtual world during that period. Apart from experiencing a personal journey, this was also a way for me to get to know and understand the whole system. I wanted to reveal something, to figure out the whole operating system, and not just focus on China Tracy.

But with China Tracy—well, it happens that this particular avatar is none other than myself. So you will see a strong sense of self, using my own body to experience and explore this world. The encounter between me and Hug Yue occurred when I was roaming around, exploring in my online journey. I saw a very handsome guy playing a piano. The first time he caught my attention I was drawn by the piano music, which was very romantic. His image was a perfect match for the music, and I was very curious because normally within the realm of Second Life if somebody is focused on something like playing piano or dancing, he or she is usually doing it for money. But when I saw Hug Yue, I found that he was simply enjoying himself, relishing and savoring the moment. I had the impression that this guy must be refreshingly fascinating. And so, quietly and secretively, I stood at a distance shooting the scene of him playing the piano. Maybe because I had been standing there for so long, he asked me (China Tracy) for a dance. Thus we began to chat and get to know each other.

You can peek into the digital world through *i.Mirror*. It's a world that is constantly in flux. In many ways it overlaps with reality. There are people dancing. There are clubs, gambling, and sex. On the other hand, everything is much more intense than in the real world. It's more compressed and dense, with more colorful tints and shades, and it teems with a great variety of stimuli as well as desires and temptations of all kinds. Compared to real life, it is much more unbridled and wild. That's why so many people get hooked. They try to find in it the kind of life or emotions that they want in real life. But in the end, you find that beyond reach. At the end of *i.Mirror* you will feel extremely sad and melancholy as you see China Tracy roaming the universe—an immense emptiness—with the sky above and the earth below or, to put it in another way, in a world in between the real and the imaginary. You will feel a huge sense of loss and deprivation. This goes back to the essence of human beings and the meaning of human existence. When we are in real life there are many intangible and incorporeal things that support us, to help mitigate our reality. When we travel through Second Life, or when we watch *i.Mirror*, we inevitably project our first life into it. In fact, we bring many of the dilemmas and quandaries that we face in real life to the fore in Second Life, hoping to resolve them. Or we hope and attempt to use Second Life to decode and interpret real life. More often than not (let's put aside real life or Second Life for a moment), we are unable to untangle or find a solution to the intrinsic dilemmas of the human condition. The fact remains that we humans cannot really resolve our own plight and predicament.

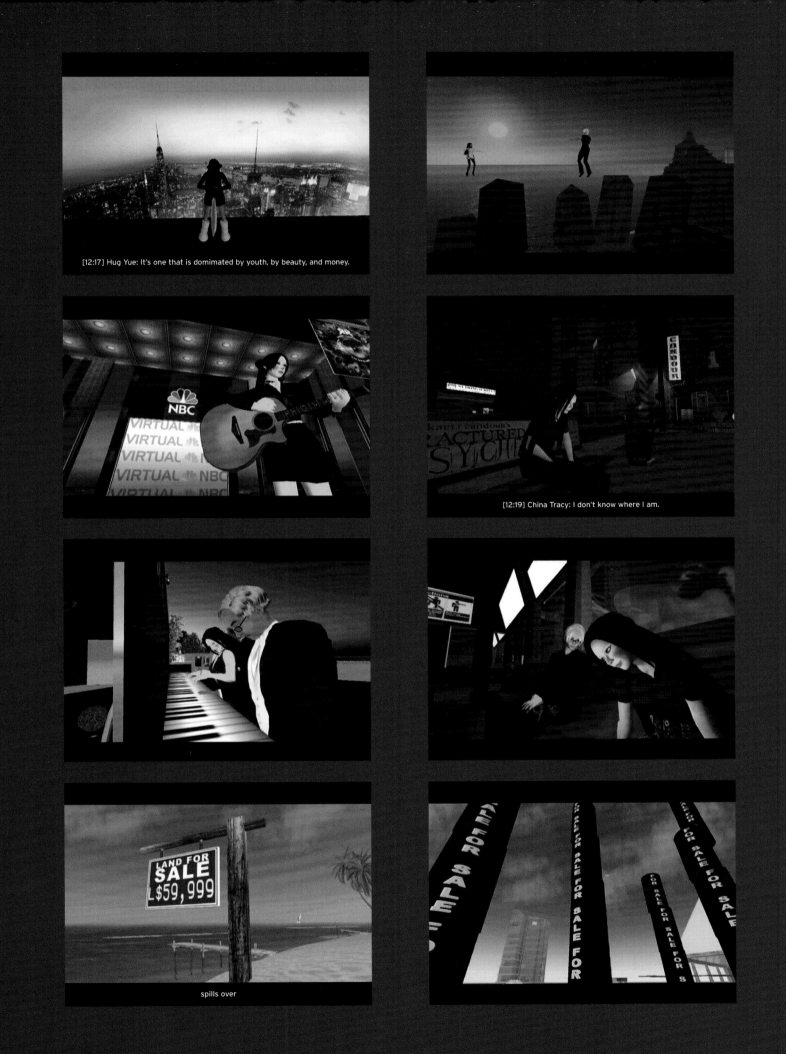

Cao Fei

ABOVE
RMB City, 2008
Mixed media, dimensions variable
Installation at Lombard Freid Projects, New York

OPPOSITE, BELOW
RMB City opening ceremony recorded
January 9, 2009

RMB City (2008) was conceived when I was still exploring in Second Life, around the time when China Tracy was about to finish her adventures. I had already developed an understanding of how Second Life works, and I was wondering if I could have my own country, my own community, and my own city built purely by myself. So I started to envision what this city might look like. The video for *RMB City* is essentially an imagining, a draft design of its overall appearance. *RMB City* represents any contemporary city in China. But it is also an imitation, to mirror the building and development of an urban center in a theatrical manner. I don't think its appearance is even the most important issue. Its design could be much wilder and crazier. It's not a total utopia. It's a utopia in the making. RMB is the abbreviation for the Chinese currency, the renminbi. *Renmin* means 'the people'. And the R could almost stand for republic or revolution. In Chinese, the name sounds like 'the people's city'. So it comes to take on all these associative meanings. I think it also

sounds like 'remember city', a city of memories, because it is actually documenting what cities look like today.

When we first started working on our designs and proposals, we made a wish list for things that we hoped to bring into existence. We then mixed together a collage of the different components for the city, such as a people's factory, a new village, and a slum building. What we were attempting to do was to select a series of images from a wide range of Chinese cities with distinctive characteristics, and overlay and superimpose them onto the virtual city. One of my collaborators saw an ancient Chinese painting at a Guggenheim exhibition. It was a painting from the Han Dynasty, a simple brush painting with rivers and mountains and a little hut on the hilltop. I observed that *RMB City* was in many ways like that particular painting. I wondered why a digital city of today would share traits with the depiction of an ancient Chinese city, the hills, the mists and clouds, the people, the skyline above, and the earth below. It made me wonder if this aesthetic is deeply

"Is this your city?" Asked the young man.
"It's yours." The angel answered.

rooted in the Asian way of thinking, so clearly represented in the composition of Chinese brush paintings with their clouds and mists, hills and rivers, and relationship between humans and nature. Even in my *RMB City* there are two rivers. There are often mists. There are also tiny human figures that appear in such scenes. All of a sudden, I was caught unawares by my own realization that perhaps we had grown up with this aesthetic sense imbued in our blood—that it had always been part of our upbringing without our realizing it. And that when we looked at the world and then designed our own new world, we would unconsciously use this intrinsic, built-in system to do our planning. We have always been vested in this framework, namely, the visual schema of the Asian philosophy of art. I didn't appreciate this invisible upbringing until I grew up and became more mature. In retrospect, I realize that I have always been looking for these connections, the differences and similarities between past and present, Asian and Western.

Cao Fei

RMB CITY 4, 2007
Digital C-print,
47⅕ x 63 inches

Mary Heilmann

A body of work starts by daydreaming, imagining, looking at my own work, the work that's already around in the studio, and also looking at the work on the computer. All the images that I've done are on the computer now. And the work is always made by morphing previous work. Speaking of getting ideas, I can't think of specific impulses and ideas that I've gotten from my students or practicing artists, but I have really been, as I say, inspired by other people. Now, since we're in the era of post-modernism, I can actually say that I really do take ideas. If I see a good idea, forget about it! It's mine! And I often put the person's name in the piece. It is a kind of a philosophical idea, a truth, that any object of art is really made out of all the other objects of art that come before it and at the same time.

Mary Heilmann

OPPOSITE, ABOVE
Little Three for Two: Red, Yellow, Blue, 1976
Acrylic on canvas, 13½ x 24 inches

OPPOSITE, BELOW
Tomorrow's Parties, 1979/1994
Acrylic on canvas, diptych: 48¼ x 72¼ inches overall

RIGHT
Kachina, 1985
Glazed ceramic, 16½ x 11½ x 2¾ inches

The dream of being an artist was something I got way back. That was what I wanted to be, whether a writer or an artist. As a kid, I didn't know exactly what that meant, but it turns out that it was really a mission I was on. It was just about the only thing I thought about: doing art, the art enterprise, something important and beautiful, all by myself. In the beginning, I didn't think much about communication with other people. As I got into it and matured, I saw that the most important thing about doing artwork was communicating and having something like a conversation through the work. Starting in graduate school, I thought about making pieces partly for their formal values, but also very much for what kind of a response I would get. Often, the response that I wanted was one of antagonism. I wanted to cause trouble because I had figured out that I wanted to be on the edge, original, avant-garde. And that meant going against the status quo.

When I decided to be an artist, one of the big reasons was to drop out—to do something sort of *outlaw*. When I told my mother, she said, "You'll starve in a garret." And I thought, "Yes, that's exactly what I want!" By then, my role models were the Abstract Expressionists. I guess a lot of us were choosing this kind of outsider type of life. But when I first got to New York I was looking for a sense of community and shared ideas. Actually, it's kind of advanced to be seeing it like that. It was really almost something like when you come to junior high school and you want to hang out with the cool kids. In the beginning, I went to Max's Kansas City where so many artists were hanging out—Robert Smithson, Carl Andre, Richard Serra, Donald Judd, Brice Marden. I wanted to be part of that community, but didn't really get to engage that much. The people were not very friendly. I wasn't making an impression on those guys, and part of the reason is that my attitude was quite contentious. People were very serious and very guarded, and an ornery young girl was not going to get attention. It's not that I wanted to learn. I wanted to engage in conversation, and it just took a lot longer than I expected to get into that.

I was a sculptor and couldn't get attention for my sculpture so I started making paintings. I didn't really study painting in school, but I remember friends who were studying painting at Yale in the '60s where the big thing was looking hard at a painting and trying to decide if it worked or not. I guess a lot of my work is dedicated to making something that doesn't work, and to make it obvious that it's not working. In the '70s, when I started, my painting was coming out of sculpture. And I was using acrylic paint almost as a sculptural material. I would paint straight up and down and then straight sideways, covering up the brushstrokes—not sanding them out, but just trying to make it not expressionistic at all. And then at a certain point, I'd put on my masking tape and paint all over the place so that you'd have this hard-edge thing and this gestural thing going on at the same time. And that was a major breakthrough. You'd get it both ways. You'd get Albers and de Kooning in the same painting.

Mary Heilmann

RIGHT
Two Lane Blacktop, 2008
Oil on canvas, 42 x 42 inches

OPPOSITE
Lovejoy, 2004
Oil on canvas, 50 x 40 inches

One thing that really interests me comes especially out of Japanese painting, even kimonos and screens, where you have a number of different kinds of space in the same painting. You have a kind of deep space and then you have something right up on the surface. *Two Lane Blacktop* (2008) has that. It has the converging lines going off into space and then the drip coming down the face of the painting which is flat so that there are two realities going on in the same painting. I've been playing with that a lot. I love it. It's one black thing with two little lines on it. I'd probably been thinking about it for four months, trying to figure out how to get that just right—and then I got it. (And once I think I've got it, I'll make about twelve of those paintings.) Simple ideas become obsessions, almost like a meditation. Another thing that speaks to that is the paintings that are on double square-shaped canvas. Often I put a deep-space kind of motif on a shaped canvas like that and then the two squares that are the empty space make the wall be part of the painting. Then you get real space and fake space, and the physical object—the canvas —shaped or rectangular. So there you've got three kinds of space in the same piece. The shaped canvas comes out of my own thinking about geometry. A lot of my figur-ing-out-what-to-make time is spent doing some basic counting and measuring and trying to figure out how big different ele-

ments of a piece should be. I could spend days obsessively thinking about three inches, two inches, six inches. It's very much a mental exercise. But then I try it out on a different, actual physical scale. The reason I don't just fool around making it physically goes back to how the Abstract Expressionists worked, just duking it out, poking the painting, rubbing it off, and putting it back on. I am just too lazy to do that so I like to just think about it forever and then finally try it out. And a lot of times it comes out right. Now that I have my computer, I do a little bit of basic fooling around in graphic programs, not so much with scale but with colors. Seeing the colors on the screen of the laptop has really influenced my color in the last ten or fifteen years. I got really in love with the chartreuse-ish kind of green, which we used to see all the time on the computer, and with the computer graphics, too. And I got inspired by the color of light that I con-stantly saw as I played with my computer. It probably seeped into my consciousness about making the paintings. But when I moved out here to the east end of Long Island, in the midst of all this green, my color perked up. It made my green much more varied. It's not all chartreuse any-more, but it isn't out of nature; it's really out of artifice. My other big inspiration is cartoons on TV. *The Simpsons!* The way they use color is just awesome.

Mary Heilmann

I always wanted a lot of attention. As a little child, I wanted to be a famous ballerina doing *Swan Lake*. I wanted everyone looking at me. Then I was a diver, and I wanted to be spinning, doing somersaults off the diving tower in Los Angeles. I was always scared. It's hard, and it usually hurts a little bit when you hit the water, even when you're doing it perfectly. So I did it for glory. After that I decided I wanted to be an artist, once again to be getting attention. I realize now that I fulfilled what I wanted to do and that it was a psychological thing—that I just wanted to have some kind of an identity. But it makes a kind of touching story to think of this little girl. And the earliest thing that I wanted to do to get glory was to be a martyr. I was a very holy little Catholic girl at about six, seven, eight years old, and what I wanted was to be in Rome in the Colosseum. The lions would come running out and they'd get me, and the audience at the Colosseum (those bad Romans who were killing the Catholics) would be cheering. And then I'd just go flying up, straight to heaven. That was my earliest glory fantasy. I loved the whole Catholic culture, as a kid. And our family really was very devout and completely faithful and trusting. What was really wonderful for me were the wonderful stories. And as crazy as the martyrdom fantasy is, it just made such a fabulous story. The way you flew up to heaven was so fabulous. Diving was not like that. You didn't fly like that when you jumped off a fifteen-foot tower. You went down really fast.

Catholicism continues on in the work. I have a tremendous love for the spiritual part of life. It's more ecumenical now, and not so specific, but my spiritual life is important to me. And I think the art-works are icons. I haven't used the word 'iconography' about it, but I've got my vanishing points, my palettes, my surfing-on-acid period. So each thing almost works as an icon or maybe an ideograph— as one idea that has resonance and makes you have thoughts about other ideas. The drip as an icon . . . bleeding people wearing crowns of thorns. I did a painting based on the martyrdom of St. Sebastian. It's called *Rosebud* (1983).

Mary Heilmann

ABOVE
Surfing on Acid, 2005
Oil on canvas, 60 x 48 inches

OPPOSITE
Rosebud, 1983
Oil on canvas, 60 x 42 inches

Mary Heilmann

Back when I was in school, I was studying ceramics and I took a course in Japanese art. And I found out about Japanese ceramics and was tremendously inspired by the rough tea bowls which, I think, would be described as wabi-sabi. I didn't know that at that time, but that kind of rough, natural way of making artworks really inspired me. I like it because it's intuitive and not labor-intensive. Whenever I'm trying to figure out an idea for a painting I spend a lot of time trying to get to the easiest way to do it.

Sometimes I get inspiration for a painting from how you glaze ceramics. When you glaze a pot, you pour some liquid glaze into it and then let it run down, back into a bucket, so the flow of the glaze makes the image. The image is the drip and the pour, so it's just like in a pot.

Mary Heilmann

ABOVE
Interval, 2002
Oil on canvas, triptych: 40 x 74 inches overall

OPPOSITE, ABOVE
Snakey, 2007
Aquatint and archival pigment inkjet
Image: 22⅞ x 1¼ inches, each side
Paper: 28⅞ x 41⅝ inches
Edition of 35

OPPOSITE, BELOW
Thief of Baghdad, 2007
Woodcut, linocut, and archival pigment inkjet
Image: 23 x 15⅜ inches, each side
Paper: 28⅞ x 38⅜ inches
Edition of 35

I take pictures. They're just in the back of my mind. I don't really look at them when I'm painting. But lately, I've been making some digital prints, which I combine with etching, and you get the idea of two ways of making images. I've always used a slide show when I give artist talks, and it involves using a lot of photographic images with painting images. That has become a very important part of my work life—looking at diptychs made with a photograph and an abstract image. Ideas are put together almost in a linguistic way. I imagine images and think a lot, and the process is very similar to how it is when I write. It happens while I'm working. The idea I have in the back of my mind usually changes as I make the work.

Every piece of abstract art that I make has a backstory. When minimalism ended and post-modernism started for me, I started giving the pieces fanciful titles that related to some kind of narrative that was going on with me. So the titles are often like a three-word poem that is a part of the piece. It's really opened up my work to where I can make an abstract-expressionist, gestural painting next to a geometrical painting next to an image of a piano, and it kind of makes sense for me. I keep a diary and I just make notes about whatever happened the day before. I write in it in the morning. I have had it now for about twenty years, so I can look back and see what was going on—and I like to read it and remember how I felt way back. Actually, remembering and then expressing emotion in the art is something that I like to do. Titles and color help with that, and then the music metaphor is something I think about when I try to put emotion into abstract work. Scale does it, and the relation of parts to the whole piece gives a feeling. Loss, loneliness, claustrophobia, agoraphobia, fear, freedom. Lifted spirits. Melancholy and joy may be in the same piece. Music inspires me. When I'm sitting, counting, and measuring, and thinking about clutter and emptiness, I might be thinking of sound and silence. So the structure of music is an inspiration for me in an abstract way. And the mathematics and emotion of music together are a really good way to talk about how I think about my work.

Jeff Koons

One of the amazing things about art is that it changes every day, and its meaning to you changes every day. When I was young, it was really a vehicle that gave me a sense of self. My sister was three years older—so I couldn't do anything as well as she could. She could always do everything better. But when my parents saw me draw, they made me feel like I could finally do something at her level. From that point I had a feeling that I had a place, and it gave me a sense of being. I started off having no idea what the power of art could be. As I developed a sense of personal iconography I learned that you start to become comfortable with yourself, to accept yourself. Once that happens, you want to go external. You go from subjective to objective art, and art becomes a journey which is really about sharing with people. When I was young I really didn't have a base in art history. My first day in art school, we went to the museum and at that moment I realized how naïve I was. I didn't know who Braque was. I didn't know Manet. I knew nobody. I knew Dali, Warhol, and probably Rauschenberg, and Michelangelo, but I had no sense of art history. I survived that day and I think that's one of the reasons I'm here now. I was hungry to learn. I wanted something to transform my life. And art has that ability to present everything in the world, all the disciplines of the world, and to unite them.

Jeff Koons

Artists are asked quite often whether there's anything repetitive in their work. If I look at all the work that I've done over the years, I can see that I continue with certain themes. I like flowers; I like certain sensual images. There are certain things that I like to work with: it's really how you look at life, how open you are to life and its spiritual aspects. A lot of things come into play. If I look at a Warhol soup can or a urinal by Duchamp, these are cries of communication. I don't think they're about the objects. Duchamp would probably roll over on hearing this—but I think that objects are metaphors for people. So it's not about accepting the object in high-mode culture; it's about acceptance of others. I think what people want from art is gesture. And when I say gesture, I don't mean just a physical gesture but a form of gesture that everybody wants to live life to its fullest and to feel life within their blood system. What does it mean, to be alive? What's my potential? That's what you look for from art, whether you're looking at dance or listening to music or looking at a visual artist's work. You want gesture: you want the person to be in the moment to show you how far you can go, and the freedom of what that means. So the job of the artist is to make a gesture and really show people what their potential is. It's not about the object, and it's not about the image; it's about the viewer. That's where the art happens. The objects are absolutely valueless. But what happens inside the viewer—that's where the value is.

Jeff Koons

RIGHT
Puppy, 1992
Stainless steel, soil, geotextile fabric,
internal irrigation system, and live
flowering plants, 486 x 486 x 256 inches

OPPOSITE
Split-Rocker, 2000
Stainless steel, soil, geotextile fabric,
internal irrigation system, and live
flowering plants, 441 x 465 x 426 inches
Installation view, *Jeff Koons Versailles,*
Château de Versailles, France, October 9,
2008–April 1, 2009

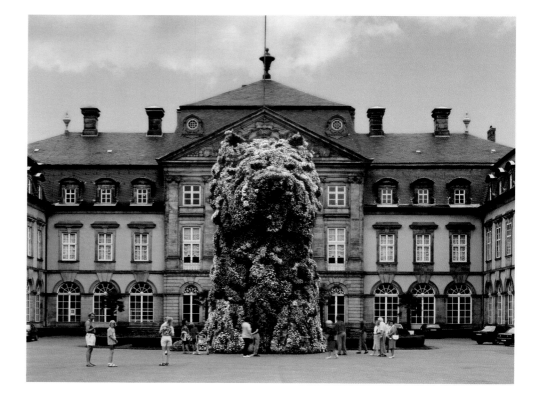

From the time that I was a child, I would take care of myself. I was brought up to be really self-reliant. I would go door to door, selling gift-wrapping paper, candies, chocolates—and I always enjoyed that I never knew who would open the door. It's the same interaction that happens as an artist, wanting this communication. All of a sudden that door opens and you don't know what odor is going to come out of the house. You don't know what's on the stove, cooking. You don't know what the furniture is going to look like, what type of clothing the person's going to have on, if he or she is going to be old, young, grumpy, happy. You just dive into that moment and start trying to communicate, to have an interaction in which both of you can find meaning.

The first time that I ever worked with an image that made reference to Louis XIV was in 1986. I did a bust of Louis XIV, and I really used him as a symbol. After the French Revolution, artists had all the freedom they wanted to use art in any manner. But Louis was a symbol of what happens to art under a monarch (whoever controls it, it will eventually reflect his or her ego and simply become decorative). I was making reference to that because if I wanted that responsibility or had that opportunity, the same thing would eventually happen. *Puppy* (1992) is a large floral sculpture made out of 60,000 large flowers. I conceived that piece really thinking that it would be the type of work that Louis would have the fantasy for. He'd wake up in the morning, look out of his palace window, and think, "What do I want to see today? I want to see a puppy, and I want to see it made out of 60,000 plants, and I want to see it by this *evening*. Go to it!" And he would come home that night and voilà, there it would be! *Split-Rocker* (2000) is also made out of live plants—90,000 of them. I was at Versailles for about three weeks, planting the piece with a team of gardeners. It was the first time that I planted a floral piece completely mathematically. It's based on a pattern of five, and I have light, dark, and mid-colors and different values in those colors. I thought it was appropriate for Versailles and the gardens because of the way Louis and his gardeners laid everything out. You can see that there's a sense of chaos and disorder, but it's all very mathematical and repetitive. There are also theatrical aspects to Versailles. It's very much a place for show—and my works want to show themselves. They're extroverted. The spaces and the major salons at Versailles are about public interactions. But there are surprising, wonderful parts. Whenever the king or queen would move, their environment would change with them. So if the king walked through the gardens, all the fountains would start to flow as he entered. And then, as he left an area, the fountains would be turned off—and they'd be turned on in the area toward which he was proceeding. Or the same could happen with all the plants and all the flowers. He could go to bed one night when every flower in his garden outside the palace might be red—and wake up in the morning to find that during the night hundreds of gardeners had changed every plant to blue.

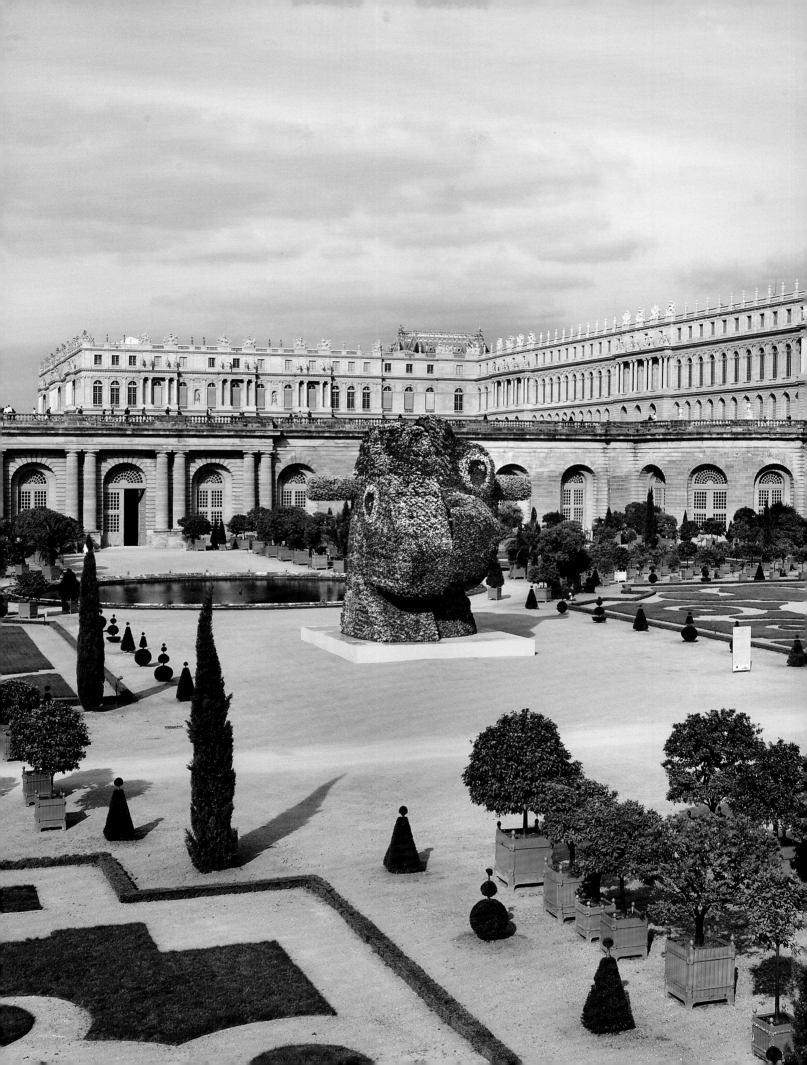

Jeff Koons

RIGHT
Self-Portrait, 1991
Marble, 37½ x 20½ x 14½ inches

BELOW
Bourgeois Bust—Jeff and Ilona, 1991
Marble, 44½ x 28 x 21 inches

OPPOSITE
Rabbit, 1986
Stainless steel, 41 x 19 x 12 inches
Installation view, *Jeff Koons Versailles,*
Château de Versailles, France, October 9,
2008–April 1, 2009

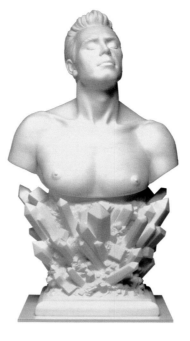

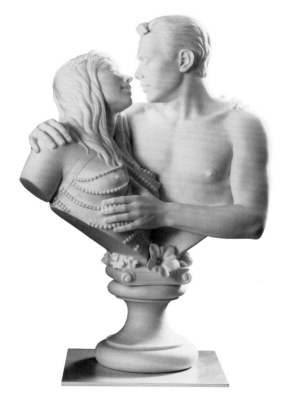

Choosing the different objects to be shown at Versailles, I just opened myself up and listened to the works that I created. What wanted to present itself in certain salons, or out in the gardens? What would be appropriate? Today you can use computers and various technologies so that you can know exactly what an exhibition's going to look like. So, even before anything was hung or placed, I knew exactly how it was going to react in its environment. And I spent about five weeks, at different times, just being in the gardens and going through the palace. I even had to almost position myself in a certain way, just as any artist at court would have had to present himself. And the way I did that was that I showed my self-portrait bust. I put the bust on top of a plinth, a base that was designed by Bernini. It was probably about eleven feet up in the air. And when I made the suggestion, some of the assistants at Versailles started to giggle, probably thinking, "How can he do that?" How could I put myself in a position like that on a Bernini base? But I realized that it was kind of necessary. It was across from the portrait of Louis XIV by Hyacinthe Rigaud. If I hadn't put myself on a base like that, I wouldn't have been accepted. I had Louis XIV on one side and Louis XVI on the other. It was kind of like being in a sandwich, and so I had to put my portrait on a monumental level also.

Showing at Versailles felt very natural, and the works felt very comfortable there. *Rabbit* (1986) was in the Salon de l'Abondance. Usually the rabbit reflects the environment of a gallery or a museum, but to reflect the interior of Versailles was very special. *Lobster* (2003) was hanging in the Salon de Mars, It's a little bit like a performer, an acrobat with broad arms, and the tentacles are like a moustache. But, if you look closely, the graphics on the lobster are like somebody being burned at the stake. So you also have this sense that if you're in the public eye long enough, that's an inevitable fate. I enjoy making reference to or communicating with other artists and dialogues throughout art history. So works like *Bourgeois Bust—Jeff and Ilona* (1991) and *Self-Portrait* (1991) make reference to baroque sculpture, but they're both unique in their own right. With the base of *Self-Portrait* and all those crystals coming off I wanted to represent something profound that came from a very deep place and, at the same time, something very masculine and strong. With *Bourgeois Bust—Jeff and Ilona,* I wanted to create something that was very romantic—a bourgeois couple, kissing. But I wanted to be able to bring Ilona's body and my body down together in a point so that it's a heart—a symbol of love—and take the flesh and cut through it to form it that way without any sense of violence.

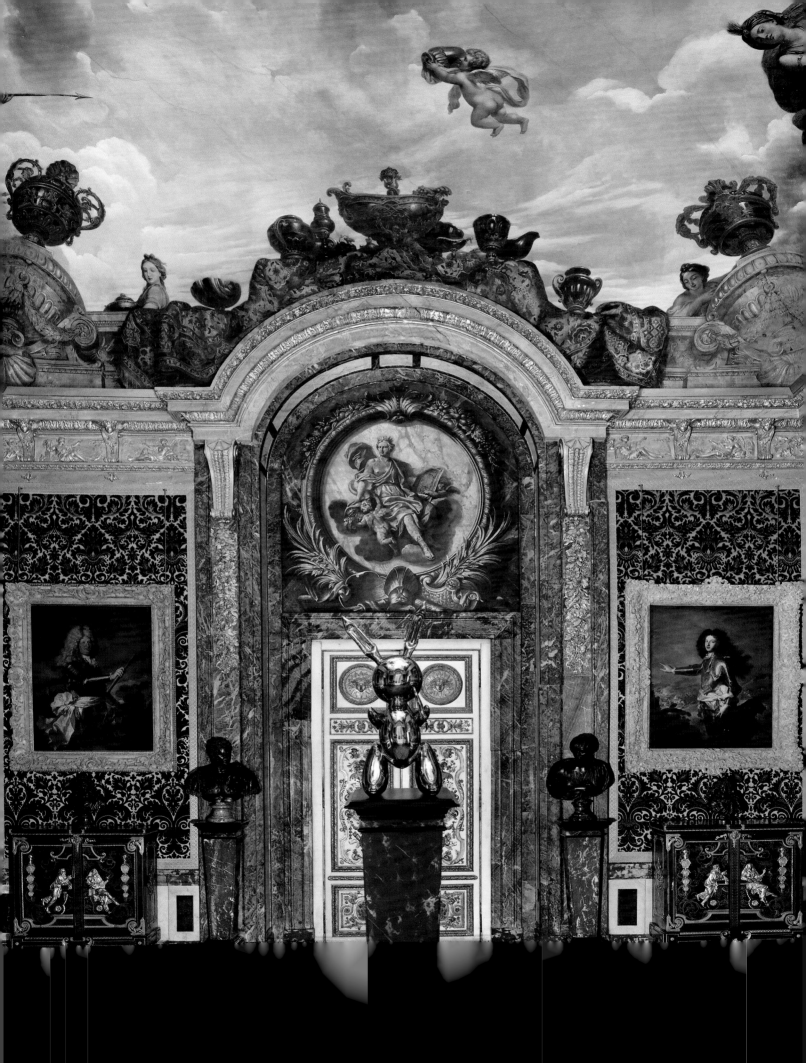

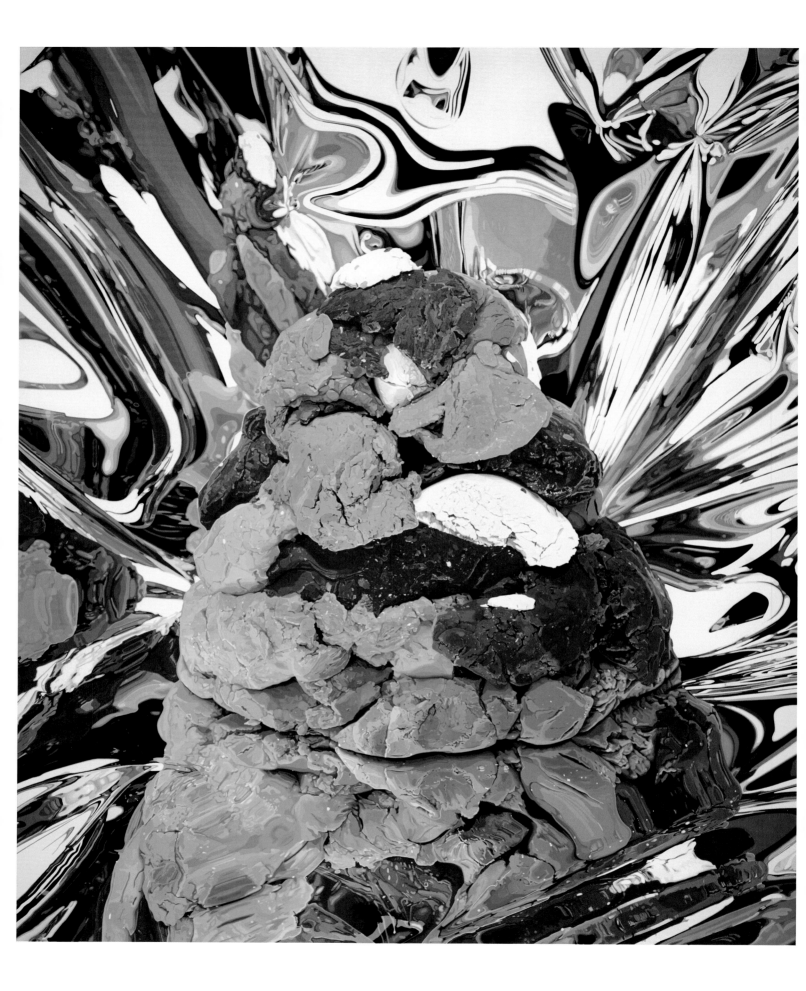

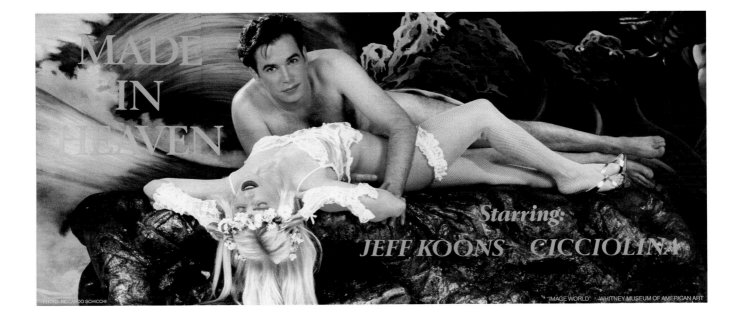

MADE IN HEAVEN

Starring:
JEFF KOONS · CICCIOLINA

"IMAGE WORLD" · WHITNEY MUSEUM OF AMERICAN ART

Jeff Koons

OPPOSITE
Play-Doh, 1995–2008
Oil on canvas, 131¼ x 111¼ inches

ABOVE
Made in Heaven, 1989
Lithograph billboard, 125 x 272 inches

I think art comes into the world through a metaphysical process. People used to say to me, "You know Jeff, you just created this piece and it's very special. Aren't you worried that in the future you won't create another great piece?" I never think about things like that, but eventually you start to think about process and how you make things. And there's really nothing special that an artist or anybody can do, whatever your area of interest may be, because the only thing you can do is to follow your interests. That takes you to a metaphysical place, and that's where you find art. If you *try* to create art, it's a decorative process and you're just really kind of wasting time, spinning gears, until you get so bored with yourself that you just stop the process and ask yourself what you really want to do. Before you know it, you're in that metaphysical place. One of the things that I enjoy so much about childhood is just how open and nonjudgmental you can be. You just accept the color blue for its blueness—and turquoise for just being turquoise. You can enjoy plastic—just a great piece of plastic—for its color, or even the cereal box that you can look at forever. And so I always enjoy making reference to that. That's the beautiful thing in life. If you can remove judgments, you can have acceptance. And it's really the highest state that art can take you to. So if I make a painting

like *Play-Doh* (1995–2008), it's really to represent one of those moments: you look at it and you just cannot make an aesthetic judgment about it. There is just a sense of acceptance.

Certain works have a timeless quality. I think there are two ways to enter the eternal or to have a dialogue with the eternal. One deals with history. Connecting to human history there's a sense of the ephemeral and ethereal, a kind of spiritual abstraction of thought. And the other is just really biological, rooted in its own sense of desiring to be. It's nature. My works usually like to play with both. If you don't accept yourself you can't empower yourself. And what areas are there to deal with acceptance? The first is biological. Some people just don't accept their bodies. They don't accept who they are; they don't accept nature, what it means to be a human being, how a human being functions, and what is important to sustain the species. So if I have a dialogue with sexuality, it's about empowerment. It's the embracing of what it means to be human and our understanding of life and how it wants to flourish and procreate. We can go back and look at our Venuses of 25,000—even 30,000—years ago. Western art is based on the embrace of the poetry of sexuality and the sensual qualities of life.

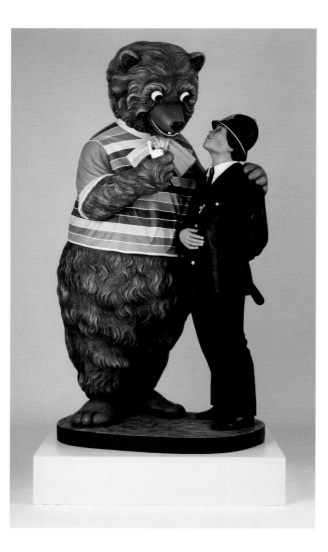

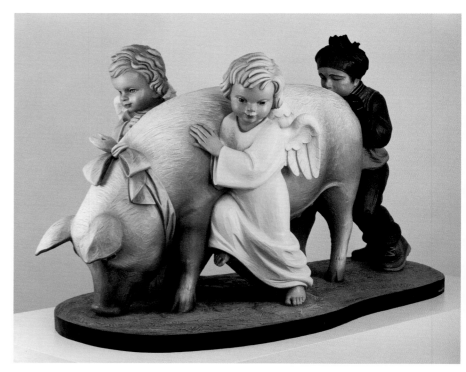

Jeff Koons

ABOVE, LEFT
Bear and Policeman, 1988
Polychromed wood, 85 x 43 x 37 inches

ABOVE, RIGHT
Ushering in Banality, 1988
Polychromed wood, 38 x 62 x 30 inches

OPPOSITE
Hanging Heart (Red/Gold), 1994–2006
High-chromium stainless steel
with transparent color coating,
11½ x 110¼ x 40 inches

Bear and Policeman (1988) is probably one of my darker works. It's part of the *Banality* series. It's made out of wood because I wanted to work with a material that had a spiritual side. It's a living material; it keeps moving. *Bear and Policeman* is an image of a bear that's really outgrown the symbol of authority. It's larger than the policeman—really a British bobby—and it's actually ready to blow his whistle. There is a sense of sexual humiliation in the overpowering of the bobby. For me the piece is really saying that art should be something powerful. But at the same time, there's a morality that comes along with that—the respect of other people, that their rights are equal to yours. So *Bear and Policeman* was always about art having that power, but being misused and going out of control. *Ushering in Banality* (1988) is from the same series. It's also made out of wood. I always felt that it was autobio-graphical. And I've always thought of myself as the young boy in the back pushing the pig, pushing in the belief of trying to make work that would communicate to people that their own cultural and personal history up to that moment was absolutely perfect—and that that would give them a foundation to move forward in life. *Hanging Heart* (1994–2006) is a work from the *Celebration* series. I've always liked that it's a symbol of romance—like a piece of jewelry—or that it reminds you of a present because of the ribbon that's on the piece. But it also has a spiritual look to it and it could be a symbol from Catholicism or have another spiritual aspect. Anything that reflects has a kind of spiritual transcendence because it involves the viewer. It acknowledges your presence. Every time you move, the reflection changes; it always acknowledges you.

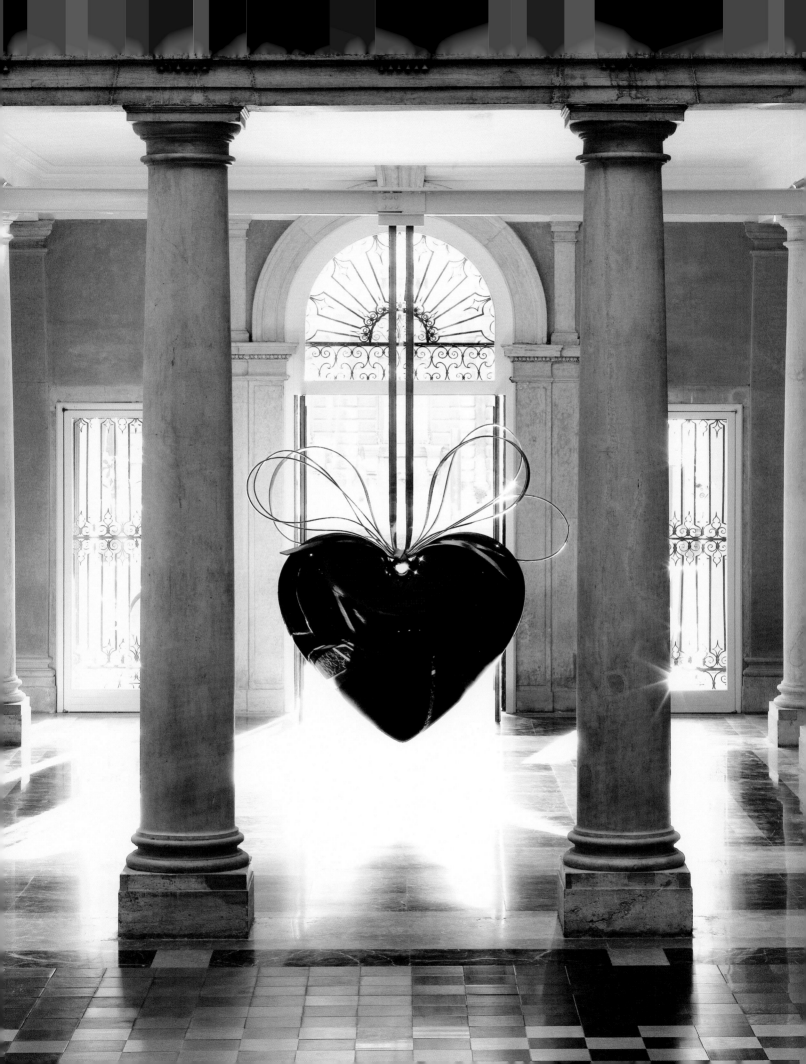

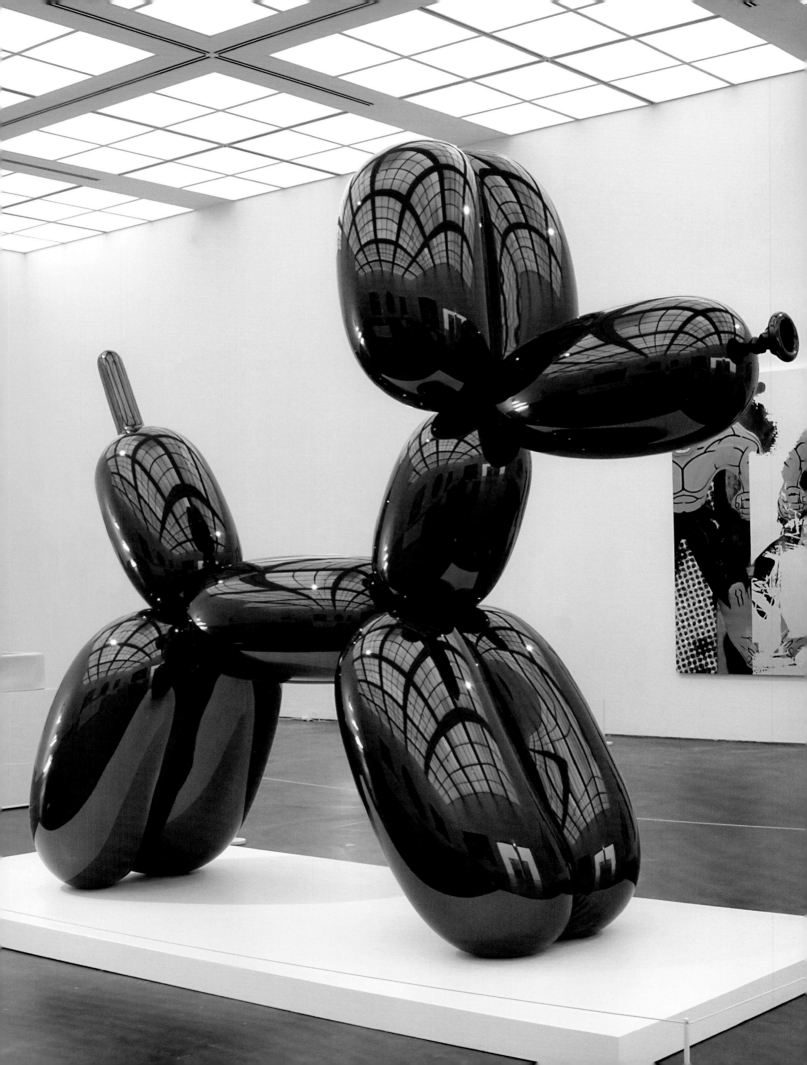

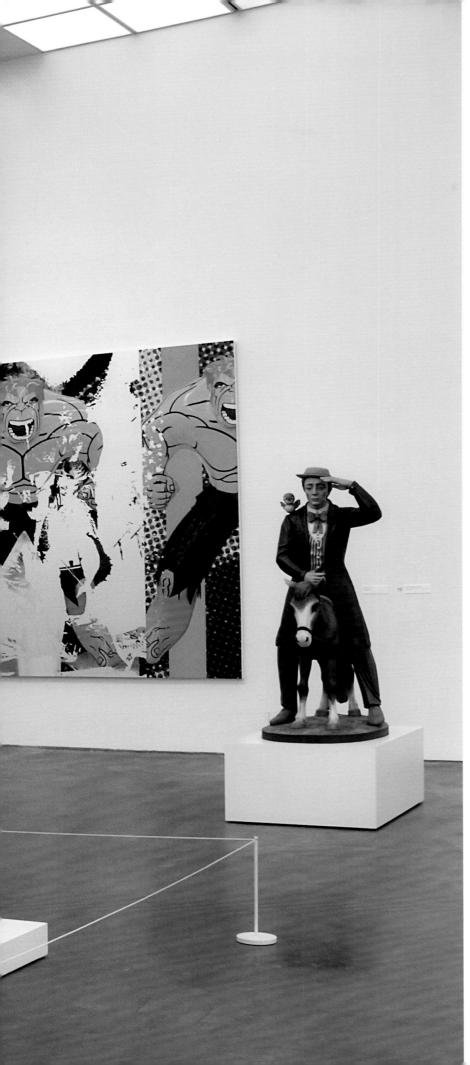

Jeff Koons

Installation view, *Jeff Koons,* Museum of Contemporary Art, Chicago, Illinois, May 31–September 21, 2008
Left: *Balloon Dog (Orange)*, 1994–2000
High-chromium stainless steel with transparent color coating, 121 x 143 x 45 inches
Center: *Triple Hulk Elvis I*, 2007
Oil on canvas, 108 x 146⅛ inches
Right: *Buster Keaton*, 1988
Polychromed wood, 65¾ x 50 x 26½ inches

I think that I've built a wide vocabulary to work with. I make paintings; I make sculptures. I make public works. And within the images themselves, some are more figurative and some are more abstract. Sometimes I'll play a little game with myself where I'll think, "Okay, did I ever make an artwork with a bird? Oh yeah, there was a bird on *Buster Keaton* (1988) and a bird on top of *Stacked* (1988). Okay, well what about a donkey? Oh yeah . . . , *Donkey* (1996–99)." I've worked with a lot of different images, and I've always enjoyed the space it gives my work. But I understand artists who work in a much more reductivist manner. I'm making a sculpture now out of fake cannon balls that are really like a large Sol LeWitt.

I've always taken the opportunity to try to let everyone know what I really care about and what's important to me about my work—how art can perform and what it means to me. But there have been some misrepresentations. Some people think that my work is just about money. Certain aspects are about money because my work also talks about desire, and it wants people to feel what it means to be alive and to continue to live and thrive. But the work's not about money and it's not about just making something to sell. People think that I have a large factory that just knocks out work. I do have a lot of people who work with me, but we make very few paintings a year. I feel a moral responsibility, every time I make something, to give a hundred percent because I care about the viewer. Today it's not unusual for artists to have large studios. If you're interested in making more than one painting a year, or if you're interested in making more than one sculpture, and you want to work in different mediums and make public works, you need to have support that can help you do these things while you are also thinking about other areas to investigate. I like to work with people because I don't want to be in a room by myself. I love the sense of family that I have with my studio; it's a community.

Florian Maier-Aichen

You probably would dismiss a term like painter-photographer or draftsman-photographer because it's almost like a hybrid, which people never like. You want to be either in this category or that. But what I like is that I turn the finished photograph almost back into a scribble. Usually a photograph is very finished, precise, and rigorous. It's an end product. But I like to use the end product and turn it into an unfinished state again. Most people think photography and painting should be strictly separate, even though photography has always mimicked painting because of a kind of inferiority complex (it wasn't considered artistic enough). The first photographers tried to use painterly devices until straight photography came into fashion and all the modern photographers got rid of the painterly baggage. But I think, today, that photography has become so technical that people have tried to investigate the medium again by researching process or photography's historical importance. I don't want to be a dogmatist, so I think that it's fine to combine photography and drawing, or alter photographs and bring in fictional elements, or just not be satisfied with photography as a super-realistic medium. Most people use the computer to retouch, touch up, or to over-produce images. I like to use the computer in a different way—to actually bring in imperfections or to turn a finished image into a more open-ended image so that it's not too precise or so over-determined. The link between photo and real and representation is sometimes too strict. That's what shuts down a photograph—because everything's in it and it's totally unimaginative. It doesn't give you any freedom or room. And that's why I'm not a documentary photographer. The work has a strong emotional content for me but it's always looking back to the way I think a place was discovered. I think about a project as an adventure, and I think about the image being like a map for an undeveloped place that once got discovered. That's what I call emotional. If I didn't react emotionally I would be a technician or a mapping scientist. Just by choosing the subject matter, by treating it, and by showing it in a non-scientific context, the work is totally different from scientific mapping. These are not scientific images that tend to be precise; they're photographs but they're also imaginations.

Florian Maier-Aichen

LEFT
Untitled, 2007
C-print, 89¼ x 72¼ inches

OPPOSITE
Untitled, 2005
C-print, 54 x 42¼ inches

The idea of drawing, scribbling on photographs, just happened over the years. At first I was using the computer in the traditional way. I thought, "Okay, this photograph is not polished enough; I need to get rid of some clouds, make it more perfect, touch it up." Then I started to investigate the computer even more and realized that you can use it to add elements. The computer has made everything much simpler but it has also opened up many more possibilities. One of the big dangers with a computer is that images become too clean, for example, like fashion shots or commercial work. But I think of the computer not so much as a tool for cleaning up and polishing photographs as a tool that gives me possibilities to draw on photos or even enhance them. It has helped me to loosen up with my camera work since I can always go back later and even try to incorporate whatever accidents might have happened. So I'm not a perfectionist. The actual image that I get tomorrow or the next day doesn't have to be that good because that's only half of the process. And I construct to a degree that's not necessarily linked to actuality anymore. It's more like an idealized image—maybe like the way postcards used to work, almost as fantasies. Sometimes I work on images for a week, or sometimes it takes months. I like to work on a lot of photographs simultaneously so that I don't just get lost in one. I let it sit and then I just start again a couple of days later with a fresh view.

Florian Maier-Aichen

LEFT
Untitled (Mount Wilson), 2002
C-print, 63¼ x 81¼ inches

OPPOSITE, ABOVE
Untitled (towards Burbank), 2004
Silver gelatin print, 22½ x 27 inches

OPPOSITE, BELOW
Untitled (St. Francis Dam), 2009
C-print, 71½ x 93 inches

I'm happy if I still find something to photograph in my neighborhood. I think it's important to be local and not just go farther and farther into more exotic places to bring home more and more sensational imagery. That's why, as I said, I try to go backwards. Let's say I find something interesting as a subject. I try to research the image, when it was taken, how it was taken, and whether there are even more predecessors. The more I find about one image, the more reason it gives me to actually take that photograph again. All photography is a sort of copy machine or appropriation—and I always find that the more I learn about a photograph historically or in terms of reference, the more interested I get in taking a photograph. I don't have problems with generic images—even Los Angeles. It's kind of a generic city, but it's also like a perfect playground or a prop, so you can use it for anything that you want to say or project. It's not Rome; it's not Paris. It's an American grid and, to me, it's like a map. It's not too precise; it doesn't shut down. It's not over-determined. It still leaves you some room to imagine or contemplate.

I'm probably too much of a photographer; I can't start from scratch. I like to use a photograph as a base for my work because it records everything that you need or everything that you want to copy and it's very precise. So the base could be an initial photograph that was not taken by me or it could be one that I took myself—and then I just re-photograph it. Sometimes I just see an interesting image and it makes sense to go there. For example, I was probably getting bored of Los Angeles, and I wanted to extend myself. I was reading about Mulholland, and I thought that St. Francis Dam could be an interesting site. So I went there and I took the photograph of the remains of the dam. I based my standpoint on one of the first photographs taken there back in the 1930s so that I wouldn't have to worry about composition too much. If you copy an old composition or standpoint you have one problem less to deal with. My goal is to get closest to the reference image that I like the most and not try for a better composition (usu-ally there is no better composition). For example, at the dam, the best spot is at one curve of the road where you have the best vista. And that's also why I like vista points: you're already given a standpoint, and you don't have to research it. It fits well with me reenacting adventures or paying homage to pioneer photographers. In this case, I was just using the old photograph as a script. I was more interested in the abstract qualities when I was researching the dam. I looked at documents from the day the dam collapsed in 1929 and at the way that the drained lake was almost cut in half. You could see a representational mountain landscape on the top and a drained lake at the bottom. And the drained lake was just like an abstract piece, like figures and forms and lines. The entire valley was flooded, and I think it caused five hundred people to die. It was a major tragedy. But I'm not a documentarian. I'm not interested in documenting the dam again; it was documented well enough in the 1930s. I thought of it more like an archaeological site.

Florian Maier-Aichen

BELOW
The Best General View, 2007
C-print, 84 x 70¼ inches

OPPOSITE
Above June Lake, 2005
C-print, 86 x 72 inches

I like to look backwards for my influences. The Bisson brothers, who were French photo pioneers, were the first to photograph the Alps. It was a huge process back then because you had to bring all the chemistry and all the ingredients to the mountains. I also saw a show of Carleton Watkins once and it was the same thing, but it was just about California. The seascapes of Gustave Le Gray, another French photographer, also made a huge impression on me. These are the historical references that I like to look back to—all early nineteenth-century photographers—and I can still work off of just these three names and use them in my everyday work.

When I look at American landscape painting from the nineteenth century I always have in mind one painting of Yosemite by Albert Bierstadt. Yosemite is already such a theatrical place—almost like a too-drastic landscape—and Bierstadt just added more

to it. He turned it into a complete fantasy by getting rid of the facts and enhancing every other aspect of Yosemite. Half Dome is an iconic image, but when I saw that Carleton Watkins had used it in one of his photographs back in the nineteenth century, it became more significant for me. Suddenly I wanted not to remake the same image but to go there and work with the subject. I couldn't access Watkins's standpoint anymore because it was overgrown, so I used Glacier Point which is next door. It's the most generic vista or viewpoint that you can get in Yosemite. It wasn't a perfect day when I took the photograph, and I didn't mind because it was just a starting point. I drew in the entire background with the blue sky and the clouds, and I brought in the bushes to make some foreground space. So in the end the image, except for Half Dome, is not really the way it looked when I took the picture.

By accident, I found a beautiful aerial photograph of a mountain resort in the High Sierras. I was instantly struck by its abstract qualities. It could have been an abstract scribble but it could also been a piece of land art. It was much more chaotic than just a pure line for example. I had never seen anything like this before because in Europe most of the ski slopes are above the tree line so you would just see a white surface. But here most ski slopes in the Sierras are below the tree line, so they have to cut out the slopes and basically create this scribble in the landscape. This is a photograph that I couldn't take myself because it's a vertical aerial photograph. I think the reference in it was taken from a satellite. But I have an aerial company in Los Angeles and I asked them whether they could take that picture. In the end, they had to take five photographs and I had to stitch them together to make it one. I had the images taken in two sets—one infrared and one regular color. The regular color didn't work out because it did what most aerial photography does. It just flattened everything out and I was missing the depth. So the infrared film is much more contrasted and it creates the illusion of more three-dimensionality. I'm not necessarily into grand gestures—and maybe this might come off as a little too grand. It's taken from high above and it's a huge landscape (and that's also the problem with the American landscape—that it's too grand in scale). Maybe it's over the top and too sensational, and maybe you lose all the mid-tones. It's not subtle anymore. So you have to counter this with some modest images—small in size and small in scale. And that might not even be taken from above, so you get back on the ground and just take a breath.

Florian Maier-Aichen

Rügenlandschaft, 2007
C-print, 42⅜ x 75¾ inches

When you turn photos into objects you have to treat each one individually and determine the right size or scale for it. Some of the works might be huge vistas, and you hang them low so that you can actually look downwards on them. A huge vista might work as a map, and since you need to be able to inspect every detail it needs to be big enough that you can actually get lost in one corner without getting distracted by the other corner. But if I need to create a photo context I would print it really small and matte it so that it just plays by those conventions. Because I don't do serial work, every piece needs its own size, presentation, and scale. I like to turn a photograph into an unfinished product because I think it has lost a lot of its status and has become very technical. So it's interesting to deconstruct a photo-graph and make it more open-ended—like a map, as I said, or like the way I use the city as a sort of generic place on which you project whatever you wish. That way it doesn't become too closed in terms of meaning.

Rügenlandschaft (2007) is an image of a map. Actually, it's was a mural at the Stralsund station, and I was instantly struck by it. What I liked about it is that it is very imprecise and open to your imagination. It doesn't give away all the facts. It's like the opposite of a photograph. I just took out all the names and descriptions and turned it into an even more non-descriptive image. It lifts you to another layer that is not neces-sarily linked to realism and opens up your own world or your own mythmaking, what-ever you want to call it. Most people prob-ably wouldn't recognize what it stands for.

Florian Maier-Aichen

Untitled, 2005
C-print, 72 x 90½ inches

When I think of Malibu I always think about how the California coast used to look before it was explored. To me, it's a good combination of the American west and the way Los Angeles industrializes landscape. I'm not a pure landscape photographer, and I'm not interested in pure landscape, the Ansel Adams way for example. What I like is when cityscape and landscape meet. Then I use infrared film to get rid of presence. People have talked about my infrared landscapes as a statement about toxic landscape and spoiled environment. That's really not what it was about. For me, it was more like trying to find a way to do landscape photography and get a result that might be detached from the present—slightly historical, maybe even slightly leaning towards the future—and also kind of abstract. With infrared film it looks like it could be early color photography. It looks historical, but also almost like a little bit of science fiction or—at least—fiction. I like that in-between state that you don't really know how to categorize. It's not necessarily a photograph of the present. You can't foresee what will happen when you use infrared film, so there's a lot of potential for accidents or coincidence. And that's also what I like in general about using film in still photography. Sometimes things go wrong, and you can use that in an interesting way. And with infrared, you get a full, fresh color palette, and when you bring it into the computer you can use it to your liking.

Florian Maier-Aichen

BELOW
Untitled (Stralsund), 2009
C-print, 36¼ x 44½ inches

OPPOSITE
Salton Seas (1), 2008
C-print, 99⅜ x 88¼ inches

This is a very modest image, but what I really just like about it is that it looks like a stage. You basically have the cut-out silhouette of the city of Stralsund taken from across the Sound, from the other side, at night—maybe a mile or two away. I first got curious about Stralsund because I saw an old postcard from the days of the GDR. And what I always notice about images from that era is that everything is very poor, very sparse, and you can always see that the cities were very sparsely lit. But I kind of like it that East Germany was under-lit. It's not necessarily nostalgic; it's simply what struck me about it. Now Stralsund is a UNESCO World Heritage site, and it's lit theatrically. So I had to get rid of all the lights again because I was just really interested in the silhouette of the city. I drew in the domes.

The composition is pretty straight. I don't go crazy about compositions. And if there's a horizon line, I just place it somewhere in the middle and try to create a good arrangement between sky and ocean. I took several photographs and there were several that I liked. In one the ocean was so still that it showed all the reflection; another was a little bit more in motion. And then I decided I'd just use all the negatives and put them on top of each other so you can have motion in the water and a pretty clear reflection. That almost brings you back to painting, where they always get the reflections wrong because the water is agitated and the reflection is in focus. I drew a little bit over it, but you have pretty sharp reflections of the city. So it's technically wrong, but for me it's right visually.

I took a seascape a couple of years ago. At first I wasn't really impressed, but it was done with one of my cameras that had a huge light leak. It exposed all the dust on the screen, so it's almost like two images. You have the actual photograph and then you have the texture of the film. That's something that you could not create if you were using the latest standards in photography, or using digital photography. And that's why I think it's still good

to use photography in an old-fashioned way sometimes. Use film, get texture, and hope for something to happen with it. For images of the Salton Sea, which is really an inland lake, I needed to take aerial shots. I gave the pilots precise directions, but the photograph that I actually ended up picking was one that I just took as a side product. I changed the shape a little bit because, when I made the drawing of the shoreline, I just added

more layers on top of each other. But the lake doesn't really have a definite shape. It changes because of falling and rising water levels. To accentuate the lake I drew in a white shoreline, which is almost like an abstract scribble. Speaking of accidents, the film didn't transport all the way—so I ended up with three-quarters of an image and I had to take out all the registrations and compensate for a double exposure.

Florian Maier-Aichen

LEFT
20th Century Fox, 2005
C-print, 29¼ x 40 inches

OPPOSITE
Der Watzmann, 2009
C-print, 86¾ x 62¼ inches

The quintessential, 'real' beginning for me was when I came to UCLA or when I came to California. I didn't come for its scenic beauty; I came for the artists who were teaching at UCLA. The art they were making was exactly the art that I liked, and it was a great bonus that they were also actually teaching. It seemed uncommon for me to see those important artists do their day jobs and teach as well. One of the reasons why I thought L.A. would be interesting, in terms of photography, was that while German photography was actually kind of starting to repeat itself, there were people working in L.A. (like James Welling or Christopher Williams) who used the medium in a more thoughtful way. They investigated more—and dug deeper down into the medium—rather than just creating pictures. The good thing about UCLA was that I usually had one-on-one discussions with my teachers. Studying with John Baldessari meant that we would hang out in my studio (by the time I was working with him, I was working on a sculpture) and discuss the work on a very non-theoretical level, in a

hands-on approach—not even throwing ideas off of each other, and maybe not even talking about art, but just having every-day plain conversation. What I learned was that sometimes you can do things wrong and do things the way you're not supposed to do them. Baldessari was breaking every rule that there was, so it was a huge encouragement for me to question things or standards a little more. A good way to sum it up would be to say that it was okay to just 'go wrong'. So I learned that it was okay, but I also kept to the standards because my idea of an image was usually very much in a standard format. For example, I probably could never envision myself using a liquid emulsion and putting it on canvas because I wouldn't have a reason to do that. I like photography as a set of rules. Maybe the only way that I break them is that I take apart the photograph after it has been taken. But in terms of presentation, I still like the photograph to be framed. I like it to be matted so that people read it as a photograph and not as a painting or a drawing.

And even though there's hardly any material value in photography, I like the little materiality or texture that is left. The transparency of a photograph and the lack of materiality—these are reasons why people are turning back towards process and, possibly, abstraction and to the conditions of making photographs. And again, that's something that Chris Williams or Jim Welling practice as opposed to a lot of photographers out of Germany, who just present you with a finished, possibly polished, product that doesn't really show you anything behind. I mean, it's just a pure window—and I'm not so sure that I find that interesting in the long run. But I'm always interested in the making, and in terms of process I want to find out how things are made. Photography used to be like alchemy. It was a medium of the few, and now it has turned into a mass medium. Maybe it's kind of reactionary to turn backwards to try to establish its artistry again, but the most interesting part of it is process and texture. The digital camera is basically like a dead black box without anything else left.

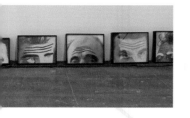 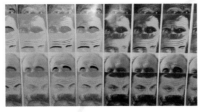 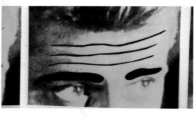

John Baldessari

Kimsooja

Allan McCollum

Julie Mehretu

Systems

John Baldessari

IT SERVES YOU RIGHT

What's a system? I think my idea is this: not so much structure that it's inhibiting or that there's no wiggle room, but not so loose that it could be anything. I guess it's like a corral around your idea, a corral that you can move—but not too much. And it's that limited movement that promotes creativity. Did I just say something profound?

Words are a way we communicate, images are a way we communicate, and I couldn't figure out why they had to be in different baskets. I was getting tired of hearing the complaint, "My kid could do this," and "We don't get it. What's modern art? Blah, blah, blah." And I wondered what would really happen if you gave people what they wanted, something they always look at. They look at magazines and newspapers, so why not give them photographs or text? That was the motivation. And when I moved in that direction, thinking about language (and I don't know exactly how this happened), it seemed to me that a word could be an image or an image could be a word. They could be interchangeable. And I couldn't prioritize one over the other. For a lot of early work, I would have files of photographs that I would take off TV and then I would have an assistant attach on the back of the image a word that she thought could be its surrogate. And then I played: I would make a sentence out of the words. And then for that sentence, I would use the images instead of the actual words, kind of flip-flopping. In my multiple image pieces, I probably had the idea that there was a word behind them and I was building blocks or frames. I don't do this so much anymore, but some parts of my work are multiple frames that I'm probably building like a writer or a poet builds words. That's a description that seems to make me feel comfortable. And I still have that idea that an image and a word could be interchangeable.

John Baldessari

ABOVE
Raised Eyebrows/Furrowed Foreheads: (Black and Blue Eyebrows), 2008
Three-dimensional archival print, laminated with lexan, mounted on shaped form with acrylic paint, 57¾ x 102 x 6¾ inches

OPPOSITE, LEFT
Raised Eyebrows/Furrowed Foreheads: (Violet and Green Eyebrows), 2008
Three-dimensional archival print, laminated with lexan, mounted on shaped form with acrylic paint, 57¾ x 63¾ x 6¾ inches

OPPOSITE, RIGHT
Raised Eyebrows/Furrowed Foreheads: (Orange Eyebrow and Blue Skin), 2008
Three-dimensional archival print, laminated with lexan, mounted on shaped form with acrylic paint, 59⅞ x 57¼ x 6¾ inches

One of the underlying themes of my work over the years is trying to figure out what's the difference between a part and a whole. And I never quite get it right because a part could become a whole, and a whole could become a part. I think it's fragmentation that interests me—leaving things out, omission—and I was doing that when I was a painter. I had a friend in the billboard industry, and I asked if I could get from him some residue that wasn't being used. I just would go through hundreds of billboard sheets and now and then I would find something I liked. There was one occasion when it was a big head, and I got maybe an ear. Or I got a nose, or a forehead and an eye. And those were a basis for paintings back then. A few years back, when I had a retrospective in Vienna and was looking through some reproductions of my old paintings, I thought, "I should get back to this again." You know, you always come back to the same idea but from a different direction.

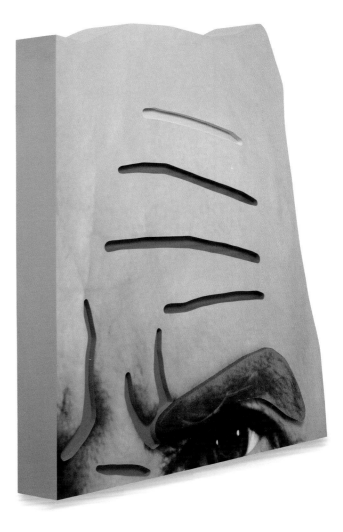

I'm very much interested in sequential color. So if you start with red, then you continue with orange, yellow, green, blue, violet. You just have a system. So I choose the primary and secondary colors—say, six in the series. They're also arranged from the widest to the smallest going up. So that takes care of that. And then, I've just used the complementary color. So if it's red, the eyebrows are green; if I have orange, the eyebrows are blue; and so on. I don't have to use taste at all in these things. It's an impossible task, trying to escape your own taste. So my idea is that if that's the case, why work at it? It's going to come out anyway. That's one of the reasons I gave up painting—because it was all about being tasteful. You know, the right red next to the right blue . . . and you're very carefully mixing the colors. So when I began to go into photographic and film work and video, I just decided to use the color wheel and work out certain systems—so I might have a triptych, and that would be red, yellow, blue, or some combination or triad like that. Usually, I seem to start with red and sometimes I'll add a black and a white. I don't have to think about it. I just follow the rule I've set up. I think my emergence in the art world was linked with conceptual art, minimal art, but I never quite totally subscribed to it. I thought it was a little boring. But there were a lot of things I did want to shed, and one of them was being tasteful. The idea of using systems, which was in a lot of that work, appealed to me where I could let this taste emerge as I worked. Because, you know, it's sort of like toilet paper on your shoe.

John Baldessari

John Baldessari: Brick Bldg, Lg Windows w/Xlent Views, Partially Furnished, Renowned Architect, 2009
Installation views, Kunstmuseen Krefeld, Museum Haus Lange, Krefeld, Germany

ABOVE
Eyebrow, 2009
Digital photographic print on painted aluminum, 50 x 16 x 6 inches

OPPOSITE, ABOVE
Left and right: *Nose Sconces with Flowers,* 2009
Polyurethane rubber, rigid polyurethane, and wood, 34³/₅ x 22 x 17 inches
Center: *Ear Sofa,* 2009
Memory foam, polyurethane rubber, rigid polyurethane, and wood, 51¹/₅ x 104 x 38³/₁₀ inches

OPPOSITE, BELOW
Left: *No Title (Landscapes and Seascapes),* 2009
Digital photographic print on aluminum, 89¹/₅ x 105²/₅ inches
Right: *No Title (Landscapes and Seascapes),* 2009
Digital photographic print on aluminum, 89²/₅ x 140²/₅ inches

I was invited by the city of Düsseldorf to do a proposal for a site-specific work related to the Mies van der Rohe houses in Krefeld. So I did a lot of homework on Mies. What I was trying to do was an anti-Mies van der Rohe space. So inside, where the walls are normally white plaster, there will be substituted facsimile brick wallpaper. And where there are windows, you'll see no windows whatsoever. They're covered up with fake brick. Where the windows should be, I cut the size of the window and there are mural-sized photographs of scenes—not what you would see out of the window. All the exterior views will be views of the Pacific Ocean and landscape in southern California (Mies was very concerned with what one saw, and he'd try to frame the garden and all the exterior views). And then, in front of each window, there'll be one Mies van der Rohe chair, where you can sit and contemplate the view! And, as an addition, I'm having manufactured a couch in the shape of an ear, which will be against a blank wall. And not only will there be a couch in the shape of an ear, but it will be flanked left and right by two upturned noses as sconces, so that you will either have light or flowers coming

out of the nostrils. I figured it's everything that Mies van der Rohe would hate. And then on the top floor, again, all the windows will be blocked out so you see nothing but a brick façade. But just a sliver of a window will be opened—exposed. And at night, you will have a blinking light (I want it to look like a winking eye) and in the exterior, you'll have an eyebrow over the window. Because, you know, the Viennese architect Alfred Loos said that he wanted to get rid of eyebrows from windows. So I'm doing a riff on that, I suppose. And lastly, between the Hermann Lange house and the Josef Esters house, on the second floor, I'm gonna have—à la Italienne—a line of laundry! And that's the project. It's not my opinion on modernism. But, aesthetically, I always look for the weak link in the chain and, rather than glorify Mies van der Rohe—he's had enough glorification—I just thought I would poke a little fun at him and do a reverse Mies van der Rohe. Reading about him, I see no evidence that he had a sense of humor.

Am I always subversive? Um . . . I'm a little bit suspicious of pompousness. And if I see that, I do go at it. It's true.

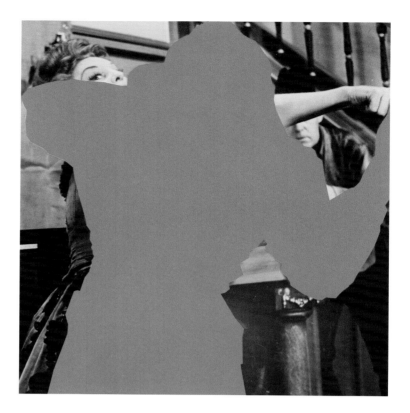

John Baldessari

In music we call it sampling; in art we call it appropriation. I really just don't think imagery should be owned, including my own. If it's part of our world, it's like owning words. How could you own words? It's stuff to use. If somebody wanted to borrow some imagery I was using, I would be flattered. What's the old phrase? A shark is the last person to criticize salt water? You're immersed in it. So people ask me or assume that Hollywood must have some effect on me. I don't know if it does or not. I started using stills from movies, not because they were from the movies but because I could get the pictures cheaply. I just wanted to recycle photographs.

It was only after I started using them that I realized that I was tapping into some sort of consciousness—that people carried around these images from movies in their minds and I could play with that by changing the meaning of an image. A lot our knowledge comes from the movies or from watching television. Or we know about other cities because we've seen a travelogue. We've never been there. So it's about images. And for me it's using this databank of images that people carry around in their heads. Then I play with and rearrange those images for them.

A lot of photographs I bought were from newspapers. They would be of local celebrities—the mayor, the fire chief, some dignitary—and a lot of them would be pointing to things, shaking hands, smiling. Photo-ops—standing with the president and that sort of thing. I was attracted but repulsed by these things—repulsed because I was isolated in my studio, and these people were making decisions that would probably affect me. I was not doing anything about it (and that was one of the arguments I had with art in the first place—that it's not doing anything). I just didn't know how to use them. But one day I had a can of white spray paint and I just sprayed the faces out. And then a little bit later I was using white price stickers in some other work and I just put them over the faces. Wow! All of a sudden it leveled the playing field. All of a sudden they had no power over me and I really saw them for what they were—that they were replaceable. But the fire chief is always the fire chief. The chief of police is always the chief, even though the individual person changes.

ELEPHANT PINK	PINK POPSICLE	SWEET 16 PINK	PINK HARMONY
TOUCH OF PINK	PARADISE PINK	I LOVE YOU PINK	PINK BLISS

John Baldessari

ABOVE
*Prima Facie (Fifth State): Elephant Pink/
Pink Popsicle/Sweet 16 Pink/Pink Harmony/
Touch of Pink/Paradise Pink/I Love You Pink/
Pink Bliss,* 2006
Archival pigment print on Parrot water-
resistant matte canvas with latex paint,
93 x 154 inches

OPPOSITE
*Portrait (Self) #1 as control + 11 Alterations
by Retouching and Airbrushing,* 1974
12 color photographs on museum board,
14 x 11 inches each

When I was in high school and college, I worked in a building-supply store that sold paints. I called them landlord colors because there was the pale green, the peach, the light blue, the ivory, and white, essentially, and I think that was it. Those were the house colors you could get. And those would be the names—pretty straightforward. But then I noticed that paint names began to have no connection to the colors. You wouldn't know what that color would be if I said there was a color named National City. What color would that be? But somebody gave a color that name (not really, but you see what I'm getting at). There's a total disconnect between the name and the color. And I said, "That's like literature." So I thought what I'd do was I'd collect all those paint names and make word pieces. And then instead of actually using those words, I'd use the colors, whatever color came with the name. So it was a way of using color but it came out of language. Sometimes (and I'm just talking about a few) I would do a piece that would be a diptych, so one rectangle would be the color but it would be photographed. And the other panel would be the name of that color, but it would be painted by hand. So the painting part would be the word. And what you expected to be painted would be photographs. It's a device that I've used a lot: where you expect the word to be printed, it's painted, and what you expect not to be painted. . . . You get the idea. I try to confuse people.

I don't see what I do so much as humor as I see it as an attitude or how I look at the world. I'm not looking for the normal stuff. Or I notice things that people don't normally notice. Actually, I've said to my students, "Don't look at things. Look between two things and see what you notice." That's not a normal way to look. See what I'm getting at? When I was teaching painting I would ask students to do an abstract painting and then go out and find a photographic equivalent of that painting. And they could do it. It's just how you look.

Do I feel misrepresented? I think people think I'm *trying* to be funny. We all know people who don't think they're funny—but we think they are. And that might be my problem. It's the way I can

understand the world; it's a way to make sense. If I were trying to be funny it would be a different kind of work. There's a great example (and I think I used it in a work once) called "The Art Teacher's Story." I had heard this story about a painting instructor who tried to throw his students off a little bit so they would think differently. This is back in the days when painting classes had easels. So he asked his students when they were working at their easels if they could just stand on one foot. And this would give them a sense of asymmetry or disharmony or whatever. That sounds really funny, but it made perfect sense to him. So it's just kind of the way I can deal with the world. I'm always seeing things

differently—spelling things backward just because I get tired of spelling them the right way. So I say, "Well what would happen if I spelled it backward? What kind of word would that be?" I think it's about having a restless mind. You're just taking things apart, putting them back together again, taking them apart, putting them back together again. Art's play.

I'm always interested in things that we don't call art—and I have to say, "Well why not? What can I do to this to make it art? How can I change people's minds?" I would like people to say, "You can't do that." I love it that all of a sudden because I've said it's art, somebody believes me. That's what interests me—the absurdity in life.

I HAD THIS OLD PENCIL ON THE DASHBOARD OF MY CAR FOR A LONG TIME. EVERY TIME I SAW IT, I FELT UNCOMFORTABLE SINCE ITS POINT WAS SO DULL AND DIRTY. I ALWAYS INTENDED TO SHARPEN IT AND FINALLY COULDN'T BEAR IT ANY LONGER AND DID SHARPEN IT. I'M NOT SURE, BUT I THINK THAT THIS HAS SOMETHING TO DO WITH ART.

John Baldessari

ABOVE
The Pencil Story, 1972–73
Photographs and colored pencil
on board, 22 x 27¼ inches

OPPOSITE, ABOVE
*Tetrad Series: WHAT IS A LITTLE
AND WHAT IS A LOT*, 1999
Digital printing, hand lettering, and acrylic
paint on canvas, 94 x 94 inches

OPPOSITE, BELOW
*Tetrad Series: UNNOTICED AMONG
LARGER THINGS*, 1999
Digital printing, hand lettering, and acrylic
paint on canvas, 94 x 94 inches

I've always been very interested in how we prioritize vision. When we look at a person we look at the face not the feet—and probably we're looking at the person's eyes. But if you make that option unavailable and you want to look at something, the next interesting thing might be handshaking or who knows what. But you've jostled the pecking order. When I was teaching life drawing in a community college, drawing class would be about three hours. The model would be there, and beginning students would probably spend a good two hours drawing the head.

Then I'd say, "Listen, you know the body's an organic thing. The head's just part of it."

"Yeah, yeah, we know," they'd say.

But they'd still do it because that seemed to be the important thing to draw. In a fit of desperation I just put a drape over the model's head so that they couldn't see the head. And in the last hour I would take the drape off. So I just got them to rethink. If you're running into a train station and you're late for the train, you're going to prioritize the clock. If you're not late, you're probably going to look at a woman with a red dress because everybody else is wearing grays and black.

I think the first artist who was a hero for me was Giotto. And then Goya, Matisse, Duchamp, Sol LeWitt. What they share is that they all look incredibly simple but they're very complex. It's that paradox that intrigues me, and that's a model that I hold up for myself. How can I be available to the most unsophisticated person that there can be but also engage the most sophisticated viewer? It's a paradox but you don't often get there, which is a great thing to achieve or try to achieve. And about Goya in particular? Other than the subject matter (his *Disasters of War* is incredibly moving, of course) it's about how he used light and dark—chiaroscuro. It would have no particular logic to it, like light coming from a certain source. It was just lights and darks where he wanted them, and done with aquatint. His use of light and dark still infects me in the work I do. I think I've said somewhere that I'm a closet formalist. When I look at my work I look at it in terms of color and light and dark. And as a 'black-and-whitist', it's totally what's going on in my mind. That's all it is.

WHAT IS A
LITTLE AND WHAT
IS A LOT

UNNOTICED
AMONG
LARGER
THINGS

A PAINTING BY PAT NELSON

John Baldessari

Conceptualism? I think *isms*—impressionism and so on—are useful for writers when something seems to be brewing and they want to give it some sort of generic title. I think with conceptual art or minimal art or the period when I began to emerge, I just got put in that basket—that I was a conceptual artist because I used words and photos. But as time goes on you begin to see the artist more distinctly and realize that the labels don't really apply. And I think if you asked any artist that you might think of as conceptual now if he or she would use that term, the answer would be, "No, I'm not a conceptual artist."

Once I said to Claes Oldenberg, "You're a pop artist."

"No, I'm not; I'm an artist," he said. And Roy Lichtenstein said the same. I have the same feeling. *Conceptualism* doesn't really describe what I do. If somebody wants to use that term, it's fine, but I'd prefer a word that's broader and better. I'm really just an artist.

TIPS FOR ARTISTS
WHO WANT TO SELL

- GENERALLY SPEAKING, PAINT-INGS WITH LIGHT COLORS SELL MORE QUICKLY THAN PAINTINGS WITH DARK COLORS.

- SUBJECTS THAT SELL WELL: MADONNA AND CHILD, LANDSCAPES, FLOWER PAINTINGS, STILL LIFES (FREE OF MORBID PROPS ___ DEAD BIRDS, ETC.), NUDES, MARINE PICTURES, ABSTRACTS AND SUR-REALISM.

- SUBJECT MATTER IS IMPOR-TANT: IT HAS BEEN SAID THAT PA-INTINGS WITH COWS AND HENS IN THEM COLLECT DUST ___ WHILE THE SAME PAINTINGS WITH BULLS AND ROOSTERS SELL.

Kimsooja

ABOVE
Conditions of Anonymity, 2005
Times Square, New York
Commissioned and presented by Creative Time

OPPOSITE
To Breathe: Invisible Mirror/Invisible Needle, 2006
Light installation, sound-performance piece
by the artist from *The Weaving Factory*, 2004
Shown at Teatro La Fenice, Venice

FOLLOWING PAGES
Lotus: Zone of Zero, 2008
Approximately 2000 lotus lanterns; Tibetan,
Gregorian, and Islamic chants; steel structure
and cables, dimensions variable
Installation at Rotunda, Galerie Ravenstein,
Brussels

I always had a dream of being an artist when I was a little girl. Of course, it was just a dream, nothing really particular. When I was at public school in fifth grade, my teacher asked us to put down two different occupations we wanted to be. I don't know why he asked for two different ones, but I put one as a painter and the other as "speaker," without knowing that I meant philosopher—a speaker not to the public, but one who gives wisdom to the people. In 1994 when I was preparing my show in Korea, I realized I had been doing both art and philosophy. All the questions I had as an artist personally or professionally were always linked to life itself. And I saw art in life and life as an art. I couldn't separate one from another. So my gaze to the world and my questions were always related to life itself.

I actually started sewing pieces, using a needle as a tool, when I prepared bed covers with my mother in 1993. And that was the moment when I was also searching for the structure of the world—the inner structure of the world—and also searching as a painter for the structure of the surface. I was mostly interested in vertical and horizontal structures at the time, so I had been trying to see every single hidden structure in that perspective and then trying to find the right methodology to express that. When I was putting a needle into the silky fabric, I had a kind of exhilarating feeling, like my head was hit by a thunderbolt. And I felt the whole energy of the universe pass through my body and to this needle point through the fabric. I just was so struck by that fact and I thought, "This is it. This is the structure I was looking for." And it was interesting, too, because the fabric itself had a vertical and horizontal structure in it. And the sewing had another circulative, performative element but, at the same time, always the connection between art and life. And that's how my work started, from just daily life activities.

Kimsooja

ABOVE
Bottari, 2000
Used bed covers and used clothing,
dimensions variable

OPPOSITE
Encounter—Looking Into Sewing,
1998–2002
Vivachrome print, 83¾ x 49⅝ inches

I think the most influential artist for me was John Cage. Right after I graduated from college, while I was staying in Paris, he had a piece at the Paris Biennale. It was an empty container, but there was a panel all the way along the corner of the floor, written in French. In English I would say, "Whether you try to make it or not, the sound is heard." And I was touched by the statement. And I immediately thought, "He is the Master." Since then, I really think I've tried to find a way *not* to make things. So I've been using a lot of found objects in daily life—not really to touch much or make things but to present as is, questioning different issues. *Bottari* was one of them. Bottari is actually everywhere in our country. We always keep bottari, which means a bundle in Korean, in our family, to keep things and protect them or to put them aside in the attic, or to carry from one place to another. Also in Korea, 'making a bundle' (when it refers to women) means leaving the family—that is, the woman leaves her own family to pursue her own life. I first discovered bottari as two-dimensional painting and, at the same time, three-dimensional

sculpture during my residency at P.S. 1. When I look back, there was a bottari that I made, which looked totally different from the ones before. I didn't realize it because I always had bottari to stack and keep fabrics in. But then I saw it as a sculpture and, at the same time, as a wrapped painting made by only one knot. So I started working on that from a for-malistic point of view, with the existing objects, not making something new. But then when I returned to Korea I started seeing them in a different, more realistic, and more critical way than before. And I also realized as a woman artist the conflict in our society, in terms of women's posi-tion and women's role. So bottari became a more social, culture-related object than formalistic sculpture. When I was in New York, since the reality there was different, I was looking at bottari in a formalistic spa-tial and time dimension—more as sculpture, or as painting. But when I returned to Korea I saw it more as a kind of a loaded memory and history and frustration that also had time and space in it. So in a way bottari had an even broader and deeper meaning for me.

Kimsooja

ABOVE
Epitaph, 2002
Digital C-print, 48 x 60 inches

OPPOSITE, ABOVE
A Mirror Woman, 2002
Korean bed covers, parallel mirror
structure walls, four fans, cable, and
Tibetan monk chant, 62 x 21⅕ x 13 feet
Collection of MUDAM, Luxembourg

OPPOSITE, BELOW
Bottari, 2000
Installation at *Partage d'exotismes,*
5th Lyon Biennale, 2000
Used bed covers and used clothes,
dimensions variable

When I was doing sewing pieces, I considered all the women's activities—sewing, cooking, laundry, pressing, cleaning the house, shopping, decorating—as two- and three-dimensional or performative activities. I wanted to appreciate that aspect and reveal the artistic context. So my work was all, in a way, related to women's activity, but then it was also linked to contemporary art issues. I'd been working a lot using femininity and female activities, but I never considered myself as a feminist. The only thing I can agree to is that 'feminist' is part of 'humanist'. So I don't even participate in feminist shows—because that really simplifies and limits my ideas. I refuse to be in a specific *ism*. But my practice can be perceived in different *isms*—like conceptualism, globalism, feminism, minimalism. My intention is to reach to the totality of our life in art, so that's also one reason my practice is quite broad and diverse—to reach that complexity and comprehensiveness.

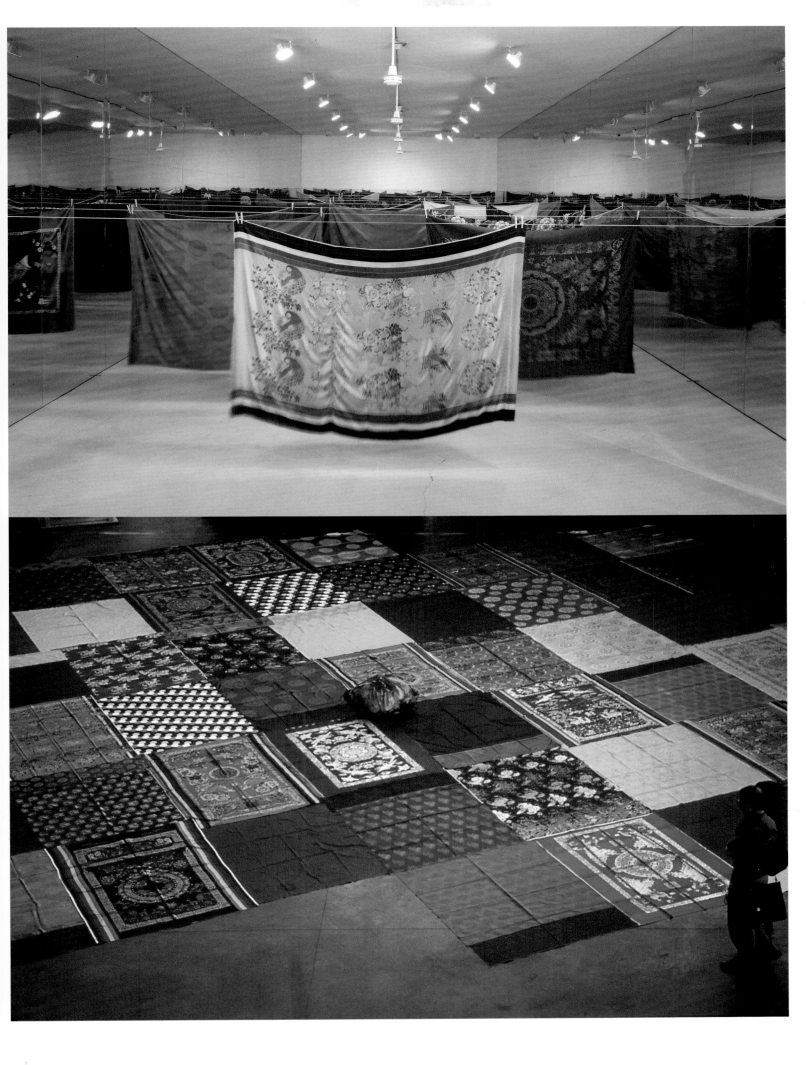

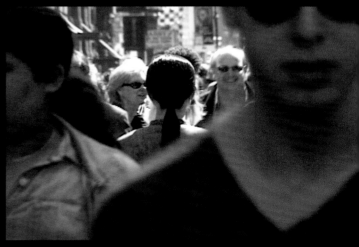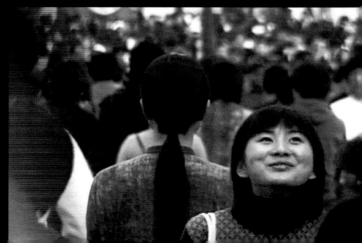

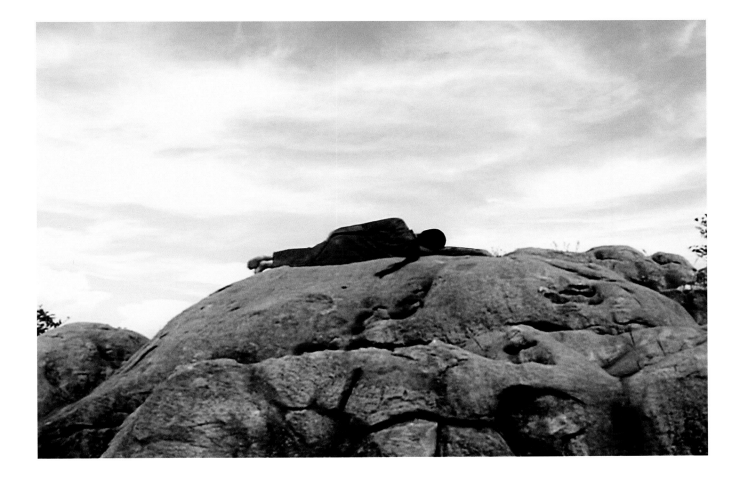

Kimsooja

OPPOSITE
A Needle Woman, 1999–2001
Eight-channel video projection, silent,
6 min 33 sec loop
Locations: Cairo, Delhi, Lagos, London,
Mexico City, New York, Shanghai, Tokyo

ABOVE
A Needle Woman—Kitakyushu, 1999
Single-channel video projection, silent,
6 min 33 sec loop

In *Needle Woman—Kitakyushu* (1999) my body functions as a central point of four different elements: earth, sky, nature, and the human being. So in a way I'm facing nature—and behind is the human, watching me. And in this I would say it is similar to a crucifix image, in terms of inner structure, and also very much related to my earlier sewing pieces, sewing cross shapes. At the same time the posture can be seen as a kind of symbolic Buddha posture, but it's different because usually the Buddha lifts his hands under his head. My arm is totally outstretched into nature, totally abandoned. My desire is abandoned and my will is abandoned—and this is different from the city version of *Needle Woman* in which I have a lot of strong will to stand still and be there. Here, I put my body into nature for a moment in a kind of donation. I see my body as a totally fragile, feminine body in the beginning. But with the process of time, with a slow movement of clouds and light changes, you don't focus on it anymore and the body becomes part of nature, part of the rock. Like a rock or clouds or wind. With that duration of performance, I experienced a certain transcendence of myself, and I hope the audience does, too. But it's also very much related to my formalistic practices, using those cross shapes and horizontal and vertical structures, and abandonment of desire. In this video, my body doesn't communicate with a human being. Intentionally facing my back towards the human side, I isolate my body from it totally. It was the moment that I felt complete solitude or isolation from the world, and I think it was also the moment when I left Korea.

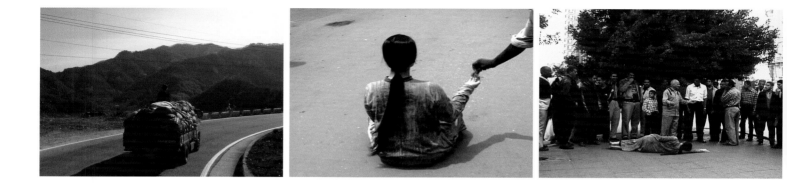

Kimsooja

When I first decided to make videos using my body as a medium, I was still thinking of making bottari because, in a way, video is a material way of wrapping the world and nature or the human being around me. Making a video is a way of using my eyes as a way of wrapping and the video as a frame, actually wrapping the real people inside, but presenting it as an art piece that has a presentation that is almost like life and shadow, always parallel. I was never interested in making images; my practice with video only represents my idea of wrapping. So my starting point of view was different from the usual image-making video works. And for me it's not about showing my identity, so I am filmed from behind—not to show my face. When a certain time passes, my body functions as a void to the audience so that it sees through me, through my body, and sees what I'm seeing in the site. The camera lens is my eye that sees my back and sees the other people in front of me.

The most important thing I'm interested in, in performative video, is my experience while doing it. I'm not really that interested in video as a result. It's really a secondary thing for me. The most important thing is the moment when my contemplation goes on and has a certain inner evolution.

After doing sewing practices for more than a decade, I started seeing my body itself as a symbolic needle. But at the same time the truth was already embedded in the nature of the needle, because a needle is a tool that is an extension of our hands and body. And the needle itself is a hermaphrodite-tool that has a masculine and feminine side—a healing part and also a hurting part. So how it functions is always ambiguous. The needle had a complexity in it, and I've been pulling out different meanings since I first considered my body as a needle. I made a performance, using my own body as a symbolic needle, in the first video of *Needle Woman* (1999) in Tokyo. That actually allowed me to broaden my concepts and my practices.

I've been always trying to find fundamental structures, generality, and universality in my work. And that's why my work looks so obvious—because it's all about things people know, which they have seen and experienced already. In a way, a whole series of performances—from *Cities On The Move—2727 km Bottari Truck* (1997) and *Needle Woman* (1999–2001) to *Laundry Woman* (2000), *Beggar Woman* (2001), and *Homeless Woman* (2000)—are a series of pilgrimages for me to contemplate the human being as a reality and also to contemplate compassion. Through the eye of compassion, I have continued these pilgrimages, in different continents of the world and different cities.

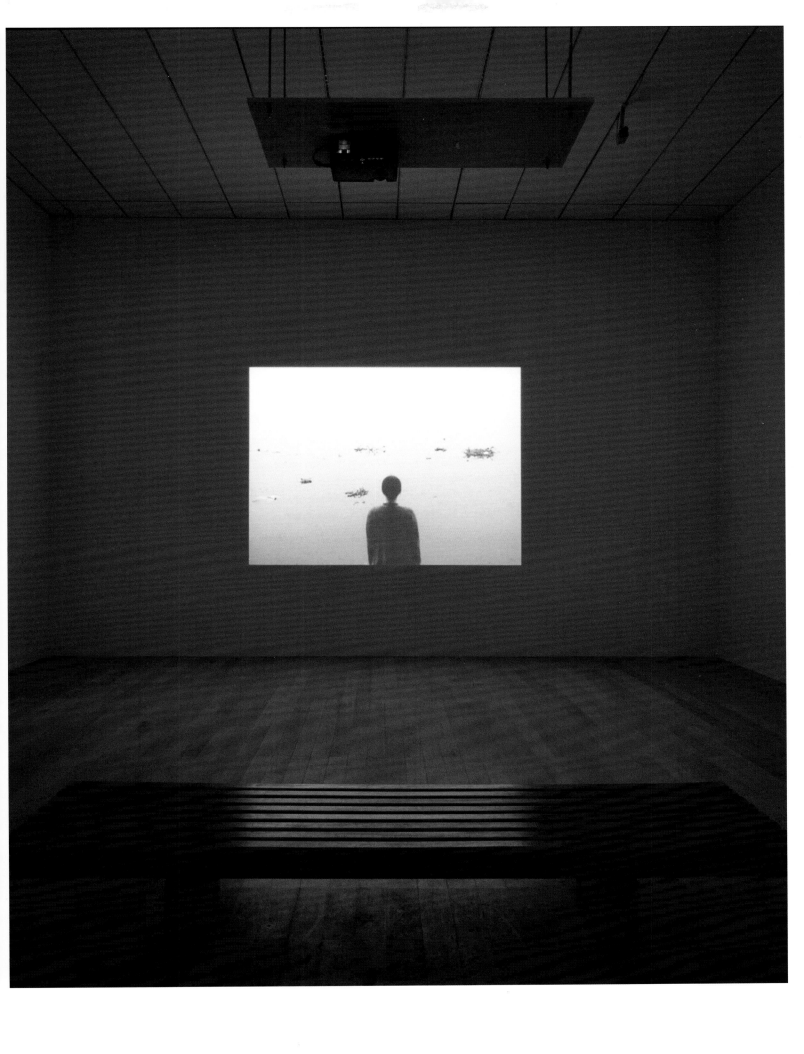

Kimsooja

LEFT AND OPPOSITE
To Breathe—A Mirror Woman, 2006
Diffraction grating film, mirror and sound performance
piece from *The Weaving Factory*, 2004
Installation at the Crystal Palace, Madrid

To Breathe—A Mirror Woman (2006), an installation at the Crystal Palace in Madrid, is the meeting point of my bottari and sewing practices. I see the piece as a bottari of light and sound and reflection—not really creating something physical but putting the void all the way to the surface of the Crystal Palace window glass, using diffraction grating film that diffuses light into the rainbow spectrum. At the same time I connected my voice (my breathing practice) to my sewing practice. A mirror, all over the floor, reflects the whole structure of the Crystal Palace. I thought the space should be empty and that I should use it just as space itself, putting the sound of my breathing inside it, occupying the whole space. In this space that is filled with the sound of my breathing,

people feel that they enter into someone else's body. They try to integrate the rhythm of my breathing with their own and feel the sensation of the rainbows diffused from the film and the reflection from the mirror of the structure. So in a way they experience my body, my breathing, and the audience's breathing as architecture, but at the same time they create their own rhythm and relate to their own reflections, to the structure within and without, and to discovering themselves. The audience's body functions as a needle onto the mirror. It's another way of sewing and breathing, using your eyes.

I always try to find the transcendent moment and space within my work. I just had an idea that I would do a breathing performance, but I didn't know what to

do. I sat down in front of the microphone, being there, and I started hearing my breathing. And then I made a sound—and I could even hear how I swallowed. Everything was very, very sensitive and overwhelming actually—the sounds that my body made. Breathing or meditation practice was never part of my life. But I know I can say that every moment is meditation for me. So in a way I don't have to meditate. I see breathing as the moment of life and death—just one moment when life ends, just one moment when you are living. Breathing is another kind of fabric—another way of weaving and another way of sewing—another way of connecting life and death and awareness of my body as both a physicality and impermanency.

Allan McCollum

I was a huge science-fiction fan all through
my childhood and very interested in three-
dimensional animation. I was also a big fan
of Ray Harryhausen, the animator who did
three-dimensional movies like *The Beast
from 20,000 Fathoms* and *Seven Voyages of
Sinbad.* He spent months making something
that only lasted one minute on the screen.
The idea of patience, making little tiny
moves to create a spectacle, always inter-
ested me and I think you could define a lot
of what I've done that way—a lot of tiny little
gestures, patience, and boredom that wind
up with something that's spectacular and
fun to look at. It's as if to put value on
repetitive labor instead of devaluing it.
Typically, in the art world, repetitive labor
is something you look down on. What used
to concern me was how interesting it was
that, say, Donald Judd could have something
made that didn't look like a hand had
touched it and it would cost thousands of
dollars. But some poor Indian in Mexico
City could make something by hand and it
would sell for nothing. It wasn't about the
thing. It was about the way we think.

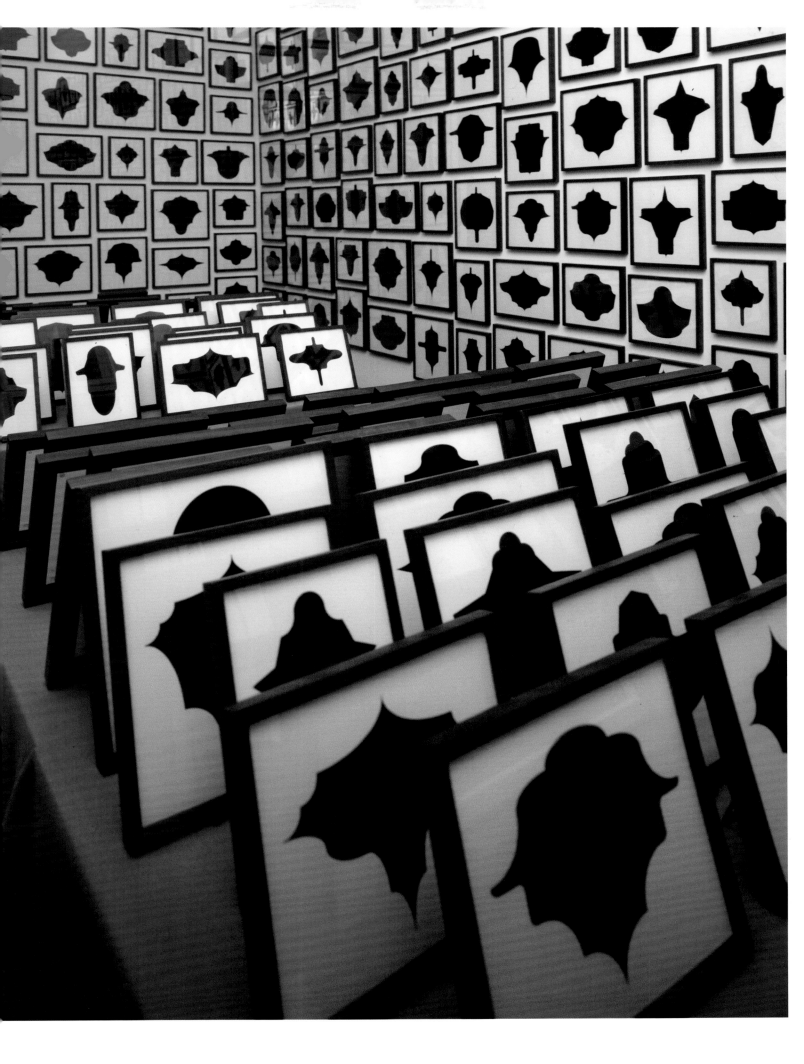

Allan McCollum

OPPOSITE
Over Ten Thousand Individual Works,
detail, 1987/88
Enamel on cast Hydrocal, 2 inches in
diameter each, with variable lengths,
each unique

ABOVE
Surrogate Paintings, 1978–79
Acrylics and enamels on wood and
museum board, dimensions variable
Installation view, *Collection of the
Artist,* 112 Workshop, New York

Each one of these objects was designed by a different person in a different country, and who knows how long it took the fellow to make the model of this little thing—and then have the design approved, making ones that didn't work, and having to test and retest. It may have taken a couple of months.

I don't know if everybody is like this but, sometimes when I go into a department store or even a grocery store and I look at all of the products, I wonder how many hands went into making all of these objects. Hundreds—maybe thousands—of people put their hands on these things and they wind up in a commercial situation. In the art world people might say, "Oh, it's just a stupid commercial situation." But in fact there may be thousands of actual hands of individual people that produced those things, and I was looking for some of that feeling in this project. There were 30,000 objects and no one author . . . not even a hundred authors. What I liked was the effort of hundreds of different people that wound up all mixed together in a mélange of creativity.

At one time I was speaking to a curator and I said, "You know the *Individual Works* (1987/88)? They're each one unique."

She said, "Yeah, right," like I was lying.

I said, "No, they really are each unique."

And she goes, "Sure . . . ," like I was trying to put one over on her.

What I like about artists in general—and about the artists that I like in particular—is that they have an idea and then see it through. I mean really see it through. They don't stop and just sort of do it halfway.

In the '70s I was making the *Surrogate Paintings* (1978–79). I would show them like stand-ins for paintings, almost like stage props, so that—in my mind—when you walked into the gallery you would recognize that you were playing a role in a social game of what a gallery is. As you went in, you would be aware of yourself as a gallery-goer instead of losing yourself in the landscape of a painting. The paintings were made from wood and it took quite a while: I would coat them with fifty coats of paint and have to press things with glue and put the frames on. I couldn't make them as quickly as I wanted, and it was only after maybe three years of doing them that way that I realized I had to have a mold to produce quantities. I wanted the drama of quantities. You can make thousands of things from a mold. As a child you have cookie cutters, candy molds, and toy molds that you buy in the toy store, so I had some experience with molds from that area.

Allan McCollum

And when I decided to start making the *Plaster Surrogates* (1982/83) in quantity, I *knew* I couldn't make thousands unless I had molds. I more or less learned how to make molds but I didn't always make them myself. I would have other people do it. It was a solution to the problem of quantity. But then you would get into everything being alike, which I didn't like. I wanted everything to be different so I came up with the idea of making separate little parts that I could then attach together to make unique things.

Do I ever break my molds? That's one of the strange elements. If somebody asks me if I am going to make any more of a particular work, I always say that I don't know. I'm not trying to create the mystique of saying there are only so many left so the value is supposed to go up. I find it a little bit offensive when someone makes ten objects and then destroys the mold so no more can be made. It seems phony to me. If you have a mold that you can use to make 50,000 things, you should use it so that 50,000

people can have that thing. But what does happen is that I get bored, or I get more interested in something else, and I set a project aside and just never go back to it. So with the *Plaster Surrogates*, yes, if you ask me am I going to make any more, I'll say I don't know. But my guess is probably not—because I haven't made any in almost twenty years. The door is probably closed on those.

I think I was rebelling against myself when I came up with the idea of wanting to design a project that I can never finish. I specifically wanted to make a project that outlived me. Whether or not anybody would want to continue it is another question, but the option is there—so it's never finished. Whenever I design a project, it's in my head while I'm designing it that I would be able to show someone else how to do it so that it could have that sense of perpetuity. I had an uncle, Jon Gnagy, who had a television show called *Learn to Draw*. He designed drawings so that he could then teach other

people how to do them. He would show you step by step by step, and I just got the feeling that it never occurred to him to come up with a painting or a drawing that he couldn't tell someone else how to do. I was just a child then, but that influenced me. I also think the five months I spent studying industrial kitchen work in a trade school was similar. Everybody worked according to recipes, and you learned how to do something and write it down so that somebody else could do it. It was just typical in the industrial world that you designed things so that they could be done by others. I guess my brain works that way. And like many, I was very influenced by the Fluxus artists whose goal was to take away the mystery of being an artist and devalue the mystique that only an artist can make a certain kind of mark and that you have to be a special, special person to do this or that. I was rebelling against that, even in the very first artwork I ever made. So I guess that's still a part of my working method.

Allan McCollum

I'd been making casts, copies, and replicas of things like the *Individual Works* and *Surrogate Paintings* but I wanted to create things that satisfied our expectations of art. One of the things that we love about art is often that it's old. But I couldn't figure out a way to replicate something old with a copy. It didn't make sense. How do you make a copy of something and then look at it and think it feels old? It only has the aura of being old. But then I slowly came to the conclusion that dinosaur fossils *are* copies. They're made by a molecule-by-molecule replacement of the actual bones with silica or other natural elements and they wind up having the same form as the dinosaur bone. But they're not the same. They're just copies of dinosaur bones. This is the way fossils are generally created, so it occurred to me that if I make a copy of a dinosaur bone, it's really just a copy of a copy. It's not like making a copy of an original bone, so it should therefore have the same aura as the first copy. It was just an odd train of thought—but I got onto the interest in fossils and dinosaur bones with the idea of trying

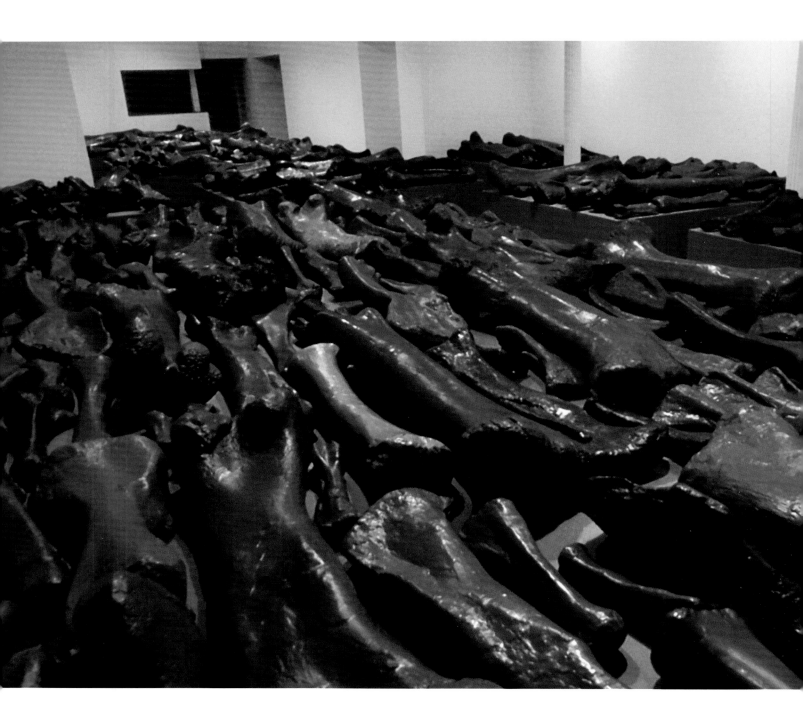

to replicate the old. I collaborated with a museum in Utah. It turned out that it was in a coal-mining town. The coal miners would find naturally formed casts of dinosaur tracks in the roofs of the coal mines. What I liked was that each one of these reverse footprints was lovingly chipped down from the ceiling of a coal mine and taken home as a souvenir. Some of them would wind up in the local history museum. Even the paleontological preparator (who made molds for me so I could make the casts in New York) used to work in a coal mine. In fact, he used to chop down some of the natural casts from the mine roof. So they were like objects valued by the community of coal miners. That was part of what appealed to me: not only were they old, but they also had a social meaning. This project was the beginning of my interest in community and the way communities give meanings to natural objects as a way of defining themselves. And it was the first project for which I got involved in creating educational material. I did research on dinosaur tracks found in coal mines and I produced the *Reprints* (kind of a pun), which are the stories that I found. So it was a project that was about art, local history, community involvement, and education all at the same time. Since then, I've always tried to include an educational element in my work so that the meaning of a project is not just for those who are artists or people who went to college or people who visit art galleries. It has a function that has nothing to do with that. It's not just a connoisseur thing.

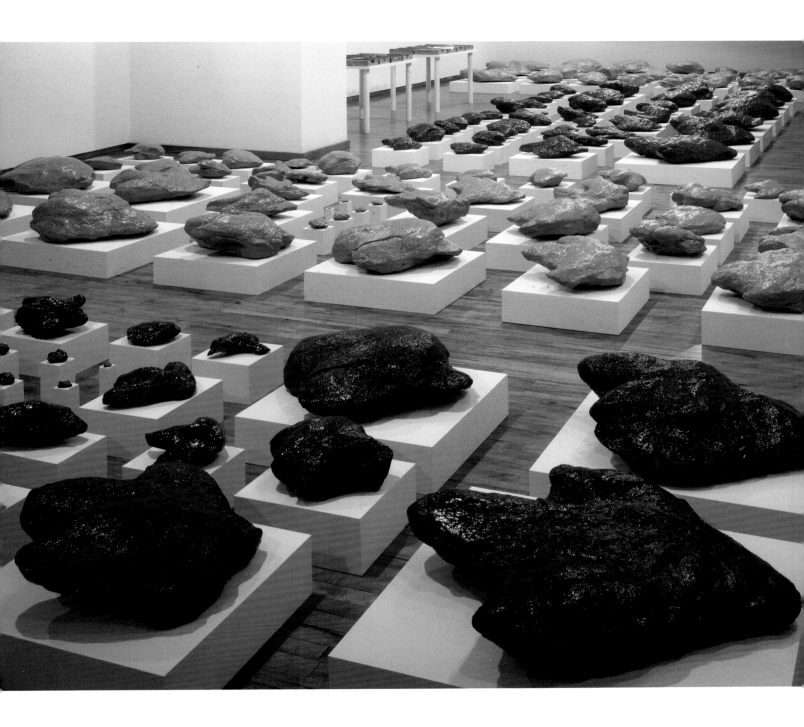

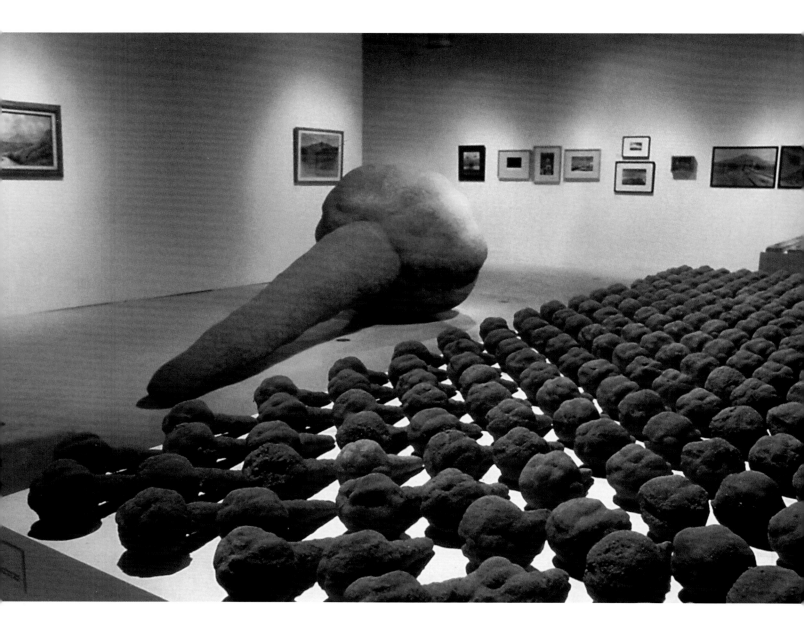

Allan McCollum

ABOVE AND OPPOSITE
Mount Signal and its Sand Spikes: A Project for the Imperial Valley, 2000
Installation view for inSITE 2000 project at
University Gallery, San Diego State University

I discovered these objects called sand spikes. They looked to me like something made by Giacometti or Duchamp, but they're actually made by nature through the action of ground water. I did a little research on them because I was interested in where we draw the distinction between natural objects and man-made objects that wind up in a museum. These seemed like a weird blend: they look man-made but they're nature-made, and they wind up in a museum the same way a painting does. It turned out that these sand spikes are found only at the base of

Mount Signal in Mexico, on the California border. When I went out there I realized that the mountain was a symbol that represented the community. The sand spikes were considered unique to the area just the way an artwork can become an emblem to the artist who makes it, the collector who buys it, or the historian who loves it. We all have emblems, and they're not always man-made. In America, especially, we sometimes choose a natural geological object to define our community. It's complicated to explain, but I wanted to do a project that was about

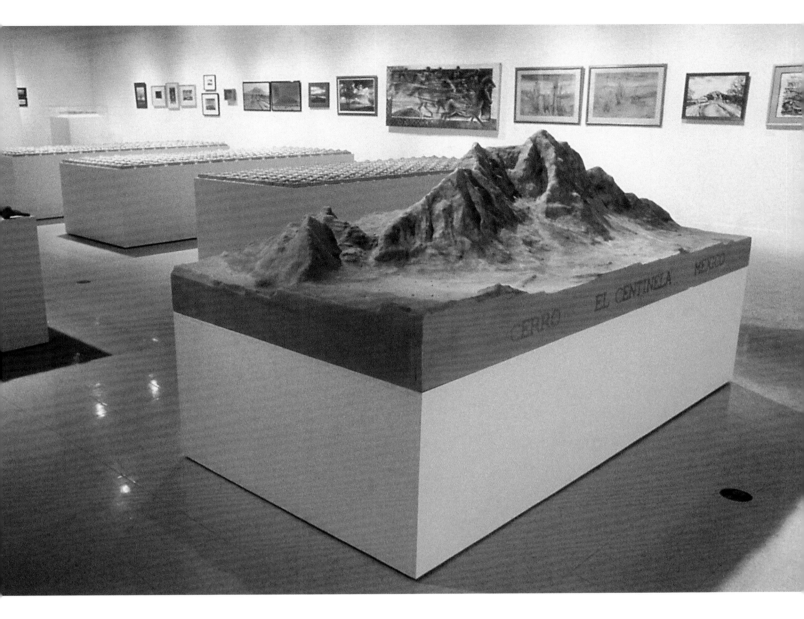

the way a town finds its identity (and involve or even intrude myself into that, and maybe even have an effect) because in the towns that surrounded Mount Signal ninety percent of the people didn't even know about the sand spikes. I wanted to collaborate with them. They let me make a mold of one of their sand spikes, and I had a thousand souvenirs of that same sand spike made, which I then showed in museums and galleries in the Imperial Valley. Almost ten years later, I have gotten into wanting to have an educational and social component to every project. So I have found articles on the history of sand spikes and their collections and I made souvenir packages for sale in the local historical-society museum. As a part of the project, which I haven't finished yet, I had somebody use satellite data to do computer renderings and make a model of the mountain. I made a mold and started making copies, and we had a big display of mountain models. We also made a giant sand spike, fourteen feet long, and a giant model of the mountain eight feet long. They are still in the collection of the historical museum.

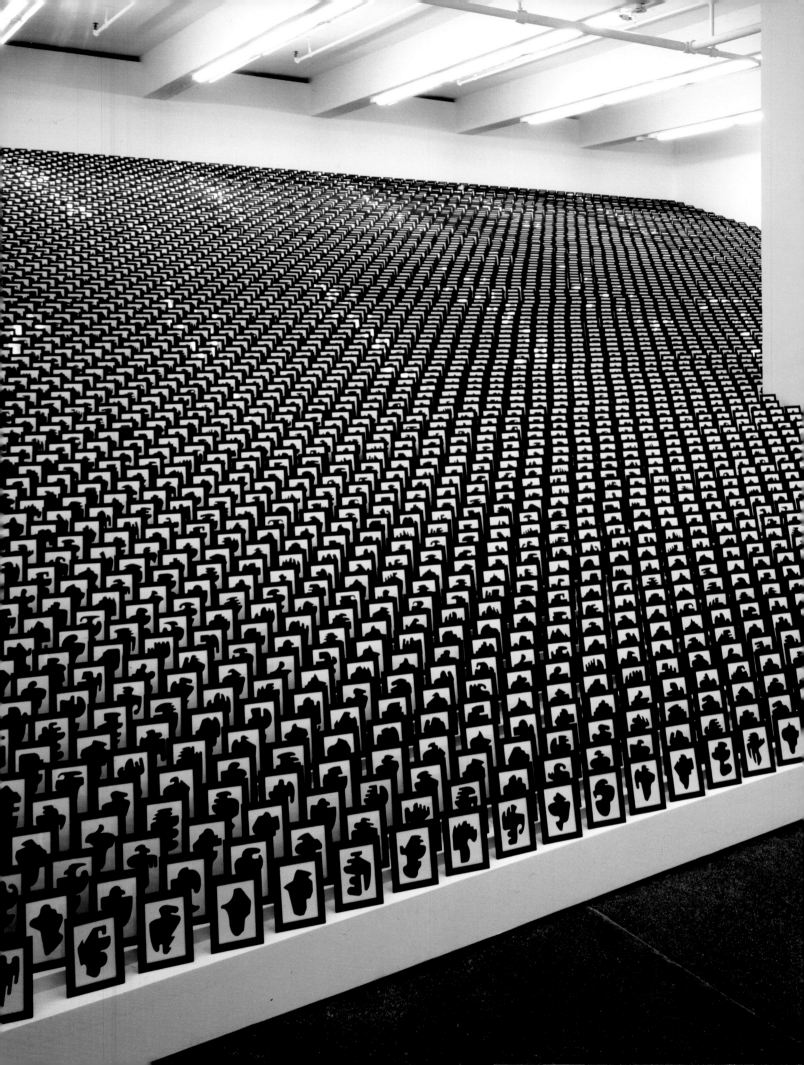

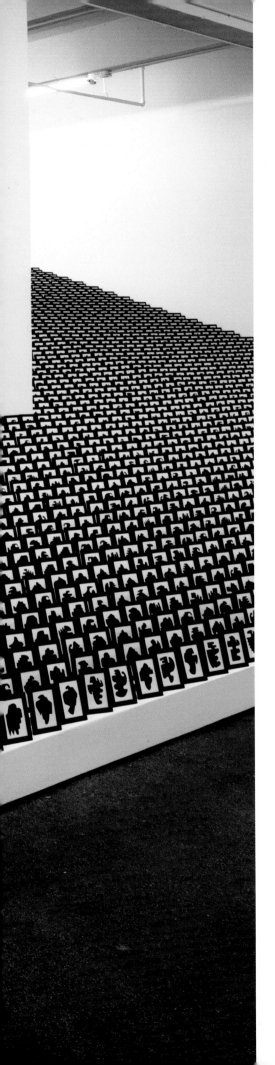

Allan McCollum

The Shapes Project, 2005/06
Framed laser prints on acid-free bond,
5½ x 4¼ inches, each unique
Installation view at Friedrich Petzel
Gallery, New York

The Shapes Project (2005/06) is the first computer project that I've done. It's all done with Adobe Illustrator, and I learned only the things I needed to know to do it. I don't know how to program or create any kind of database that generates anything. What I do is very simple, like what I've been doing in combinatorial projects for twenty-five years or even longer. All my projects have had combinatorial elements where I'm taking a vocabulary of parts and putting them together to make something else, which is very computer-like, but there was never a computer involved before. The closest things to this project were the *Drawings* and *Individual Works*. The *Drawings* even look like the shapes that I'm working on now, but they were all done by hand with pencil. In those days I was using photocopiers and stencils. But once I started learning Adobe Illustrator to combine shapes it freed me to think in larger quantities. I don't know if it got me to think about things I couldn't have done otherwise. It was just that if I used the computer I could do more of them, more quickly. I spent about five months making all the little parts that I designed for *The Shapes Project* by hand, the way you do with a drawing program—filling in, getting them to the right size, testing, and making sure it worked. Once I finished all of the shapes I had about three hundred, and then I was able to make some of them

smaller and fiddle with them a little more. But what I can do now is just copy one shape and another one, put them together, and then copy a bottom and put that together. Every shape has an ID number, and I have hundreds of notebooks with just lists of numbers that I've made using the computer. As long as I keep track of my list, I'll know that I'm not duplicating. That's the important thing. What I'm doing is incredibly simple. It's childlike; anyone could do what I'm doing. The hard part is having the patience (and a boring, compulsive personality) that allows me to keep doing it over and over and over again. So from four shapes I can make around 200-or-so million unique shapes. But there's another system where I use six shapes. Once you start using that, you can produce 60 billion shapes. This is consistent with wanting to make a shape for everybody on the planet. I had to come up with a system that not only created enough unique shapes for everyone on the planet, but I wanted there to be enough (even in fifty years when there are billions more people) to play with and experiment with. So I went way overboard. One of the problems, of course, was that I didn't want the shapes to be reversible and suddenly be the same as others. So the system never creates one that—if you flip it—is the same as another. Once I did that, there were only 30 billion.

Allan McCollum

Shapes from Maine, 2009
Installation view at Friedrich
Petzel Gallery, New York

It looks like I do them one at a time. But that's an exaggeration because I have documents that contain 144 shape parts—144 tops in a specific order according to a specific sequence of a specific protocol—and then, in another document, I have 144 bottoms. These arrays are numbered. So once I've done all this, I can take a top array, copy it, and paste it into a bottom array, and then make 144 at a time, and that instantly becomes what I call a collection of shapes. Then it becomes really tedious because I have to copy each one of these shapes and put it into another document in order to send it to the people who are making cookie cutters, or whatever. There's no rest in this process. But once you've got the arrays finished in order and in sequence (and it'll take me years to finish all of the arrays), then I'll feel like I've done my part. And when I'm long dead, if anybody's still interested in this process, all they'll have to do is combine arrays to create more shapes. One of the things I was concerned about was that they should be distinctly different. It's very easy to, say, choose four shapes and have them all be different: one's a triangle, one's a square, one's a circle, and one's a parallelogram. But when you have to design 144 shapes that are instantly different from one another, it's a lot harder than you think. Many of my shapes look quite similar, but it just takes a few seconds to recognize that they're different—whereas one might be tempted to make shapes that had very tiny differences that would take a long time to see. I didn't want to fall into that trap of see-if-you-can-find-the-difference. If you're looking at a thousand shapes and somebody says that each one is different and you have to really check, you just go, "Oh, who cares?" But if they clearly are different, then I think that's exciting. So

that was my dilemma. And I wanted them to be something you could instantly identify with, something emotionally engaging. However weird they are, they always seem to have some kind of vaguely animistic or humanoid quality. When you look at them, I want you to say, "Oh! That's a screaming man with a backpack on; that's a pregnant woman; that's a fellow getting an erection." I want to invite an emotional response, the same way a designer does when he designs a bottle he wants you to reach out and touch and buy. It's just a principle of making something that appeals to you emotionally. But the idea of making 60 *billion* things that appeal emotionally was really a challenge. Sometimes I've spent months and then realized I'd made one little mistake that's been duplicated over and over, and I've created three thousand mistaken arrays. Then I have to dump them all and start all over again. I don't like incorporating errors. If there's one mistake, it seems to me—if one person finds one mistake—then we can't trust or believe that these are unique. But if you think there are no mistakes, then you're in awe of the possibility of billions and billions of unique shapes. And that's the kind of awe I'm interested in. A mistake ruins the effect for me, and that's why I'm doomed to keeping track of things all the time—because I don't want to spoil the effect. And so it just goes on and on and on. Sometimes I don't know when to stop. In previous projects I've done 30,000 unique plaster objects that are made of combinations of shapes. And I had to do all of that by hand. The word 'digital' includes fingers. I hate it when people say that my shapes are *generated* digitally, because what does that mean? It's like saying a painting is generated by a brush. Of course, it's by hand.

Tables, front to back:
Shapes from Maine: Shapes Copper Cookie Cutters, 2005/08
Polished copper, 5½ x 3⅔ x 1 inches each, each unique, formed in
copper by hand. Produced in collaboration with Holly and Larry Little,
founders of Aunt Holly's Copper Cookie Cutters, Trescott, Maine
Shapes from Maine: Shapes Ornaments, 2005/08
New England rock maple, hand-cut with scrollsaw, 3⅜ x 2¼ x ½
inches each, each unique. Produced in collaboration with Horace
and Noella Varnum, founders of Artasia, Sedgewick, Maine
Shapes from Maine: Shapes Rubber Stamps, 2005/08
Wood and rubber, 1¼ x 1⅝ x 1³/₁₆ inches each, each unique.
Produced in collaboration with Wendy Wyman and Bill Welsh,
founders of Repeat Impressions, Trescott, Maine

Wall:
Shapes from Maine: Shapes Silhouettes, 2005/08
Hand-cut black paper on museum board, approximately
3¾ x 2½ inches each, each unique; 7 x 5 inches framed.
Produced in collaboration with Ruth Monsell, founder of
Artful Heirlooms, Damariscotta, Maine

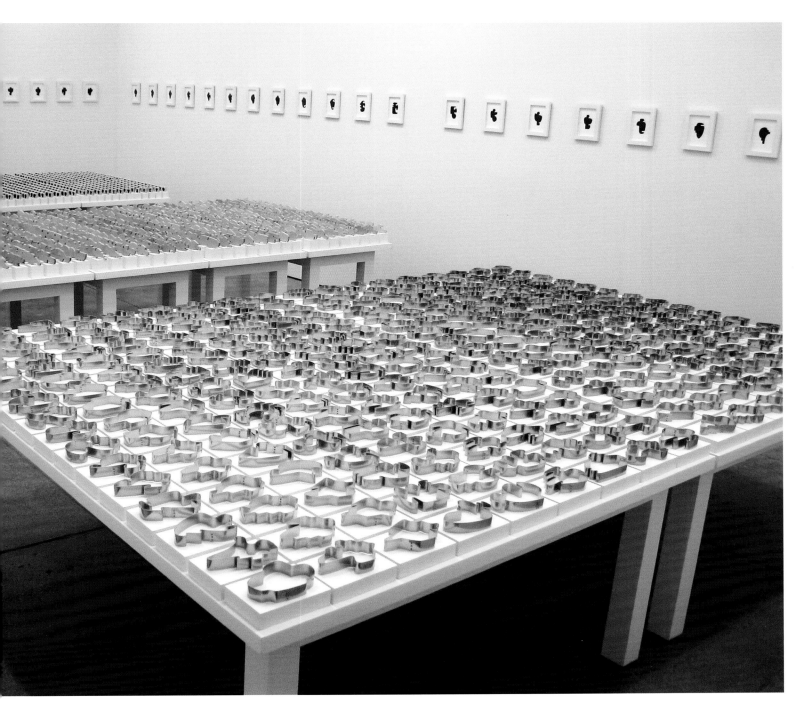

Julie Mehretu

ABOVE
Untitled, 2000
Ink, colored pencil, and cut paper on Mylar,
18 x 24 inches
Collection of Nicolas Rohatyn and Jeanne
Greenberg Rohatyn

OPPOSITE
Easy Dark, 2007
Ink and acrylic on canvas, 108 x 72 inches
Louisiana Museum of Modern Art
Collection, Humlebæk, Denmark

It used to be that I was just trying to understand my initial impulses in developing work because I wanted to make sure that I was using it to bridge different aspects of my interests and concerns about the world, and who I was within it. As I've continued to grow and understand my work, that is not so necessary; it happens without effort. Most amazing to me is when something happens in the work that, without an expectation or desire in the impulse of making it, completely illuminates a situation. What I'm most interested in is how I push the work, allow it to have conceptual meaning, and allow it to be free enough that it reveals itself to me. In looking at the paintings that are most successful it's the experience of what happened in the painting that actually was able to illuminate or be reflective of something much deeper in myself that continues the creative impulse. The earlier, more analytic impulse was to use very rational but kind of absurd techniques or tendencies —mapping, charting, and architecture—to try and make sense of who I was in my time and space and political environment. But there's only so much truth to a theoretical understanding of something. The action or behavior—or what happens organically and intuitively, rationally and spiritually, or majestically—in a world is a very different thing than what can happen in our effort to understand it. So there was more of an impulse to use those approaches, trying to make sense of these two sides of myself in the earlier work. And I developed a whole language and body of work that evolved from that investigation. But the thing that kept it all together and that keeps me going is the painting—making the pictures—and drawing. In getting lost in doing that, language is invented. And that shows you something you never thought you would know about yourself or understand.

Early on, I made some drawings where I realized that the little marks looked like a map of a city. That moment of getting lost in the drawing can be very telling about the way that I think about things. It's about trying to understand process and language and that the creative process is part of a continuum of thousands of years of the desire to make a mark on something and communicate through that. What is it that you are trying to communicate? Why the language of abstraction? These questions come up, especially when you're trying to define yourself. Then, as you become a little more comfortable with that, the question becomes, "Why continue with this? Why is this interesting to me? What is it that's evolving?" It's in the commitment to digging deeper in the work that it becomes a self-revealing process.

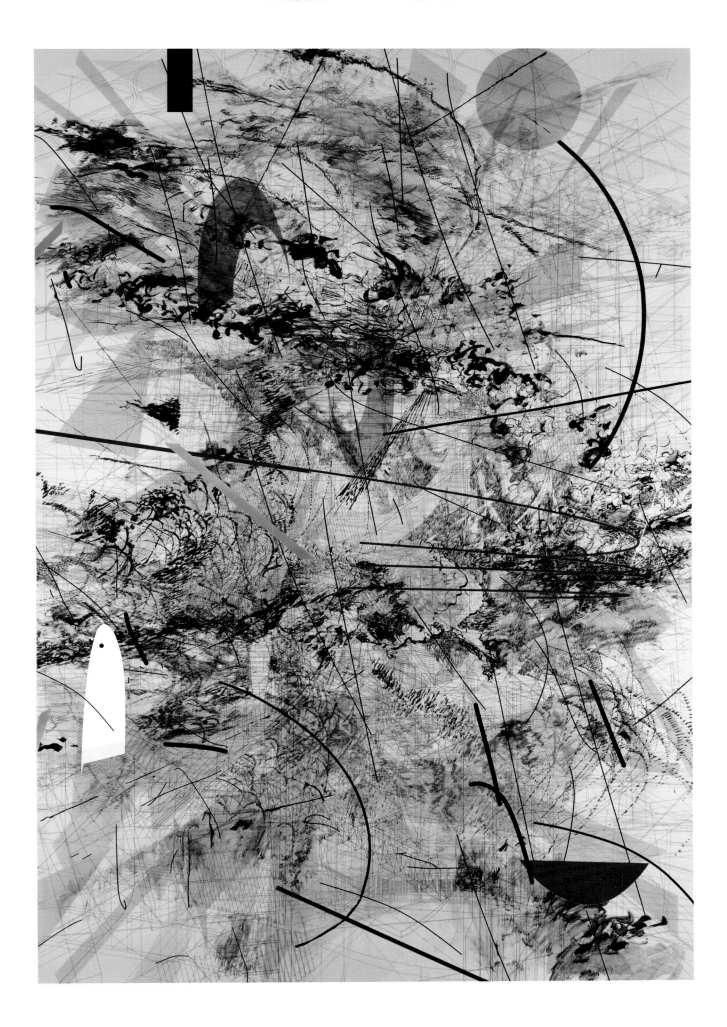

Julie Mehretu

Citadel, 2005
Ink and acrylic on canvas, 72 x 96 inches
Collection of Mellody Hobson

There are different types of information
that go into the picture, depending on
the painting, and especially in the work
now. In certain paintings, that information
is very readable and it's just pure geometry
—geometric shapes that mimic architec-
ture. So you look at the structure and
you can't really define anything, but you
know that it's really just created out of
geometric shapes. Then there's other
work in which I incorporate a lot of
specific architectural plans. As the works
progress, the more the information is
layered in a way that's hard to decipher
what is what. And that's intentional. It's
almost like a screening out, creating a
kind of skin or layer of just this informa-
tion that we recognize. So if a building
is from Baghdad or New York or Cairo
it's not so important. I don't necessarily
reveal which building is from which
place. It's more that this information is
part of the DNA (that's how I keep think-
ing about it) of the painting—part of the
ancestral makeup of what it is and the
information that informs your under-
standing or your vision of it. I'm attracted
to different types of images because
of what's going on in the world. And
because I used to work with this informa-
tion more directly, I think I've become
much more well-versed in the language
of architecture. So all of that comes into
the work in different ways, but I don't
really spell out exactly that this is, for
example, an image from Baghdad. This
painting is not a description. I want the
work to be felt as much as read. My
interest in using parts of these broken
buildings is that these are elements of
our built environment. It's just another
representation of that type of landscape.
The question for me is how the marks
interact with these deconstructed build-
ings? How do they deal with that space
rather than just constructed space?

Julie Mehretu

Palimpsest (old gods), 2006
Ink and acrylic on canvas, 60 x 84 inches
Collection of Mehretu-Rankin

I'm very interested in looking at Turner right now. The seascape was his point of reference, and even when he was trying to paint historical scenes around that it was the sky and the atmosphere that he was painting. Being able to paint forces of this kind coming together that you can't quite grasp in some way is his majesty. But, with my work, it's the architecture and the space and the built environment that become a kind of palimpsest, another type of atmosphere. The buildings are so layered, the information can be so layered and disintegrated, that it almost becomes a dust-like atmosphere.

Why drawing? It was so complex at one point, working with so many different elements, I just wanted to take away all the color—just work with ink—and pare it down to just the mark. Why did I think of the marks in the way that I thought about them? Did it really make sense that I wanted to work this way? I wanted to try to really understand, in every little facet, my desire to create in a particular way. The more engaged I became with the way I was making work, the more I could just allow a certain amount of freedom so that the work could grow and then ask new questions. And then it became clear that it wasn't just about understanding the work, and it wasn't about building a theory so that I could make work for thirty years or fifty years. It was really about working in a language that was evolving.

When I was working on the watercolors, there was a phenomenon that I wanted to bring into the painting. As I started to work with that element and bring it into one painting for its different references it was just not working. I kept pushing the color into the painting where there had been an intense amount of drawing and an intense action between all the different marks.

 At one point I just started to sand away all the color that came into the work. And when I'd finished sanding it, I turned around and looked at it and it was a finished painting. I called it a poltergeist in the work. The erasure itself became the action. And all the marks were frozen around this hovering. It reminded me of the caves in Afghanistan where the Taliban removed the Buddhas—that image of their absence. There was almost that type of feeling to that area in the painting and what happened in the work. It became the dragon that I really started to chase with the rest of this work since then, thinking about excavation, erasure, and palimpsest within my own language and my own work. It seemed to me to suggest a moment in terms of how sad or pessimistic you can feel in a political environment or a historical situation. But it felt like a really hopeful gesture in the painting.

Julie Mehretu

CENTER
Untitled (2005 drawings), 2005
Ink, colored pencil, and graphite
on paper, 26 x 40 inches
Collection of Edward Nahem

BELOW
Vanescere, 2007
Ink and acrylic on linen, 60 x 84 inches

Julie Mehretu

Bombing Babylon, 2001
Ink and acrylic on canvas, 60 x 84 inches
Collection of Giulia Ghirardi

I went to see the Babylon show at the Pergamon in Berlin. There was a deep description about the history of Babylon, the number of wars, the number of times that a certain type of history has been erased. One has a strong sense of responsibility in the Iraq war—being an American citizen and an active agent in a time of really horrible war—especially in these very ancient places that are part of our collective history as human beings. The blatant, haphazard wiping out of part of that history can be very depressing. The other side of it is that things will continue and that there is a different kind of growth that can come again and that things evolve. Looking at these things simultaneously—seeing those two powers challenge each other in the work—time and space are collapsed. You can go back 2000 years and come right back. The reason that I was working earlier with transparency and layering was more analytic, in an effort to layer these things one on top of the other. Now there's a little more understanding of the information. I'm actually building in a way where you can't as easily see through the layers and decipher what is what. It doesn't matter how expert you are in architectural history. It's hard to pick out what is what if everything becomes so congested. And part of that is the intention of everything just distilling—allowing everything to break into pieces of dust, vapor, or more atmosphere.

Julie Mehretu

Excerpt (suprematist evation), 2003
Ink and acrylic on canvas, 32 x 54 inches
Collection of Nicolas Rohatyn and Jeanne
Greenberg Rohatyn

There are different types of work that have informed mine, in terms of how it's made and what it may be quoting. But if you think of an abstractionist who really tried to deal with the social through abstraction, it's Kandinsky. Or think of the desire of the great utopians that nothing was without meaning. There's a very clear relationship between my work and the history of that work, or the Constructivists or Italian Futurists in certain ways. But in terms of what I'm interested in painting, I can go after a painter—one part of a person's painting—and not necessarily his or her whole work. I am interested in the history of painting. While I like many artists, my favorites are not necessarily painters—or they tend not to be painters who are the strongest contemporary artists. But I'm working with the history and tradition of painting, and that's been a consideration of mine since I started really making conscious art. I'm a painter; and that's what I'm obsessed with. But what I'm really focused on and trying to go after in my work is not necessarily

being informed by other artists' work. It's about trying to understand myself. I keep going back to that, digging deeper into who I am. You have all this experience that determines who you are, and you can't change that too much. You can only get to know and understand yourself better, and evolve and try to grow. That's how I am with the work and trying to push to understand what I make and why I make it the way that I do. Why the fascination with certain materials? The images just are in my head. They follow me around like ghosts. And going after a particular occurrence in the painting is really to try and figure that out, too—whether it's through making and erasure, or working with color and the ink and paint, or being able to have an image come about that you know you can't forget—that stays in your head whether it comes to you waking up in the morning or as you're going to sleep at night. There's a certain high you get when you can find that. And maybe it's for that. Maybe it's just pure addiction.

Julie Mehretu

ABOVE
Stadia II, 2004
Ink and acrylic on canvas, 108 x 144 inches
Collection of Carnegie Museum of Art,
Pittsburgh, Gift of Jeanne Greenberg Rohatyn
and Nicolas Rohatyn and A.W. Mellon
Acquisition Endowment Fund

OPPOSITE
Stadia II, detail, 2004

When I come into the studio in the morning it usually takes about an hour or two of circling and cleaning up a little bit or doing something else—and then slowly nestling into the point where I can actually remember where I am in a painting or even realize a new point of entry so that I can get back into the making of the picture. I used to work ten or twelve hours a day. I couldn't do that, working the way I'm working now, because it's so much more of an intense engagement with the image. It comes in waves and I have to get it when I can. Some days I'll be engaged in painting, and make great headway, and then the next day I'll come in and I have no access. You can have the whole day just feel like you're spinning your wheels. But I think that's part of the work—being in the studio, just looking at the work for a long time, and realizing the painting. If you spend that time with the work you'll see the complexity. The painting will then come to you. Sometimes you have to allow that type of looking. Sometimes it can take days to know what to do next in a work. If I don't have access

one day, I can try and work on something different, but sometimes I don't have access into any of them and I have to draw.

Your relationship to the space in the painting shifts depending on where you're standing and what you're looking at. Standing in one spot you can participate in several different spaces conceptually, at the same time. And when you're standing in a different spot you see those same spaces in a very different way. Your relationship to the piece changes. Nothing comes from one particular perspective. Nothing can be read one way only. The experience is really about seeing. When you're standing in front of a painting, you have a physical relationship to the size, small or large. You have a bodily experience. You have the tactile experience, the brushstroke, whether you get lost in the texture, and you have the light. All of that informs the experience of the work and whether a piece can be really powerful. Like certain Agnes Martin works or Eva Hesse pieces, you have to be in front of them to experience them.

Julie Mehretu

I've looked a great deal at Chinese calligraphy paintings. I haven't studied them in the way art historians have but, in terms of that kind of mark-making, I think each mark has meaning because of the way that it was made. And that meaning is conveyed by the lean on the mark. That is really similar to the way that I make my mine. They started with graphic marks that almost looked like glyphs and little symbols and quickly evolved into notation and then more of a gesture—miniature gestures that can mean different things in my mind and in the work depending on how they operate and lean. A mark that leans forward has a very specific kind of gesture to it and you can assign a particular social meaning to that. So in my mind these marks operate with that type of social gesture. But I'm not trying to spell out a story that you can read through the painting in that way. I still think you feel the painting, and the reason you read the mark is because you also feel the mark. But I think that's the way that a lot of the Chinese paintings were made—not only trying to depict, for example, a leaf but to depict the spirit of that leaf that you could mimic in the gesture, action, and intention. I know when a painting needs a particular kind of work, and I know when I can do it and when I can't. I think any painter deals with this: can you actually sit down and craft this? To get it right I have to *not* think about it and allow the drawing to happen.

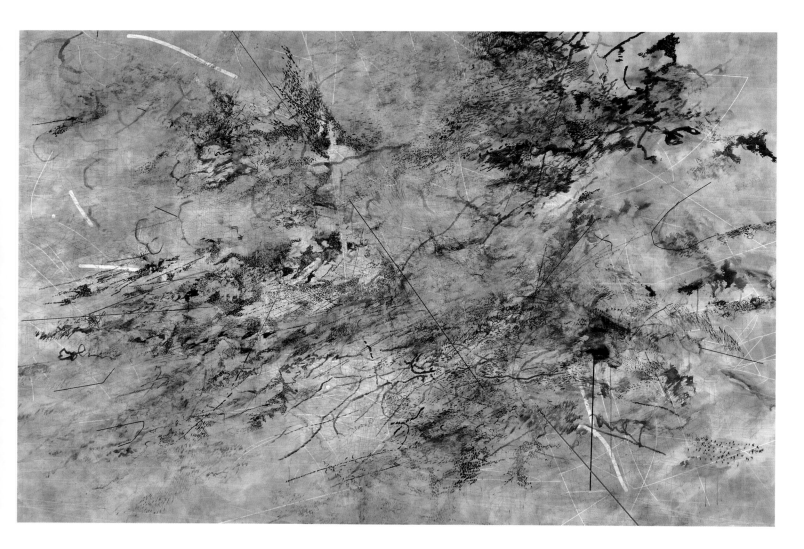

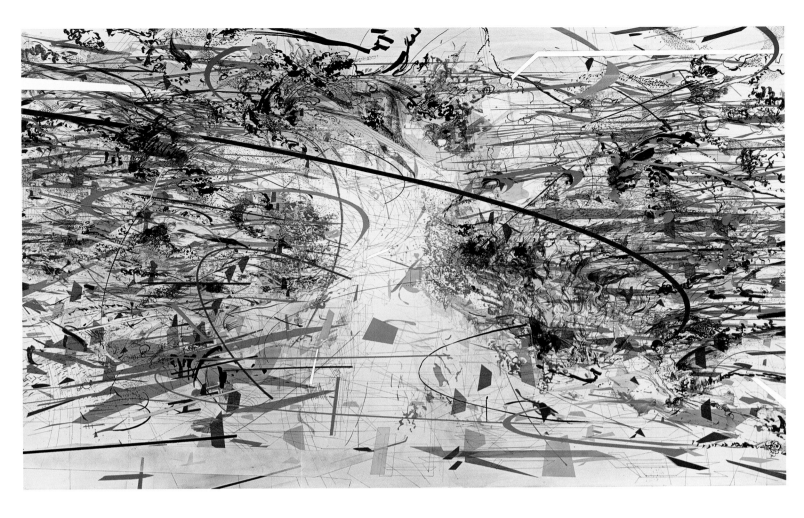

Part of the conversation that my work has brought up is the idea that the work is a description of my experience. That's just a bit of a misunderstanding. I'm not trying to make these paintings to understand my time in the same way that I was five years ago. I'm not trying to make a painting that makes sense at the moment. That will happen through the work whether the piece feels like it was made for the moment or not. For example, right before 9/11 it felt like there was a buzz in the American economy and then it started to fall apart. I tried to incorporate part of that information into making a picture that could be informed by that. Now I approach a picture out of a collection of information that comes to me, and through the experiment of projecting information

and working with the language, the mark-making, painting the color and texture, and whatever other elements that I want to bring into the work. The investigation of making is illuminating *towards* that moment rather than the other way around, a reversal of the way that I would approach making a painting before. I think that it gets to a richer illumination of the moment, which is what I was trying to do at the beginning but going about it a little backwards. My earlier drawings and paintings had a diagrammatic, map-like, pictographic element to them. But as the work has shifted to being more atmospheric or painterly, I think I refrain from trying to explain what's going on. The paintings are not rational descriptions or efforts to articulate something in that way.

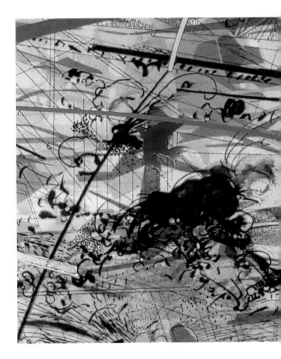

Julie Mehretu

Mumbo Jumbo, 2008
Ink and acrylic on canvas, 96 x 144 inches
Collection of Jaime Frankfurt

A lot has been said about who I am—that I've lived in different places and traveled a lot—and that I come from a biracial background. I've intentionally stayed away from talking about that in the work because in the end I see myself as an American who lives in the United States. I'm Ethiopian American, but I move around the world as an American. That's just the reality of who I am at the moment. As you work you really recognize what drives you to make work. For me it's about being able to make a painting that will arrest me. It has to engage me. And that's not about any description of who I am or where I come from. All of that informs my perspective on the world and therefore also the direction of the work. Almost anything in the environment tends to inform the work for me in one way or another. Different studios have done that for my work as well, and living in different places—whether it's a place that has a view or no view. I'm very affected by place and space, and it comes through in the work. I think there are some artists for whom it doesn't matter where they are. Their work is so embedded inside their heads that it's not informed by all of this other stuff. I'm a very private, internal artist. When I work, even with assistants in the studio, I have my headphones on and I try to get lost. That's where I have to be in order to draw and paint and have that conversation with the work. I work with music a lot so that I can kind of try and lose myself. It's very rare that I work in silence. Somebody said, "First you get everybody who ever writes or thinks about your work out of your studio. Then you get the artists you dream about or have conversations with out of your studio. And then, if you're lucky, you can get yourself out of your studio." So music is a way to do that. I try to get so lost in what I'm listening to that I can actually *allow* the work, allow my hand in the work, have the floor fall out from under me, and let new things happen.

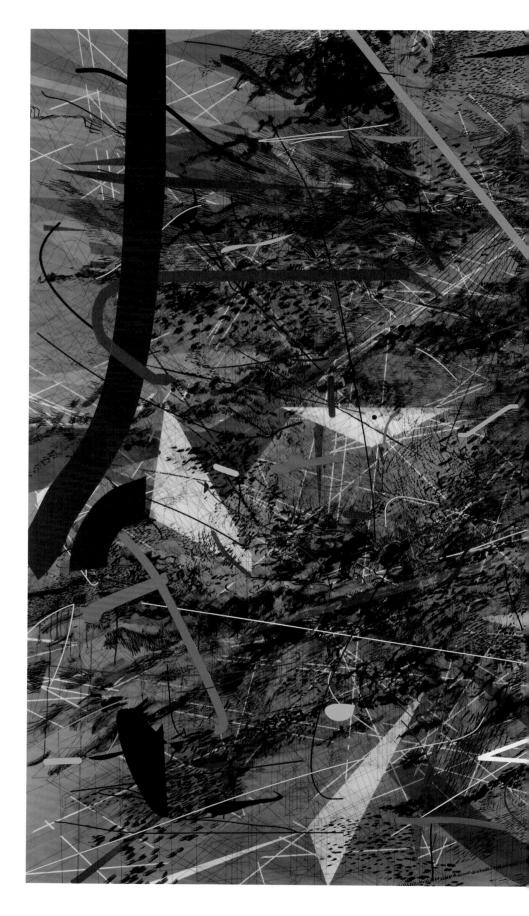

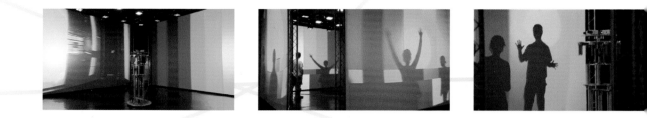

Paul McCarthy

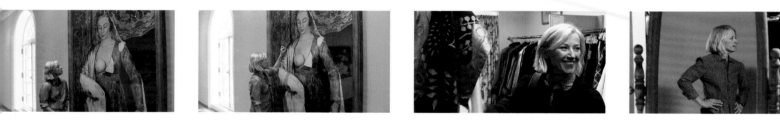

Cindy Sherman

Yinka Shonibare MBE

Transformation

Paul McCarthy

Paul and Damon McCarthy

You're asked questions and then somehow have to figure out what a piece is about. It's ridiculous. You work on something for five years and then someone's asking you, "Why did you make this?" The problem is that the only way you might get to the answer is to just keep talking until you stumble on it. My responsibility is to the ideas and not to the audience. But it's the audience demanding a concise answer to why I'm doing this and what's my justification. It's as much an exploration as anything. I can't tell you *why*. The why and the answers to why are in the piece itself—in the work. It's not in what I say here—and certainly not what I say when I try to answer a question about something that is intentionally and purposefully entangled. When I answer these kinds of questions I sometimes leave out the critical parts because maybe I haven't really defined what exactly was going on and why something came up. In *Caribbean Pirates* (2005) there's referencing and layering—from *Who's Afraid of Virginia Woolf*, from a Bruce Nauman video—and these become entanglements. What's critical is that it's a process of making an entanglement—layering, stacking, and abstracting, thinking in terms of visual art, appropriating film. Confounding the situation happens in that process. There's something coming from making sculpture and making the films—and it's about looking to flip the thing. So you might want to put Elizabeth Taylor in a pirate movie and depict it as *Who's Afraid of Virginia Woolf*, and you might insert a Bruce Nauman thing. And you might use a term like fucking it up to describe this.

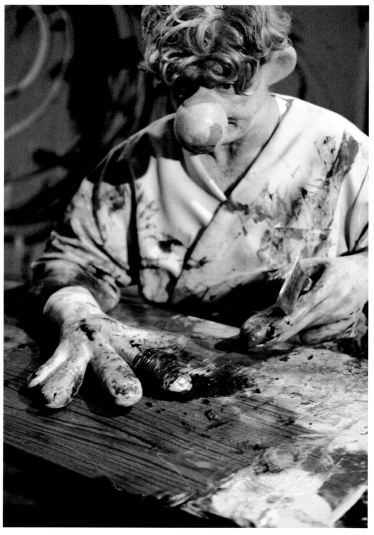

During the '60s I'd seen the Living Theater live. And of course during the Vietnam protests and political demonstrations there were all kinds of theater. I was aware of Artaud and Genet and some of Beckett's work. I was aware of the Happenings, but I'd never really seen any of it. I had just seen images. And although that was a total verification of what I wanted to do, there is another more important aspect of my work, which is *not* about an outside influence. In the '60s I painted paintings with my hands, flat on the ground. And then I would light them on fire and burn them. I didn't think of this as perform-ance or theater. I was painting and burn-ing them—it was like a flash fire that would turn them black—and there was an *action* aspect to painting beyond just the action of a de Kooning. I'd use an axe and I'd pound on them. It wasn't because of Jackson Pollock that I painted them flat on the ground. I literally painted them on the ground because you could pour gasoline on them and it would stay on the surface. So there were practical reasons for painting that way, not formal ones. But there was *real* action—a spontaneous going into character. I didn't plan on it. And I wasn't thinking Living Theater or Julian Beck or any of that.

Paul McCarthy

ABOVE, LEFT AND RIGHT
Painter, 1995
Wood paneling, carpet, paint, furniture, canvas, kitchen utensils, over-sized paint tubes and brush, video projector, latex noses, and folding chairs, dimensions variable
Video tape, performance, and installation in Los Angeles with Brian Butler, Sabina Hornig, Paul McCarthy, Fredrik Nilsen, and Barbara Smith
Collection of the Rubell Family, Miami, Florida

OPPOSITE
Pinocchio Pipenose Householddilemma, 1994
Installation, video, and photographs, dimensions variable
Performance, video, and installation at Villa Arson, Nice
Collection of Fundación "la Caixa," Barcelona

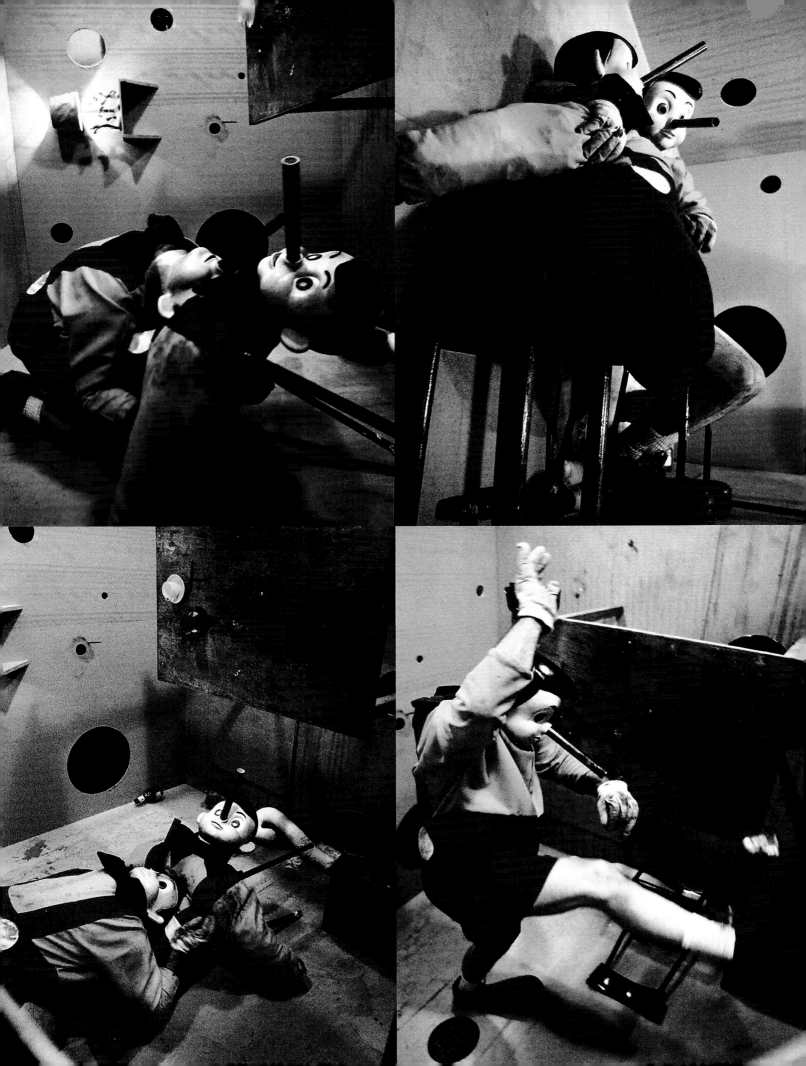

Paul McCarthy

LEFT, TOP TO BOTTOM
Meat Cake #3, 1974
Performance, video, black-and-white
and color photographs, 35 min 9 sec

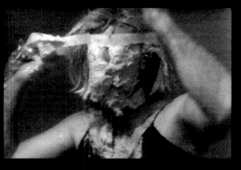

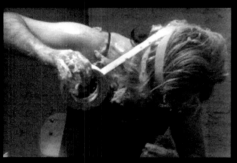

In the early videotapes it's just me as the artist making something very minimal, just using whatever was in the room, the architecture, the doors. Most of the tapes were very static—one action repeated over and over, or task-oriented. In the early tapes you see my face and it's clear who I am. It's me, Paul McCarthy, making an artwork. In these other tapes the persona happens—and it usually starts with covering the face and head.

In the '60s I didn't photograph many performances or actions. It was part of the rejection of documentation. In the '70s I started photographing, but then I actually was really interested in the photograph as painting. And so it wasn't purely documentation; it was about figuration in painting. I would photograph a performance—I would have fifty photographs—and I was really into looking at the images as a type of painting or as a type of figuration in a frame. And that carried over until the last few years. The extreme of it began in the '80s, where a performance is videotaped by five to six cameras and ends up with 20,000 still images. I also like photographing the sculptures in process. Then somehow that photograph is an object; it's a finished thing. But it's at a *moment* of the sculpture—and I'm really into the fact that the sculpture might evolve into something else at that moment.

The performances and videos evolved through the '70s. I went from being a male dressing as a female to covering my head with tape and butter. And then I start using wigs and costumes. Then the rubber masks happened. And there was a period of patriarchs, like the grandfather mask that was really from *The Texas Chainsaw Massacre,* and then monkeys and pigs (the pig being from Miss Piggy). Then it went into this sort of cartoon thing of Popeye and Olive Oyl. About 1983 I stopped doing performances, but one of the last things I wanted to do was to make videotapes in which I appropriated a script or a cartoon. I became less interested in the audience and more interested in a set in which I videotaped the situation. The audience was the crew or a few friends gathered around the dark set space— more like making a Hollywood film— and I performed. I was interested in an audience that just peered into something that was actually being made for the camera. So when someone said, "Oh you're no longer doing performance," I said, "Well no, it's for the camera. But I'm really aware of the people who are in the room to watch the film being made." I was very influenced by performer-viewer interaction—this thing in Los Angeles where you stand on the sidewalk and watch a film being made.

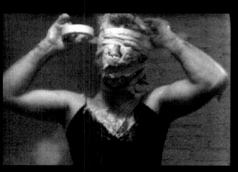

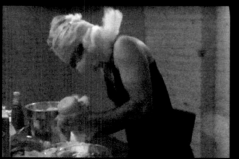

Paul McCarthy

RIGHT, TOP TO BOTTOM
Bossy Burger, 1991
BBQ turkey leg, television, stage set, bowls, cooking utensils, chair, counter, milk, flour, ketchup, mayonnaise, dolls, chef costume, rubber Alfred E. Neuman mask, and video, dimensions variable
Performance, video, and installation at Rosamund Felsen Gallery, Los Angeles

The set for *Bossy Burger* (1991) actually came from a 1960s' TV sitcom called *Family Affair;* it was the hamburger stand where the teenagers in the story hung out. I set it up in the gallery, and I enclosed it—made it into a room with swinging doors. I referred to the set as a trap: you entered it and you couldn't get out. Everything around it was a void. It floated in a void. We filmed in the gallery. I got a mobile TV truck that had all the editing and switchers in it and we pulled it into the back of the gallery with the director and three or four cameras inside. We filmed in one night, edited in the truck over the next two days, and then put the monitors in the room with the set and showed the tape. For years I kept the set but didn't show it again. All the materials, the ketchup and whatever, were old. The question is, how does it continue? The work is evolving and changing. It's in process. Some pieces of mine go on for quite long periods of time, or they get taken apart and included in other pieces, or they're being worked on. There could be a point where they stop, where they are finished or at least I'm moving on from them. But I view exhibitions sometimes as not the end of something but a beginning. It's like you see the pieces for the first time, or you see them out of their context, and you can think about them differently. Then you start again. The exhibition is not the end of the piece.

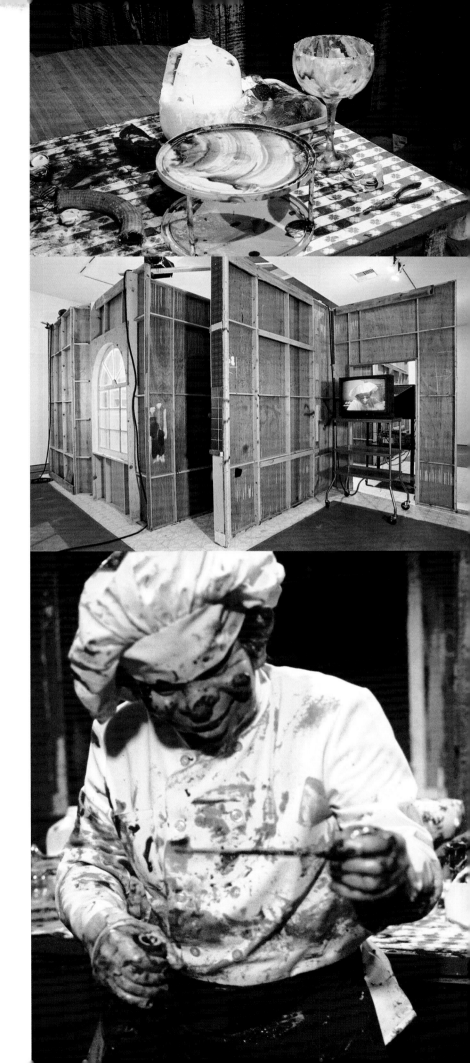

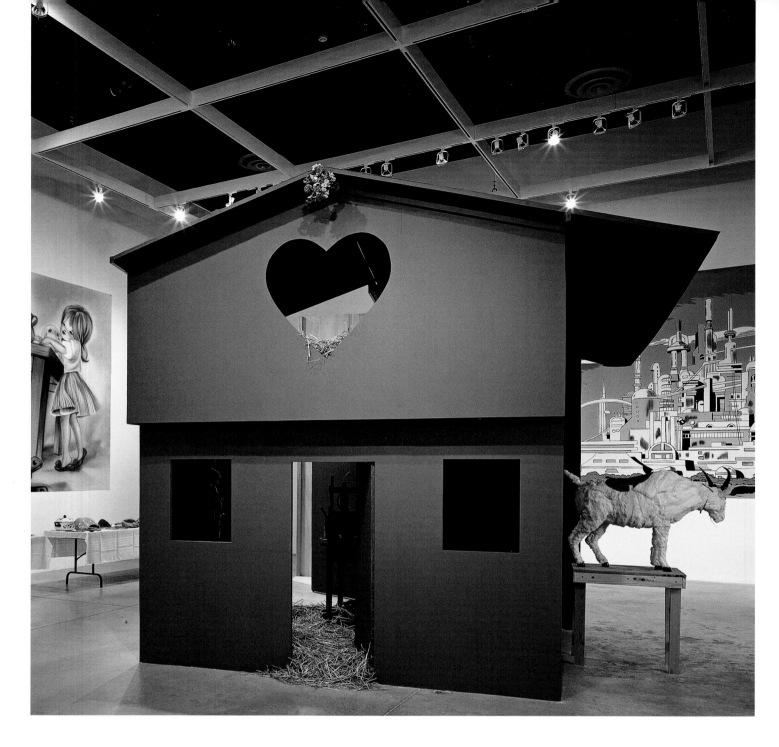

Paul McCarthy and Mike Kelley

ABOVE
Heidi, Midlife Crisis Trauma Center and *Negative Media-Engram Abreaction Release Zone*, 1992
Wood, paint, various wood objects and utensils, straw, latex rubber figures, clothing, stuffed goat, canvas, folding table, photographs, postcards, and collage, dimensions variable
Performance, video, and installation at Galerie Krinzinger, Vienna

I'm actually interested in Greek sculpture and the notion that the god is endowed in the sculpture itself by a process. In the process of creating the realism an abstraction happens. And then it's just a matter of stopping it. It's a matter of recognition no different than what Duchamp would propose in a readymade. I think I got interested in making statues in the early '90s, maybe even the mid-'80s, with figuration and statues being like the body in performance position but on

a type of presentation pedestal. So this idea of statuary started after I quit doing performance. Some people had sent me Hummel figures over the years, I think, because of the *Heidi* piece (1992) and my interest in Alpine culture. So I ended up with these Hummels. They're ceramic figurines that are mass-produced in Germany, and lots of people collect them. One day I just decided to make one. And then it kind of clicked as a form. I would just say, "Let's make this

Paul McCarthy

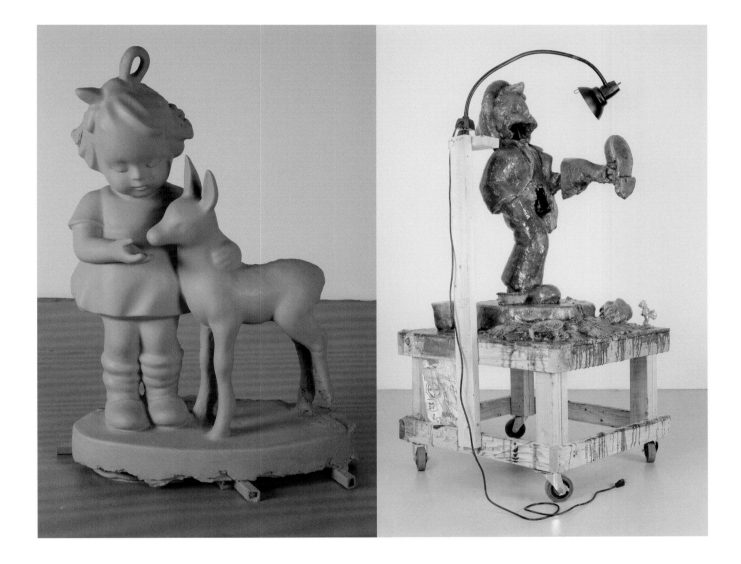

Hummel," and then it would start forming and begin to abstract. It was something to act on, to alter, shift, and to work through ideas, and it just keeps going. There's always one or two or three or four or five going on at different scales. I do buy them and I do choose them sometimes, but I often just run into them. I'm kind of interested in the ones that are trees, where little kids are on trees, but I haven't found one or bought one. I probably have five or six different ones that seem to be just recycled. So it's not really about going out of my way to go pick one out. It doesn't seem necessary. Any of them will do.

When I started making the Hummels, I would talk about it as taking a mass-produced object and making a one-off of it—taking low art (mass-produced sculpture) and pushing it back into high art. But what's also going on with the Hummels is the nature of the sculpture itself—that they're sculptures of children.

In a sense, they're taken out of a portrayal of innocence and placed in another context where they become the image of something that's brutalized them. They become victimized within what we would think of as expressionism. It's the emotion of pounding on them or twisting off a leg that's expressionistic, like a sculptural gesture, but in another way it's like a brutal effect on the sculpture. And then it's a form of abstracting, or of just directing energy at it.

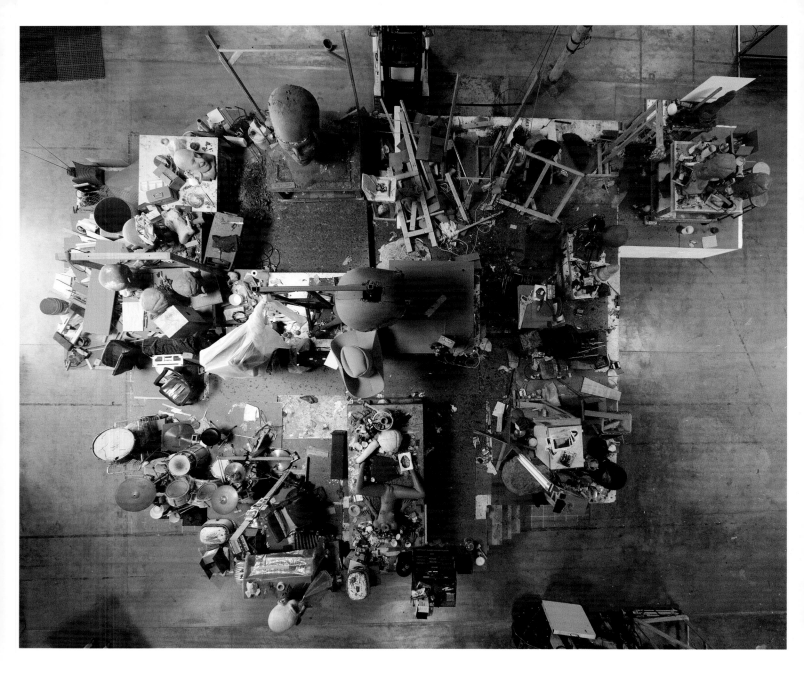

Paul McCarthy

In the beginning, the people who help me with these things think they're making a sculpture. Then they begin to realize that what the sculpture is going to be doesn't exist at the end, but it may exist anywhere in between, and they have no idea where that is. What begins to be important is that they start to see the aesthetic of this, or what I'm looking for, but then it begins to be about how we don't contrive that aesthetic. Some of it really is just about letting something go and finding something. And some of it is really about directing and knowing pretty long ahead what's going to happen and what I'm working towards. Now I want to go into the piece and dig out the back. I want to get inside. At one point I realized that I kept cutting inside the body and talking about building sculptures that you could get inside of—figurative sculptures that you could climb into—this whole thing of the sculptor having to cut out a hole and then go inside and start digging, like going in a cave. Then you begin to sculpt in the inside. Not that you're trying to make a figure in there. It's just that you're digging it out.

Paul McCarthy

Bang Bang Room (1992) was a type of kinetic architecture with some relationship to an earlier piece (*Bavarian Kick,* 1987) and one of three or four other variations. I built it because it was actually the simplest one to build. You had the walls opening every so many minutes—three, five, ten minutes. But the doors in the middle kept banging (you could go through the doors, if you could make it). If you waited for the walls to open, you could step into the platform, the walls would close, and then you'd be standing in the room with the doors banging on all four walls. When it was shown in Berlin, I was already in the process of building *Spinning Room* (1970/2008) and *Mad House* (1990/2008). All three were square rooms, like cubes, that you could enter and go into a kinetic or video or virtual architecture. I was really interested in the cube and how it opens up. *Bang Bang Room* is a solid object in a way, or at least it's visible as a concrete architecture, a cube without a roof, but when it opens up it's an object that disappears. The walls hang out, floating in space. With *Mad House*, it was about spinning a cube. If you ride it, you're physically moving at one speed or at one direction and perceptually it's spinning at another speed or in an opposite direction. I guess I was thinking about the idea of the carnival and the fun house being connected to sculpture, coming out of an influence of '60s Happenings, and having the viewer go through an experience—the idea of making a ride as a sculpture (*Mad House* being like a title for a carnival ride). And I was thinking of the cube as a minimal

sculpture. So in a way it's like a reference to a Tony Smith up on a pedestal and the idea of a person inside the spinning cube. And then there's this issue of the cube being the skull. I had made a couple of cube pieces, one called *Skull With a Tail* (1978), with the cube being a skull and the interior and the exterior being hollow. So *Mad House* had connections both to art and to a ride, to an interior and exterior, and the illusion of the split of the body and perception, splitting how you perceive the world.

Spinning Room, which is the video room, was a piece from the '70s. At that time I couldn't build it because of the difficulty of sending a video signal while it was spinning (having four cameras spin around, sending the signal, and then being able to pick up the signal and send it to projectors live). I had made pieces about reflections in mirrors and being confounded by a mirror, and I had made photographs where I would photograph a room, print it twice, and then put the one under the other, upside down. I got into making photographs of rooms and hallways and then inverting the room or the hallway. They often were in a mirrored position where you would have the room upside down and right side up, but centered, so it kind of made a mirror image. I was interested in the idea of abstracting—that when you turn something upside down you see it in a completely different way, like in architecture. This also came from looking at the ceiling and imagining walking over it (even in a room with a light like a fluorescent tube) so that instead of it being in the air above your head, it's on the ground and you're walking around it or above it, which would in a way create a sculpture. Inverting an object creates a sculpture, an object that you look at differently. When a chair is upside down, you look at it differently. It's like you see it for the first time, or you see it another way. So I was interested in illusion—in not being able to tell what was real—and being tricked as to what reality is. How did you know whether a mirrored image was a mirrored image or a real image? At one point I realized, "Wow, this is the opportunity to mirror a whole wall and, in a sense, butterfly the whole room." It would look like the room continued another fifty feet and with the darkness of the room and the mirrored pieces there'd be two mad houses, two spin rooms.

Paul McCarthy

OPPOSITE
White Head Bush Head, 2007
Vinyl-coated nylon fabric, fans,
and rigging, 299¼ x 360¼ inches
Installation view at The Hague
Sculpture, The Hague, Netherlands

RIGHT
Piccadilly Circus, 2003
Performance, video, installation, and
photographs, dimensions variable
Performance, video, and installation at
Hauser & Wirth, Zürich and London

There is something about being able to make a giant object that is ephemeral, in that it blows up, it's full of air, and exists for a short period of time and then disappears. It's monumental and at the same time fragile—and it goes away. It's not so expensive to produce and it's not there forever. It has a short life. It makes an image for people and then it's gone. That part I like a lot about it. The first two or three actually worked. But I have a better idea of what to do each time I do them and it's like I'm beginning to understand. But it's been going on for six, seven years, making these things.

I'm interested in films made like play—like kids putting on plays, or the way Warhol's or Jack Smith's films were made. Improvised play. I think the interest came from doing performances and realizing that it's a bit of a genre. I don't mean saying, "Oh look, Warhol does that, I

should do that." It was more like, "Okay I'll be the Queen, you be Bush." Or, "Okay, we're going to have a party now." Very loose, like pretend and play. I was thinking about Bush or the Queen or bin Laden. In one way, they're real; in another way, I kept thinking of them like Mickey Mouse or Santa Claus, like media characters or some sort of fabrication. But on the other hand, they were not fabrications at all. They're like illustrations of a hierarchy that affects the world, that we have very little control over, a manifestation of a spectacle out of control. I don't know whether I was looking for truth. I was just building a piece. I was making a work of art, constructing something. It's a portrayal of absurdness, of an insanity. In another way, it's not insanity. It's play. So it kind of teeters back and forth. They're all hanging out together, mucking about, having tea, and out of touch—isolated in a formal architecture that indicates some

sort of control and refinement. They almost appear to be puppets because the heads look fake. Then you realize there are real bodies in them, so they become both puppet and real. Just by choosing to make a piece about Bush or bin Laden, it's political. In the beginning I questioned whether it was too didactic, too political, and too specific to deal with Bush. But the issue isn't Bush. The issue is something larger, more connected to our whole system of material global greed. To alter or question architecture, to cut up roles, to put holes in buildings, is a political act. To reconstruct language, written or verbal, to attempt to find an alternate to how film is presented or constructed or to attempt to alter painting has a lot to do with interchange and dialogue amongst artists or amongst people. I guess, by nature, my work seems to be about tearing down, opening up conventions, and I believe that's political.

Cindy Sherman

Almost right from the beginning of my career, people were using my work to describe what was going on with appropriation in the art world—even before it was called appropriation, when that famous show was at Artists Space in New York. I wasn't even in the show, but a lot of people assume I was because my work eventually went on to be emblematic of that. There were all kinds of articles in *October* magazine back then that I would read and be surprised about, because my work was more a completely intuitive thing. I didn't want to make what looked like art in terms of painting. I just thought, "No. I want to make something that looks mass-produced and kind of tacky and cheap." And I even printed the 8 x 10 film stills badly because I thought that they should look like you just bought them in a bin at a thrift store. I purposely developed the first roll of film to make it all extra grainy so that it would even really look like it was shot terribly. I wanted it to look like stuff that people would be familiar with outside the art world—that they wouldn't have to

have read theories about. You know—things like the use of color in painting, or about the surface of the painting being as important as the edge. I didn't want the work to have anything to do with art theory, and I wanted it to look like anybody would understand it. Film has always been more influential for me than the art world. And maybe it's because, while there are film theorists, it's not as elitist as the art world is. The public can weigh in with their opinion, and that makes it more something that everyone can relate to.

My work is not about fantasizing about characters or situations. Some people have thought that I've always fantasized about the characters I do, about being a femme fatale or whoever in my film stills. But when I'm doing the characters, I really don't feel like it's something that grows out of my fantasy, my own dreams. It's not like some wish-fulfillment or wishful playacting, like "Oh I've always wanted to be a young starlet, so I'll make myself into one by posing in this picture." It's not that, because I think the characters are too troubled for me to really be happy doing that.

Cindy Sherman

Untitled (#93), 1981
Color photograph, 24 x 48 inches
Edition of 10

I haven't titled anything since the *Film Stills*. Beside the fact that I never felt very much of a wordsmith, I didn't want people to have a preconceived notion of what they're supposed to imagine. So as in one of the *Centerfold* pictures, which I call *The Black Sheets* for obvious reasons, I think of that character as having just woken up from a night on the town. She's just gone to bed and the sun is waking her up and she's got the worst hangover, and she's about to pull the sheets over her head. Other people look at that and think she's a rape victim. If I had titled it, it would still be ambiguous enough, I guess, but *The Black Sheets* isn't any more interesting than *Untitled* (#93), or whatever it is.

Cindy Sherman

OPPOSITE
A Cindy Book, c. 1964–75
Album with 26 black-and-white photographs and
handwritten notes, 8 pages, 8¾ x 11¾ inches

RIGHT
Doll Clothes, 1975
Video stills
16 mm film transfer to DVD, 2 min 22 sec
Edition of 10

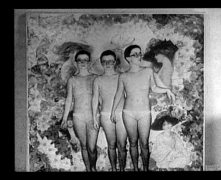

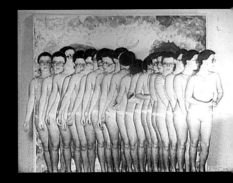

I don't know exactly when I started *A Cindy Book*, (1964–75) but judging by the handwriting maybe I was seven or ten. Family snapshots are just stuck throughout this grade-school kind of yellow paper that's stapled together. It looks like a book that I made—a school project, for all I know. There are all these snapshots, and I circled myself in them and wrote, "That's me." I guess I kept it up for a couple of years because the handwriting changes and I grew up a little bit in the pictures. Maybe I only did it for a year or two and then forgot about it until college when I found it and decided, "Maybe I'll update it." So I did, and I tried—and even faked—making the handwriting seem like it was growing up along with the figure in the pictures. I think I liked remembering that I had done this—and I think people relate to it—because it's kind of interesting to see yourself as a completely different person, as a small version of yourself and to see your evolution. As a child you're just coming to terms with your identity, like the first time you see the reflection in the mirror and realize the reflection is yourself. Even as a child, you're not really self-conscious the way we are when we become adults. But maybe "That's me" was the beginning of my becoming self-conscious.

When I was a kid, I would be alone in my room and just play with makeup. Probably there's some psychological reason why, but I was doing it at a time when it was not really p.c. for women to be wearing much makeup. In the '50s, women did do all this stuff to themselves that wasn't natural—and yet as the '60s progressed and the '70s moved on, it was all about being natural. I kind of missed the before and after of what it does to you—and the transformation. So I would just play—to see what makeup could do. In college when I did it, I would become

a character and then think, "Well, gee, here I am as Lucille Ball. What do I do now?" There'd be some friends in the other room watching *Saturday Night Live* and I'd just go sit with them and hang out. It became sort of a *thing*, a little more like performance. I started to go to parties in character. When I moved to New York I did it a few times, but suddenly it wasn't the same. In the city I felt like I needed my own sort of 'street armor' just to deal with the people out on the street and the *real* crazy people who looked like some of my characters. I didn't want to be confused with them. But I remember going to a couple of parties as characters. I felt like people wouldn't know I was there and it wouldn't really matter because I didn't know them anyway. Or it was kind of an interesting disguise.

When I was in college, I made this book of doll clothes for my photography course. I was documenting a piece that I had already made for a film course, but I wanted to bring the doll to life so I shot myself doing all the poses, and it became this goofy little film. It completely ties in to everything I'm doing now because I decided that I liked the cut-out figures more than the film. From there I went on to do several series where all the characters were cut out and spread out like a deck of cards. And from there I started to put little figures together to tell narratives. When I moved to New York I was so fed up with cutting these things out to tell stories that I realized I just needed to do it in one shot, working alone. And thinking about how to imply narrative when I was working alone just led me to the film stills. Now I'm combining the characters by cutting them out and putting them together to show a narrative with two characters interacting. It's what I'm doing now, digitally. So it's come full circle, in a way, and I like that.

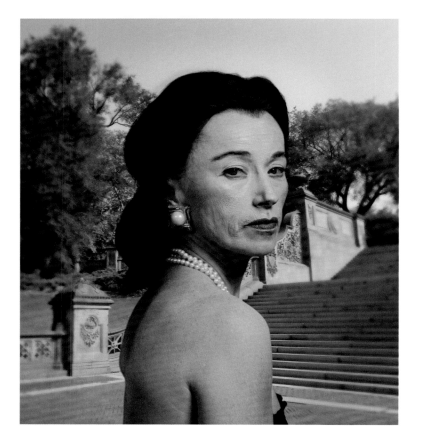

Cindy Sherman

LEFT
Untitled (#465), 2008
Color photograph,
70 x 63½ inches (framed)
Edition of 6

OPPOSITE
Untitled (#466), 2008
Color photograph,
101⅞ x 69¼ inches (framed)
Edition of 6

I think I've always responded visually to things. When I look at books and magazines, I almost think that my sense of reading is more about reading pictures than reading words. I've never been one of those people who devours a lot of books. I'm not one of those artists who reads all the art magazines and knows all the theory and can apply it to her work. I've always been like that, even in grammar school—not really reading what I should be reading. I just respond to things in a more visual, visceral way. So . . . landscape as character? The background? No. I think of it in a more painterly way. I feel a little freer with it because even though I want to read it as a landscape or an interior, I still feel like I can change it around so it doesn't have to look realistic, without somehow taking away from the integrity of the portrait. Even though you can tell that it's a photographic representation of a figure with the background being PhotoShopped and not quite realistic, I don't think it ruins the idea that you're looking at a portrait that's half photographic and half not-exactly photographic. I just see the background as an element.

The first time I tried shooting with a digital camera, I was kind of nervous. It was a big deal to be shooting in my new studio. I hadn't done any work in three years, and I'm suddenly experimenting with a digital camera. I don't really know how to use it. Does it work the same with the lights? And I have to look at my computer while I'm shooting—all kind of touch-and-go and a little scary. But once I was into it, I was a total convert. I threw out all my film and it was like I would just never go back to film. Since I'd always shot in 35 millimeter, I never had the opportunity to have such clarity. I could have gotten it with a larger format camera earlier on, but for my way of working digital just makes my life so much easier. I can see the results right away. In the past I used to take Polaroids—like a contact sheet of Polaroids, so tiny you could never tell exactly how it was going to look, whether it was in focus or the color was right. Now I can just keep tweaking as I go. I love it! I never really decide the sizes until the last minute when I'm ready to start printing. In the past, since I always shot in slide film, I would project the slides onto the wall and just measure.

With this work, I needed a digital projector. It was such a change for me to see the images really big. Suddenly they seemed much more tragic and had such real presence. They felt like real people. I wanted to make pictures that were really big, in your face. They're kind of aggressive, but not exactly. Part of that idea, before I even shot anything, was that I wanted to make a show of big pictures. You see male artists doing it all the time, even when they're not even well known. They just make a picture as big as the entire wall of the gallery. And who on earth is going to buy that except a museum or some person who's rich enough to have her own museum? It just seemed like such an egotistical thing. And I thought, "I don't know that many women who do that. And dammit, I'm going to do it." I didn't know that they would be successful as big pictures. I was kind of afraid when I went to the lab for the first time to see them; I thought they might start to break down digitally. And maybe, I thought, they should be subtle. I don't know if that's just me—as a woman you sort of want to have things a little subtler than out there, in your face—but I was happy with how they looked.

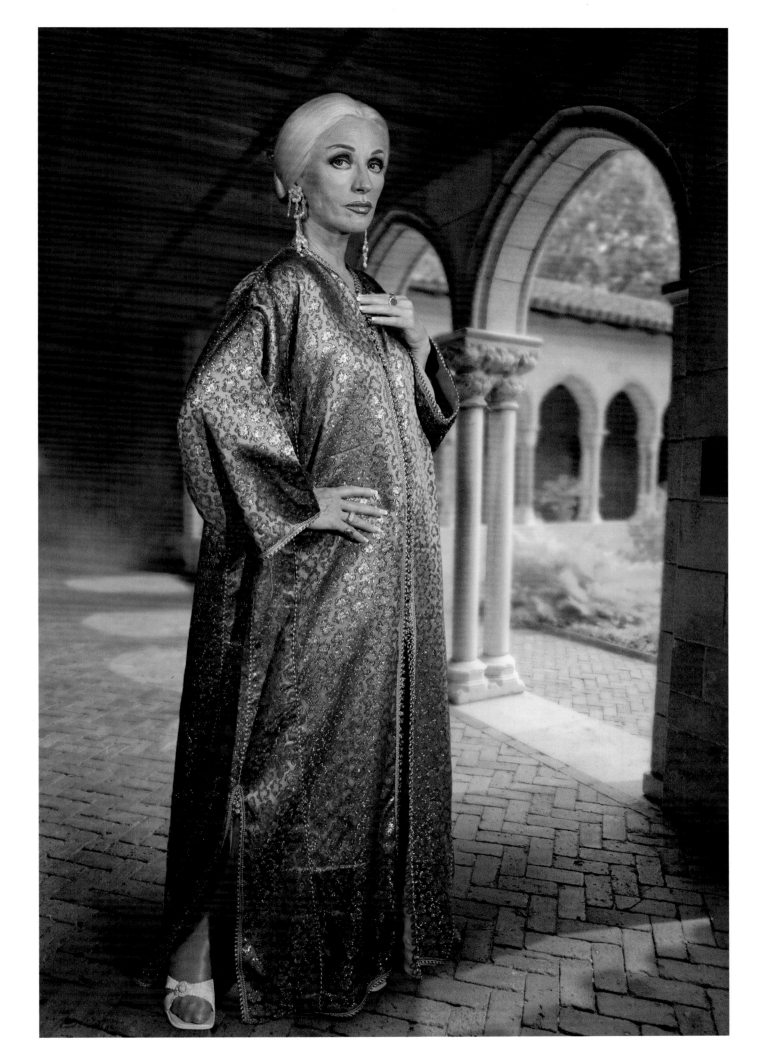

Cindy Sherman

OPPOSITE
Untitled (#224), 1990
Color photograph, 48 x 38 inches
Edition of 6

ABOVE
Untitled (#314 F), detail, 1994
Color photograph, 30 x 44 inches
Edition of 6

The camera lies! When I said that I was talking about how people believe a photograph is "real" because it's a photograph and not a painting. They don't realize that everything can be completely manipulated and staged in a photograph—even in the news. This has nothing to do with PhotoShop and what we can do now with images. So I guess I was saying that depending on the lighting, depending on the weather, makeup, on the angle of somebody looking, you can look like a completely different person. You can look fantastic and you can look horrible, all within the same hour—depending on all those elements. We're brought up to believe that what we see is fact, and I guess my work has always been about that—that I can make it look like it's from a movie, but it's not really from a movie, and you think you've seen it before but you haven't!

Often I've thought I can't imagine really doing this for my whole life, my whole career. In the late '80s and '90s I was experimenting more with gradually taking myself out of the picture, where I was just sort of a reflection in something, or only a part of my face was shown in the shadows. And then eventually I was just using a lot of mannequins and dolls to suggest that there is actually a living person in the picture but it was in fact all still life. In a lot of that work people just assume that I'm still there, that my eyes are the eyes that you see through the mask or that the hand in the foreground is actually my hand, as if I still have to be in the picture somehow. But I wasn't in this whole group of work. I wanted to see if I could still make pictures that were interesting to me without having to be in the picture. And I guess I proved that I could do it. I still liked the results. But it was much harder than using myself because when I use myself I can play, so that every single picture is completely different. I'm never really sure when I've experimented with other people as models. I'm frustrated at trying to capture on film something that I can't even articulate because I don't really know what it is I am looking for until I see it. I just don't know what to tell them to do. So I tend to rush them through the whole process and make it seem like we're just play-acting, like this is Halloween and isn't this fun, and shush them out the door. Then I redo it with myself in it, and it's grueling. So even though I love to do it, working alone is so intense that when I do finish something I don't go into my studio for months at a time afterwards. I just have to get away from it.

Influences? I don't know at what point I would have discovered them, but Goya and Duchamp are probably my favorites. It's Goya's use of grotesqueness, making things horrific seem comical (but still horrific and poignant), and the ability to be recording, much less living through, those events but balancing that with his own version of society portraiture. And then there's all of the really fantastical, bizarre stuff that he did with the black paintings. The Dadaists and the Surrealists were also always a huge inspiration for me, even when I first learned about them. I just think Duchamp was such a genius, taking an ordinary object and calling it art, making those suitcases of his greatest hits, different versions of them, to give to people or sell—and that he just sort of gave it all up to play chess.

I guess I just want a lot of the work to be seen as funny as much as it is horrific. Even when I was doing shots using fake blood and dead body characters in the fairytales, I still wanted to seem humorous—perhaps because the real thing is so much worse. I'm not interested in making things look realistic, so I don't want it to look like real blood and guts and body parts. I want people to see that it's fake, that the tits are fake, the nudity is fake, and it's like a horror movie. You can be terrified and screaming and hiding your eyes, but you're laughing, the worse it is, because it's just so over the top and cathartic to confront these things that are really disturbing. It's okay because they're fakes. It's all set up. It's functioning like a fairytale.

Cindy Sherman

ABOVE
Untitled (#305), 1994
Color photograph, 49¾ x 73½ inches (framed)
Edition of 6

OPPOSITE
Untitled (#153), 1985
Color photograph, 67¼ x 49½ inches
Edition of 6

Sometimes the work has been criticized because people thought I was making fun of certain characters. But I think, especially in the recent work, maybe because they're not so stereotypical, they seem extremely compassionate and poignant and moving. That, even I wasn't expecting. There was some criticism of earlier works, like the Hollywood-Hampton characters, when I first showed them in L.A. They thought I was just making fun of the Hollywood types, as if 'here she comes from the East Coast, and who does she think she is' or something. But I kind of liked those characters, too. It's not like I said, "I'm going to make fun of these women." I just think they were a little bit more cartoon-y than real three-dimensional people but, you know, sometimes in L.A. that's all you find.

I loved the clowns so much. The idea was, "Well, okay, I'm making these pictures of clowns but I don't want them to look like me." That's easy enough to say when you have clown makeup on. But how do you make one clown really look like a different person from another and have some character underneath the makeup? And what could that character be? People have such differing reactions to clowns. A lot don't like them, or are afraid or suspicious of them. That's kind of the attitude I was trying to get out of the characters—trying to make them look a little seedier around the edges, a little as if maybe there's some sort of desperation as to why they're clowns. Are they good or bad? Unsuccessful? Down on their luck? It was all about that makeup and everything that they do in order to create their faces.

Cindy Sherman

ABOVE, LEFT
Untitled (#408), 2002
Color photograph, 54 x 36 inches
Edition of 6

ABOVE, RIGHT
Untitled (#351), 2000
Color photograph, 30 x 20 inches
Edition of 6

OPPOSITE
Untitled (#419), 2004
Color photograph, 57½ x 48¼ inches
Edition of 6

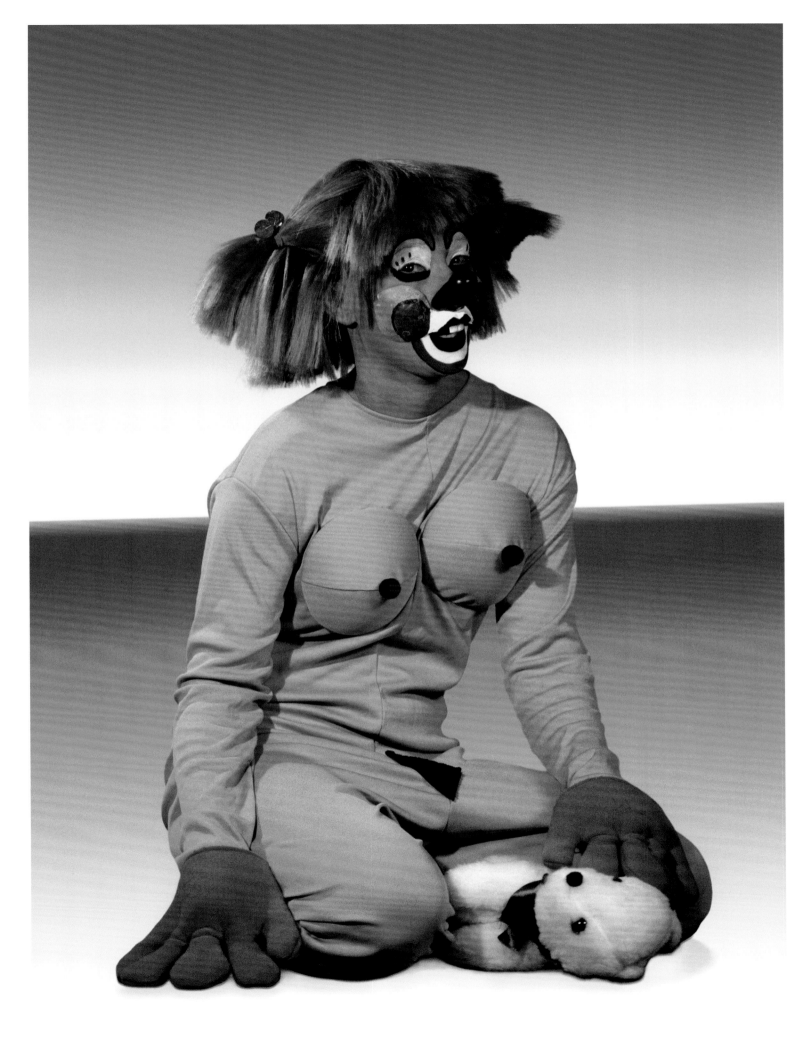

Yinka Shonibare MBE

ABOVE
Line Painting, 2003
Emulsion and acrylic on Dutch wax
printed cotton, and painted wall,
122⁴/₅ inches diameter x 2 inches,
30 panels 11⁴/₅ inches, 15⁷/₁₀ inches,
23³/₅ inches varying diameters
Collection of Arts Council, London

OPPOSITE
Un Ballo in Maschera (A Masked Ball), 2004
Video stills
High-definition digital video, color,
and sound, 32 min loop
Edition of 6 with 2 AP

I've been lucky to have grown up in a fairly affluent situation, so it surprised me when I came to Britain and I learned that being black meant that you were supposed to be somewhat inferior. I didn't understand that concept at all. Now I understand it better in the context of colonialism and slavery. But it was rather strange—because I didn't grow up feeling inferior to anyone. So I couldn't quite understand the hierarchy of race in this country and it is still somewhat of an alien concept to me because it's not my natural disposition. It's not the context I grew up in. I feel more like an observer because of my African origin. But despite my background, within this context, race is still an issue. It's one that's difficult to ignore entirely. When I started making art, and people would talk about black artists who don't make work about being black, I thought that was kind of interesting because it's a case of damned if you do or damned if you don't. I realized that my identity will always be central to how I am perceived, and that's why I chose to just look at it head on. I'm also fascinated by the issue of class, and the idea of parodying or mimicking the notion of class in my work. The irony is that somebody like me, who's made work that's always been critical of the Establishment, was awarded an MBE (Member of the Order of the British Empire). I've always imagined that I was a very strong political republican —anti-monarchy—and I think I actually am, but I also have to confess that I was somewhat excited going to Buckingham Palace. So there's a kind of a contradiction. On the one hand, I hate the Establishment and I want to criticize it. But I also want to be a part of it. Part of me loves all of that, and that's what my work tries to reflect. But it's not clear-cut, me against the Establishment. There's also the issue of complicity, and there's a degree of flirtation that goes on with the Establishment. My work really plays with those ideas. To be given this award is quite hilarious. It was actually expected that I would turn it down. But I would have no impact by turning it down. Quite a few people have done that already because they've felt that the British Empire was actually quite brutal, so they didn't want to be associated with it. But I thought I would just take this thing on and use it after my name. So my artist name now is Yinka Shonibare MBE.

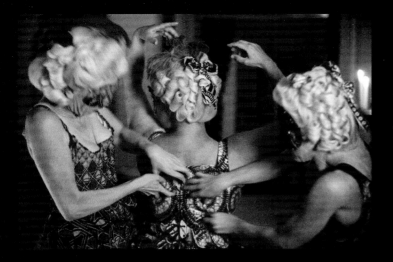
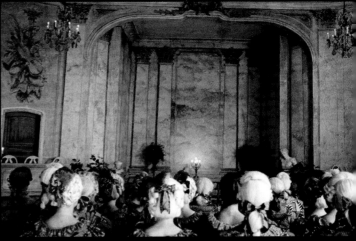
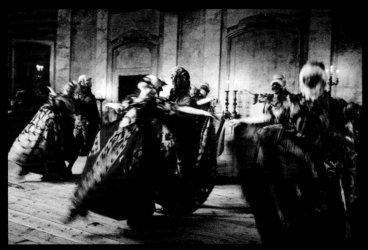
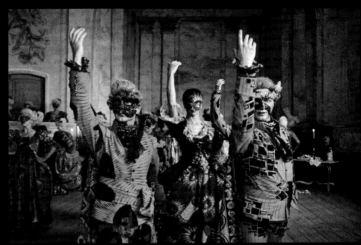
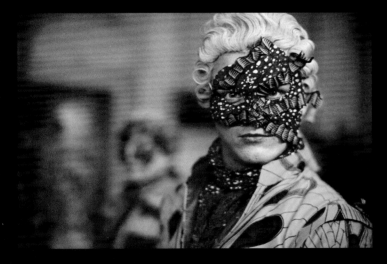

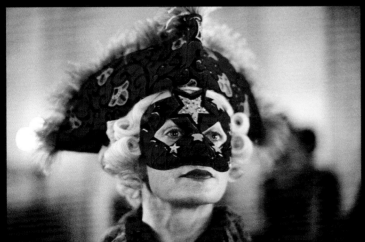

Yinka Shonibare MBE

RIGHT
*How to Blow up Two Heads
at Once (Ladies)*, 2006
Two life-size mannequins, two guns,
Dutch wax printed cotton, shoes,
and leather riding boots,
plinth: 63 x 96½ x 48 inches overall;
each figure 63 x 61 x 48 inches
Collection of Davis Museum and
Cultural Center, Wellesley College

OPPOSITE, LEFT
Man on Unicycle, 2005
Life-size mannequin, metal,
Dutch wax printed cotton, resin, and
leather, 86 x 53 x 47½ inches
Collection of the Libra Art Collection,
Milan

OPPOSITE, CENTER
Lady on Unicycle, 2005
Life-size fiberglass mannequin,
metal, Dutch wax printed cotton, resin,
leather, 86 x 53 x 47½ inches
The Tiqui Atencio Collection

OPPOSITE, RIGHT
Child on Unicycle, 2005
Life-size mannequin, metal,
Dutch wax printed cotton, resin, and
leather, 79 x 46 x 38½ inches
Collection of the American Masters
Collection I, Managed by the Collectors
Fund, Kansas City, Missouri

Politics is really about lifestyle and personal identity. So it's about looking around me and looking at the kinds of disadvantages that people who look like me have. I am of Nigerian extraction. Historically, the deal has not been that great for Africa. And my work is a way of thinking about that and asking why. Why has Africa been so held back? Why do the people of African origin in Europe and America have such a raw deal? Those questions have led to my own politicization. You grow up with this idealistic idea of wanting to change the world, realizing later on that artworks that look too much like propaganda scare people and people just become defensive. So I realized that the strategy would have to change. I trained as a painter—and I used to draw from the nude, like most people. But then I got really politicized and started to question why I had to do nudes and I

started making work about perestroika. But the world was changing, the Cold War was coming to an end, and I didn't know quite what the implications of that would be. One of my tutors said, "You are of African origin aren't you? Why don't you produce authentic African art?" But given my background (I grew up in a fairly middle class Nigerian family, in a very contemporary, modern society in cosmopolitan Lagos), my connection to tradition was sort of limited. I wondered what my teacher meant by authenticity and African art. I started to investigate what that would actually mean for me, for a contemporary, modern African. How could one be authentic? I started to look at the representation of the ideas of African art and at what things represented Africa. I came upon the fabrics. Although they are associated with Africa, they have their origins in Indonesia. The Dutch started

to produce these fabrics industrially for the Indonesian markets towards the end of the nineteenth century but the industrially produced versions were not popular there, so they tried West Africa. There the fabrics were really popular and they were appropriated. And now they are associated with Africa. I like the fact that the fabrics have a multi-layered history. So I guess the point I'm trying to make is that things are not always what they seem. I enjoy working with that. The fabrics are also very beautiful. I've always enjoyed using beauty and seduction as a way of engaging people with the work. It's a device that is apparently non-confrontational. I'm an artist, and my work is not just about illustrating something; it's also about engaging the senses. And so once people have a look and they're sympathetic to the work, then they might start to think, "What is he doing? What's the work about?"

Yinka Shonibare MBE

BELOW
Gallantry and Criminal Conversation (Woman With Leg Up), 2002
Two life-size fiberglass mannequins, three metal and wood cases, Dutch
wax printed cotton, leather, wood, and steel, 50 x 57¹/₁₀ x 46¹/₁₀ inches
Collection of Daniella Luxembourg, Geneva

OPPOSITE
Gallantry and Criminal Conversation, 2002
11 life-size fiberglass mannequins, metal and wood cases, Dutch wax
printed cotton, leather, wood, and steel, dimensions variable; carriage:
78⁷/₁₀ x 102²/₅ x 185 inches; plinth: 354³/₁₀ x 354³/₁₀ x 4⁷/₁₀ inches
Installation at Documenta 11, Kassel, Germany
Commissioned by Documenta 11

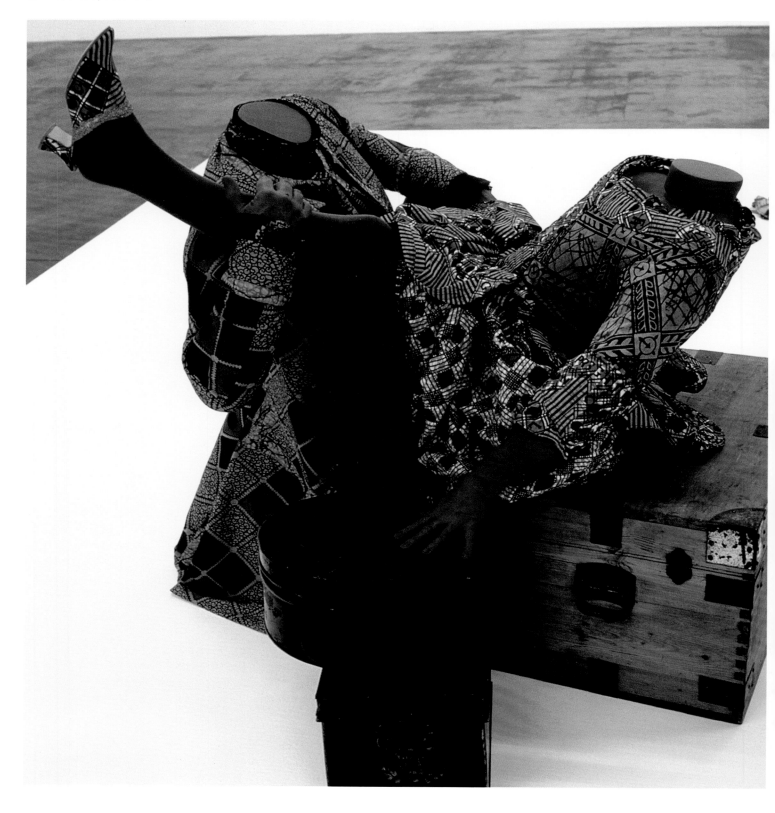

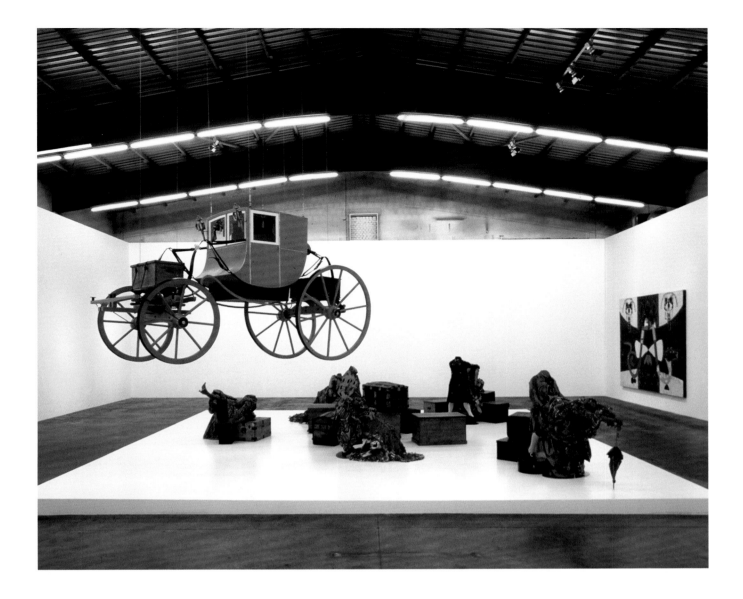

My work is often discussed in terms of post-colonial theory. And, of course, my work does deal with the aftermath or the result of colonialism and its impacts on identity. But it is a fraction of what I do. There are other aspects to my work—the aesthetic aspects, the contradictory aspects—and those are not focused on often enough. There is an over-emphasis on the post-colonial. There is a theory industry, and it likes to categorize, but that is not a matter for the artist. Theory can be useful if you're an art historian but it's not the place of the artist to do theory in that way. Artists don't start off thinking, "You know what? I'm going to create this grand movement." It's the people who write about culture who frame what art is doing at certain times, and then it sticks.

When I made *Gallantry and Criminal Conversation* (2002) I was just thinking generally about our society at a period of unprecedented wealth. A lot of people were getting richer and richer; they were having lavish parties with so much money around. I was kind of fascinated by that level of excess, and I was thinking about that in relation to the Grand Tour—when people went to Italy and France in the eighteenth and nineteenth centuries to learn about culture. But then I read *Ladies of the Grand Tour*, and I found that a lot of people actually indulged their sexual fantasies when they went on those so-called cultural tours. So if people could not be gay at home, they were free to do that abroad. And some people wanted to

(quote-unquote) commit criminal conversation. (In the eighteenth century, adultery was known as criminal conversation.) Being able to indulge in your fantasies really belongs to the privileged and the wealthy. I was fascinated with the fashion that comes with that luxury and excess, and I wanted to produce a piece that would be slightly surreal and also a bit of satire as well—poking fun at the whole thing, but also loving it at the same time. It's not sexually explicit. Really it's about people having a sense of humor. I like the satire of the eighteenth century, and I'm very interested in the work of William Hogarth. I love looking at what he did with the aristocracy. But Hogarth was a man of his time; a lot of his pieces were quite moralistic.

Yinka Shonibare MBE

In Nigeria, if you want a fairly peaceful life for your family, it's best not to engage in politics. My father was a lawyer, and I think my family took that line. Political conversation was always part of the family, and political debate was active in the household. But I think my parents stayed away from actual participation in politics because too many people who got involved in politics ended up in trouble. Nigeria had a long period of military dictatorship, so the periods when people could actually vote when I was living in Nigeria were fairly limited. Artists actually did get into trouble. The military government actually took artists very seriously and there was a limit to how you could express your political views. People found metaphors or other ways so they didn't have to refer to the government directly. And those who were brave enough to refer to the government directly more than likely would have been arrested and imprisoned. So it wasn't a conducive environment in which to develop as an artist at that time, or to produce antiestablishment art.

Black Gold II (2006) is about oil in the context of the war in Iraq. I was just thinking about oil becoming a rare commodity—a source of wars because of its rarity. The piece is literally like a sort of oil splash on the wall, with black and gold painted onto the fabrics. It's just oil as black gold, but the explosive impact of oil on people's lives can be traced back to oil. I was also thinking about the oil in Nigeria and the disasters there as a result of the greedy Western companies that have destroyed flora and fauna and left rivers full of oil gunk. It's just too horrible, what the less fortunate people have to live with: the consequences of Western greed.

There's something bizarre about people doing active things if they don't have heads—a kind of gallows humor, a joke about the French Revolution when the aristocracy had their heads guillotined. It's also a device that manages to make the pieces post-racial. My figures are of mixed race, neither white nor black, and they don't have any facial features that identify them racially. A piece that comes to mind is *Scramble for Africa* (2003), which is based on a conference that was held in Berlin in 1884–85. The European countries came together to divide up Africa, to decide who would have which trading area. The Africans themselves were not consulted. So the boundaries within Africa were more or less created at that time. And so I re-imagined that conference with these brainless men, literally *brainless,* sitting around the table. Their heads have been chopped off and they're having this meeting to decide the fate of Africa! Headless people seated around the table, and there's a map of Africa on that table. Absolutely, it's a contemporary analogy to the annexation, more or less, of Iraq and its oil and the issue of Afghanistan. People in those countries have ideas about what they would like to do with their own countries. They don't need us to tell them.

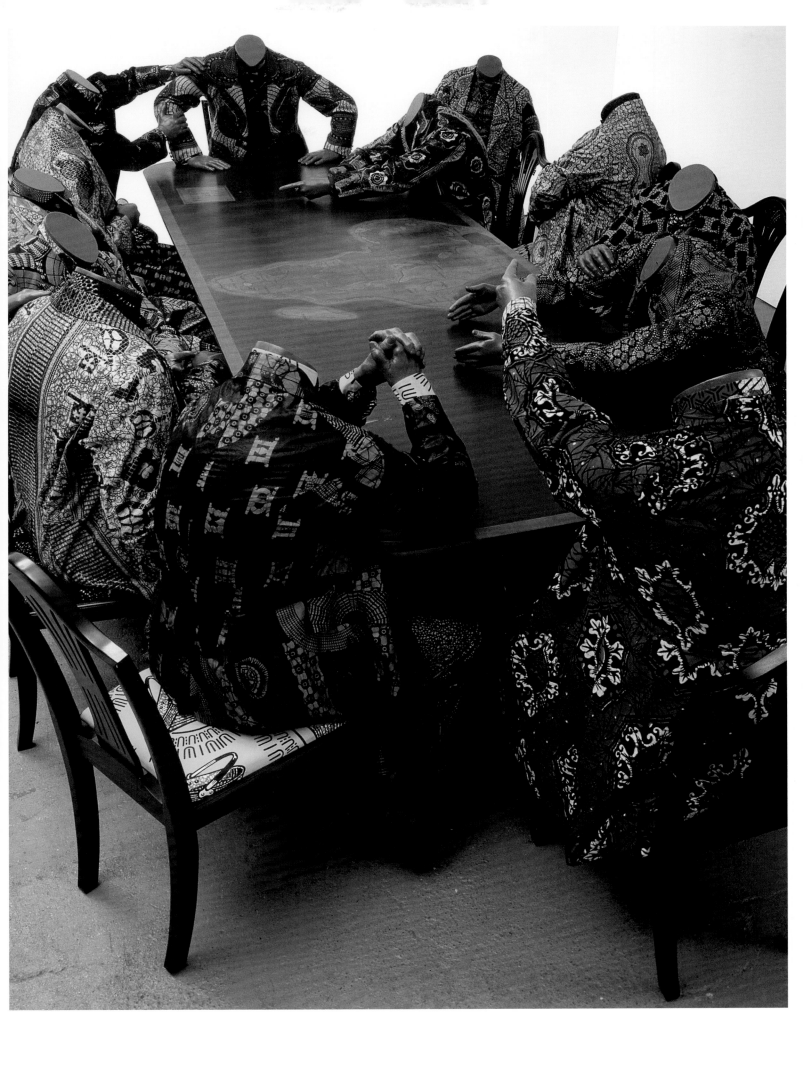

Yinka Shonibare MBE

RIGHT, TOP TO BOTTOM
Diary of a Victorian Dandy: 14.00 hours, 1998
Diary of a Victorian Dandy: 17.00 hours, 1998
Diary of a Victorian Dandy: 03.00 hours, 1998
Type-C photographs, 72 x 90 inches each
Edition of 3 with 1 AP each
Collections of Peter Norton and Eileen Harris
Norton, Santa Monica, California

Looking at my early pieces I can see the journey that I've made to arrive at the later pieces—how I would want to animate the fabrics in the painting and onto figures and then how, doing the figures, I actually wanted to dress people in the fabrics. And then how I moved from photography to film and using the costumes in film. A lot of my work is really about my own identity, about my history, my background. And when I wanted to work with photography it was obvious that I would use myself because (fortunately) I'm kind of self-obsessed like most artists. So naturally I started working with myself and using my own body. *Diary of a Victorian Dandy* (1998) came out of my interest in the work of Oscar Wilde and William Hogarth, and the piece is loosely based on Hogarth's *A Rake's Progress*. But in my series there is no moralistic picture at the end. The dandy ends with a wild orgy. It's really about complicity with excess (power creates excess), my relationship to excess, and how I play with that. I could choose to point a finger at it, but—actually—I would like to have the trappings of wealth myself, even though I may be criticizing it. And the dandy is a figure who stands out-side of the class system and usually uses wit and style to get in. The dandy is a bit of a trickster, really, and gets away with things. That's why I've used that metaphor in that work. I know that within Yoruba culture the trickster is a well-known figure, but that's not something that I grew up knowing about. My trickster evolved out of my own personal trickiness!

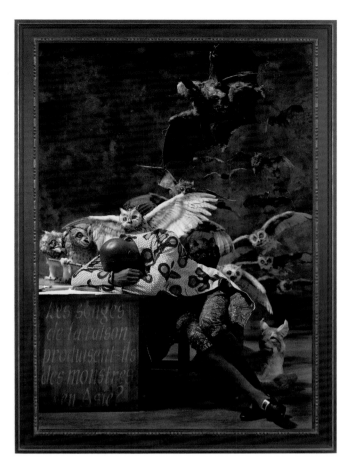

Yinka Shonibare MBE

ABOVE, LEFT
The Sleep of Reason Produces Monsters (Africa), 2008
Type-C photograph mounted on aluminum, 72 x 49½ inches
Edition 5/5
CB Collection, Tokyo

ABOVE, RIGHT
The Sleep of Reason Produces Monsters (Asia), 2008
Type-C photograph mounted on aluminum, 72 x 49½ inches
Edition 5/5
CB Collection, Tokyo

The Sleep of Reason Produces Monsters (2008) is actually from *Los Caprichos,* Goya's series of etchings about war, irrationality, and the folly of humanity. I was thinking about the idea of democracy and the way that the West has been trying to export democracy, and that one of the justifications used for the war in Iraq was to make Iraq more democratic. We all know that oil has more to do with it than democracy, but nevertheless that was the pretense. So I was thinking about this idea about democracy against militant Islam, and also about militant Islam in relation to the West. Both sides have managed to demonize the other so that the other becomes the monster, and the demonization has reached irrational levels. And then I remembered that we'd been here before—that Goya made a series of etchings about similar issues in relation to war. I thought about recreating *The Sleep of Reason,* blowing it up and making the animals (quite an outrageous thing to do because it's so elaborate to actually go to

the trouble of constructing every little owl). And what I then did was not exempt any area of the world from this, so the piece is based on five different continents. And because of the legacy of France (the French gave the Statue of Liberty to America, and American democracy has its origins in France—*liberté, égalité, fraternité*) the text is in French: *Les songes de la raison produisent-ils des monstres en Asie?* Does the dreaming of reason produce monsters in Asia? But I change the sentence in relation to the continent, with a black man in that image—and I juxtapose the people who are meant to represent each continent just to create a little confusion. What I like about Goya's image is the poetic and dreamy nature of it. That's the fascination— the reason for doing that piece. We live in dark times. And Goya does seem to resonate as an artist with whom a lot of artists identify just for the horror and the things that are happening in our times. He managed to capture the essence of the dark side of humanity.

Yinka Shonibare MBE

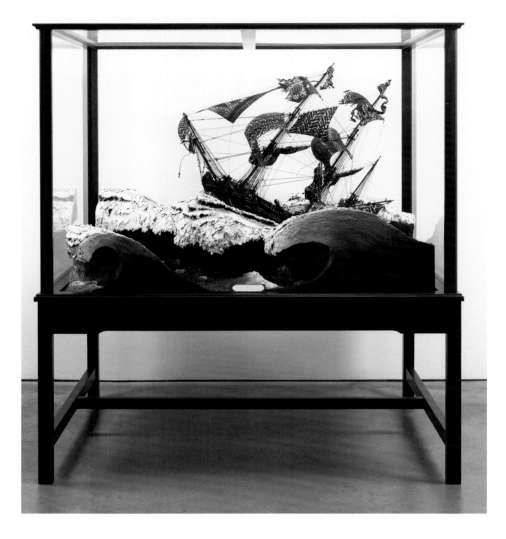

I always want to refer to the fact that my work is artificial; it is artifice. It is art, made as art; it is not unmediated reality. It is mediated reality through form, and form is artifice. What I really like in a work of art is for the formal strategy to be part of the meaning of the work. So the fabrics —they're not just textiles. They're tactile things but there is historical content there, so it then becomes difficult to separate what something looks like and what it expresses. They are linked. And that's very much where meaning creates form. It's not just about using form to illustrate something. It's about the meaning also being held in the form that illustrates something. Beauty is part of the form, but beauty is also emotional. So it's actually form and content. And those two things work together or express each other.

My interest in Fragonard? It's just one of those off-the-wall things really. He was a painter of the aristocracy, of the excessive lifestyle that was associated with Versailles before the Revolution, before they all had their heads chopped off. Look at his painting, *The Swing*. She's the mistress of a wealthy patron, and it was an extremely naughty painting at the time because showing that much leg would have actually been hard-core pornography. And the most irreverent thing is that she's being pushed on the swing by a priest. The painting was absolutely scandalous at the time. I liked the kind of carefree abandon of the work, and that's what I tried to pick up on in my piece. She doesn't totally get away with it because I do behead her. But she's wearing this gorgeous Chanel fabric that I got

in Brixton market. I've used it a few times in other pieces as well because I like it so much, and because the Chanel logo is kind of bootleg. It's about capturing that sense of abandon. You can see her shoe is just flying off, and I love the way it's captured in Fragonard's painting because the shoe is suspended in time. The painting is a snapshot of a moment of joy, of ecstasy, of excess, of abandon. And that's my attraction to the work. My reason for doing that work is, again, that interest in complicity with abandon and excess, and celebrating but also critiquing it. I enjoy all of that and there's something naughty about it. At the same time, I understand that that level of excess can only be achieved at the expense of other people. But I'm not so moralistic as to say that I don't want to have fun, too.

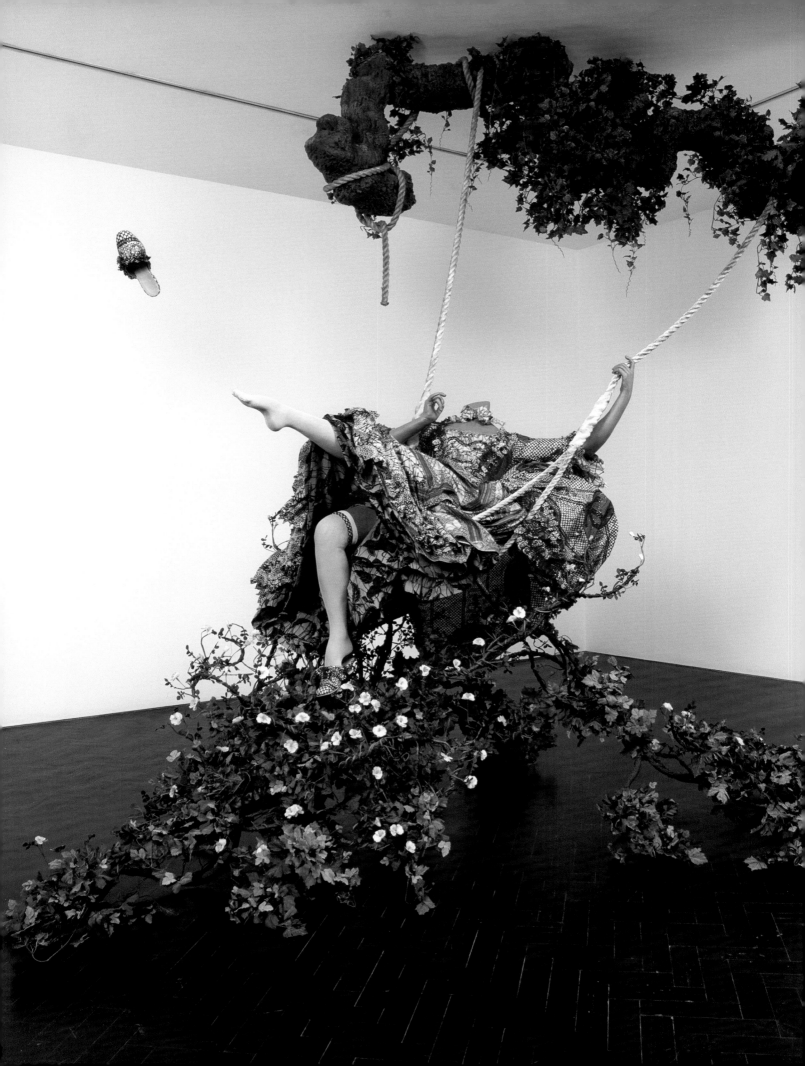

Yinka Shonibare MBE

Theatricality is central to my work. I use theatrical devices because I want people to enter a different world, a fantasy world. For me that's what art is. It's that world you can enter that's different from your regular, everyday world. I just love being able to travel into a different space, a different realm. And theatricality is a device for doing that. Then you can deal with everyday issues but be transgressive —take it to a different place. And a theatrical device allows me to do that.

Art making is a form of alchemy. You're trying to turn the mundane into gold, trying to make gold from nothing. When it works very well you manage to turn the ordinary into the extraordinary. I think that all artists are transgressive. My job is to challenge the status quo, constantly looking at it from a different angle. Some people call it thinking outside the box. And that's what interests me. Rather than just passively accepting the system, the idea is to actually turn the system another way and see what happens if we look at it from that angle. I want to make people see something different in the familiar.

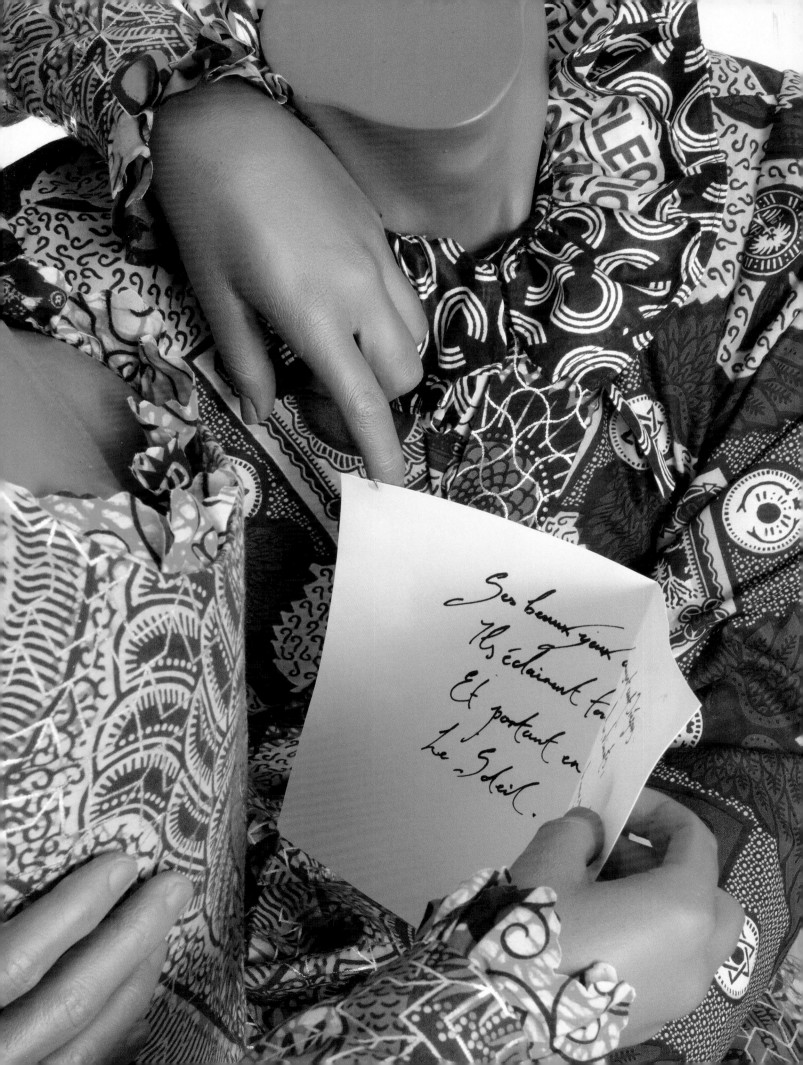

Biographies of the Artists

Cao Fei

Cao Fei was born in Guangzhou, China in 1978. She earned a BFA from Guangzhou Academy of Fine Arts in Guangzhou, China (2001). Cao Fei's work reflects the fluidity of a world in which cultures have mixed and diverged in rapid evolution. Her video installations and new media works explore perception and reality in places as diverse as a Chinese factory and the virtual world of Second Life. Applying strategies of sampling, role play, and documentary filmmaking to capture individuals' longings and the ways in which they imagine themselves—as hip-hop musicians, costumed characters, or digitized alter egos—Cao Fei reveals the discrepancy between reality and dream, and the discontent and disillusionment of China's younger generation. Depictions of Chinese architecture and landscape abound in scenes of hyper-capitalistic Pearl River Delta development, in images that echo traditional Chinese painting, and in the design of her own virtual utopia, *RMB City*. Fascinated by the world of Second Life, Cao Fei has created several works in which she is both participant and observer through her Second Life avatar, China Tracy, who acts as a guide, philosopher, and tourist. Cao Fei's work has appeared in solo exhibitions at the Serpentine Gallery, London (2008); Orange County Museum of Art, Newport Beach, California (2007); Museum Het Domein, Sittard, Netherlands (2006); and Para Site Art Space, Hong Kong (2006). She has participated in the New Museum Triennial (2009); Carnegie International, Pittsburgh (2008); Prospect.1 New Orleans (2008); Yokohama Triennial (2008); and Istanbul, Lyon, and Venice Biennials (2007). Her work has appeared at the New Museum, New York (2008); Walker Art Center, Minneapolis (2007); P.S.1 Contemporary Art Center, New York (2006); and Asia Society, New York (2006). Cao Fei lives and works in Beijing.

John Baldessari

John Baldessari was born in National City, California in 1931. He received a BA (1953) and MA (1957) from San Diego State College, continuing his studies at Otis Art Institute (1957–59) and Chouinard Art Institute. Synthesizing photomontage, painting, and language, Baldessari's dead-pan visual juxtapositions equate images with words and illuminate, confound, and challenge meaning. He upends commonly held expectations of how images function, often by drawing the viewer's attention to minor details, absences, or the spaces between things. By placing colorful dots over faces, obscuring portions of scenes, or juxtaposing stock photographs with quixotic phrases, he injects humor and dissonance into vernacular imagery. For most of his career John Baldessari has also been a teacher. While some of the strategies he deploys in his work—experimentation, rule-based systems, and working within and against arbitrarily imposed limits to find new solutions to problems—share similarities with pedagogical methods, they are also intrinsic to his particular world view and philosophy. Baldessari has received several honorary doctorates, the most recent from the National University of Ireland, Burren College of Art (2006). He has participated in Documenta (1982, 1978); the Venice Biennale (2003, 1997); and seven Whitney Biennials, most recently in 2008. His work has been shown in more than 120 solo exhibitions and 300 group exhibitions. A major retrospective will appear at Tate Modern, London; Metropolitan Museum of Art, New York; and Los Angeles County Museum of Art in 2009–10. John Baldessari was elected to the American Academy of Arts and Letters in 2007. He lives and works in Santa Monica, California.

Mary Heilmann

Mary Heilmann was born in 1940 in San Francisco, California. She earned a BA from the University of California, Santa Barbara (1962), and an MA from the University of California, Berkeley (1967). For every piece of Heilmann's work—abstract paintings, ceramics, and furniture—there is a backstory. Imbued with recollections, stories spun from her imagination, and references to music, aesthetic influences, and dreams, her paintings are like meditations or icons. Her expert and sometimes surprising treatment of paint (alternately diaphanous and goopy) complements a keen sense of color that glories in the hues and light that emanate from her laptop, and finds inspiration in the saturated colors of TV cartoons such as *The Simpsons*. Her compositions are often hybrid spatial environments that juxtapose two- and three-dimensional renderings in a single frame, join several canvases into new works, or create diptychs of paintings and photographs in the form of prints, slideshows, and videos. Heilmann sometimes installs her paintings alongside chairs and benches in an open invitation for viewers to socialize and contemplate her work communally. Mary Heilmann has received the Anonymous Was a Woman Foundation Award (2006) and grants from the National Endowment for the Arts and the Guggenheim Foundation. She has had major exhibitions at the Parrish Art Museum, Southampton, New York (2009); New Museum of Contemporary Art, New York (2008); Wexner Center for the Arts, Columbus, Ohio (2008); and Orange County Museum of Art, Newport Beach, California (2007), among others. Her work has appeared in Whitney Biennials (1972, 1989, 2008) and is in many collections, including the Museum of Modern Art, New York; Whitney Museum of American Art, New York; and Orange County Museum of Art. Mary Heilmann lives and works in New York and Bridgehampton, New York.

William Kentridge

William Kentridge was born in Johannesburg, South Africa in 1955. He attended the University of the Witwatersrand, Johannesburg (1973–76), Johannesburg Art Foundation (1976–78), and studied mime and theater at L'École Internationale de Théâtre Jacques Lecoq, Paris (1981–82). Having witnessed first-hand one of the twentieth century's most contentious struggles—the dissolution of apartheid—Kentridge brings the ambiguity and subtlety of personal experience to public subjects most often framed in narrowly defined terms. Using film, drawing, sculpture, animation, and performance, he transmutes sobering political events into powerful poetic allegories. In a now-signature technique, he photographs his charcoal drawings and paper collages over time, recording

scenes as they evolve. Working without a script or storyboard, he plots out each animated film, preserving every addition and erasure. Aware of myriad ways in which we construct the world by looking, Kentridge uses stereoscopic viewers and creates optical illusions with anamorphic projection to extend his drawings-in-time into three dimensions. Kentridge has had major exhibitions at the San Francisco Museum of Modern Art (2009); Philadelphia Museum of Art (2008); Moderna Museet, Stockholm, (2007); and Metropolitan Museum of Art, New York (2004), among others. He has also participated in Prospect.1 New Orleans (2008); the Sydney Biennale (1996, 2008); and Documenta (1997, 2002). His opera and theater works, often produced in collaboration with Handspring Puppet Company, have appeared at Brooklyn Academy of Music (2007); Standard Bank National Arts Festival, Grahamstown, South Africa (1992, 1996, 1998); and Festival d'Avignon, France (1995, 1996). His production of Dmitri Shostakovich's opera, *The Nose,* will premiere at the Metropolitan Opera, New York, in conjunction with a retrospective organized by the San Francisco Museum of Modern Art and Museum of Modern Art, New York (2010). William Kentridge lives and works in Johannesburg, South Africa.

Kimsooja

Kimsooja was born in 1957 in Taegu, South Korea. She earned a BFA (1980) and MA (1984) from Hong-Ik University, Seoul. Kimsooja's videos and installations blur the boundaries between aesthetics and transcendent experience through their use of repetitive actions, meditative practices, and serial forms. In many pieces, everyday actions—such as sewing or doing laundry—become two- and three-dimensional or performative activities. Central to her work is the *bottari*, a bundle traditionally used by Koreans to wrap and protect personal belongings, which Kimsooja transforms into a philosophical metaphor for structure and connection. In videos that feature her in various personas (Needle Woman, Beggar Woman, Homeless Woman), she leads us to reflect on the human condition, offering open-ended perspectives through which she presents and questions reality. Using her own body, facing away from the camera, Kimsooja becomes a void; we literally see and respond through her. While striking for their vibrant color and

density of imagery, Kimsooja's works emphasize metaphysical changes within the artist-as-performer as well as the viewer. Kimsooja has received the Anonymous Was a Woman Award (2002), among others, and has been an artist-in-residence at the World Trade Center, New York (1998); P.S. 1 Museum, New York (1992–93); and École Nationale Supérieure des Beaux-arts, Paris (1984). She has had major exhibitions at the Los Angeles County Museum of Art (2009); Hirshhorn Museum and Sculpture Garden, Washington, DC (2008); Museo Nacional Centro de Arte Reina Sofía, Madrid (2006); Magasin 3, Stockholm Konsthall, Sweden (2006); the MIT List Gallery, Cambridge, Massachusetts (2005), and other institutions. Kimsooja has participated in international exhibitions, including the Venice Biennale (2001, 2005, 2007); Yokohama Triennial (2005); and Whitney Biennial (2002). Kimsooja lives and works in New York.

Jeff Koons

Jeff Koons was born in 1955 in York, Pennsylvania. He studied at the Art Institute of Chicago, and received a BFA from the Maryland Institute College of Art, Baltimore (1976), and honorary doctorates from the School of the Art Institute of Chicago (2008) and Corcoran College of Art + Design, Washington, D.C. (2002). Koons plucks images and objects from popular culture, framing questions about taste and pleasure. His contextual sleight-of-hand, which transforms banal items into sumptuous icons, takes on a psychological dimension through dramatic shifts in scale, spectacularly engineered surfaces, and subliminal allegories of animals, humans, and anthropomorphized objects. The subject of art history is a constant undercurrent, whether Koons elevates kitsch to the level of Classical art, produces photos in the manner of Baroque paintings, or develops public works that borrow techniques and elements of seventeenth-century French garden design. Organizing his own studio production in a manner that rivals that of a Renaissance workshop, Koons makes computer-assisted, hand-crafted works that communicate through their meticulous attention to detail. Among the awards he has received are Officier of the French Legion of Honor (2007); the Artistic Achievement Award from Americans for the Arts (2006); and the Skowhegan Medal for Sculpture (2002). Recent major exhibitions have appeared at Château de Versailles, France (2008); the Metropolitan Museum of Art, New York (2008); Museum of Contemporary Art, Chicago (2008); Neue Nationalgalerie, Berlin (2008); Victoria and Albert Museum, London (2006); the Guggenheim Museum, New York (2002),

and other institutions. Koons has participated in the Bienal de São Paulo (2002); Venice Biennale (1990, 1997); Sydney Biennale (1990); and the Whitney Biennial (1987, 1989). He was elected as a Fellow to the American Academy for Arts and Sciences in 2005. Jeff Koons lives and works in New York.

Florian Maier-Aichen

Florian Maier-Aichen was born in 1973 in Stuttgart, Germany. He studied at Högskolan för Fotografi och Film, Göteborg, Sweden; the University of Essen, Germany; and earned an MFA from the University of California, Los Angeles. Alternately romantic, cerebral, and unearthly, Florian Maier-Aichen's digitally altered photographs are closer to the realm of drawing and fiction than documentation. He embraces difficult techniques, chooses equipment that produces accidents such as light leaks and double exposures, and uses computer enhancements to introduce imperfections and illogical elements into images that paradoxically are visually right, for him, though they are technically wrong. Often employing an elevated viewpoint (the objective but haunting "God's-eye view" of aerial photography and satellite imaging), Maier-Aichen creates idealized, painterly landscapes that function like old postcards. Interested in places where landscape and cityscape meet, he chooses locations and subjects from the American West and Europe—from his own neighborhoods to vistas of the natural world. Looking backwards for his influences, Maier-Aichen often reenacts or pays homage to the work of the pioneer photographers of the nineteenth century, sometimes even remaking their subject matter from their original standpoints. Always experimenting, he marries digital technologies with traditional processes and films (black-and-white, color, infrared, and tricolor), restoring and reinvigorating the artistry and alchemy of early photography. Maier-Aichen's work has appeared in recent major exhibitions at Museo Thyssen-Bornemisza, Madrid (2008); Museum of Contemporary Art, Los Angeles (2007); Yvon Lambert, New York (2007); and the Whitney Biennial (2006). Florian Maier-Aichen lives and works in Cologne, Germany and Los Angeles.

Allan McCollum

Allan McCollum was born in Los Angeles in 1944. In his twenties, McCollum briefly considered becoming an actor, then attended trade school to study restaurant management and industrial kitchen work. In the late 1960s, he began to educate himself as an artist. Applying strategies of mass production to hand-made objects, McCollum's labor-intensive practice questions the intrinsic value of the unique work of art. McCollum's installations—fields of vast numbers of small-scale works, systematically arranged—are the product of many tiny gestures, built up over time. Viewing his work often produces a sublime effect as one slowly realizes that the dizzying array of thousands of identical-looking shapes is, in fact, comprised of subtly different, unique things. Engaging assistants, scientists, and local craftspeople in his process, McCollum embraces a collaborative and democratic form of creativity. His drawings and sculptures often serve a symbolic purpose—as surrogates, faithful copies, or stand-ins for people—and are presented theatrically, transforming the exhibition space into a laboratory where artifice and context are scrutinized. Economical in form, yet curious in function, his work and mechanical-looking processes are infused with humor and humility. Allan McCollum has had more than 100 solo exhibitions in Europe and the United States, where his work has appeared in major exhibitions at the Metropolitan Museum of Art, New York (2009); Museum of Modern Art, New York (most recently in 2007); and the Guggenheim Museum, New York (2004), among others. He has also participated in many international exhibitions, most recently at the Bienal de São Paulo (2008). Recent solo exhibitions include Friedrich Petzel Gallery, New York (2009); Barbara Krakow Gallery, Boston (2008); and Musée d'art moderne et contemporain, Geneva (2006), among others. Allan McCollum lives and works in New York.

Paul McCarthy

Paul McCarthy was born in 1945 in Salt Lake City. He studied at the University of Utah, Salt Lake City (1968–69); earned a BFA from the San Francisco Art Institute (1969) and an MFA from the University of Southern California, Los Angeles (1972); and was a professor at the University of California, Los Angeles (1984–2003). Paul McCarthy's videotaped performances and provocative multimedia installations lampoon polite society, ridicule authority, and bombard the viewer with a sensory overload of often sexually-tinged, violent imagery. With irreverent wit, McCarthy often takes aim at cherished American myths and icons—Walt Disney, the Western, and even the Modern Artist—adding a touch of malice to subjects that have been traditionally revered for their innocence or purity. Absent or present, the human figure is a constant element in his work, whether in the form of bodies in action, satirical caricatures, or animistic sculptures; as the residue of a private ritual; or as architectural space left uninhabited for the viewer to occupy. Whether conflating real-world political figures with fantastical characters such as Santa Claus, or treating erotic and abject content with frivolity and charm, McCarthy's work confuses codes, mixes high and low culture, and provokes an analysis of fundamental beliefs. His work has been shown in recent major exhibitions at CCA Wattis Institute for Contemporary Arts, San Francisco (2009); the Whitney Museum of American Art, New York (2008); Stedelijk Museum voor Actuele Kunst, Ghent (2007); Moderna Museet, Stockholm (2006); and Haus der Kunst, Munich (2005), among others. He has participated in many international events, including the Berlin Biennial (2006); SITE Santa Fe (2004); Whitney Biennial (1995, 1997, 2004); and the Venice Biennale (1993, 1999, 2001). Paul McCarthy lives and works in Altadena, California.

Program, Glassell School of Art, Museum of Fine Arts, Houston (1997–98) and the AIR Program at the Studio Museum in Harlem (2001). Mehretu's paintings and drawings refer to elements of mapping and architecture, achieving a calligraphic complexity that resembles turbulent atmospheres and dense social networks. Architectural renderings and aerial views of urban grids enter the work as fragments, losing their real-world specificity and challenging narrow geographic and cultural readings. The paintings' wax-like surfaces—built up over weeks and months in thin translucent layers—have a luminous warmth and spatial depth, with formal qualities of light and space made all the more complex by Mehretu's delicate depictions of fire, explosions, and perspectives in both two and three dimensions. Her works engage the history of nonobjective art—from Constructivism to Futurism—posing contemporary questions about the relationship between utopian impulses and abstraction. Among Mehretu's awards are the Berlin Prize (2007), from the American Academy in Berlin; a John D. and Catherine T. MacArthur Foundation Award (2005); and the American Art Award from the Whitney Museum of American Art, New York (2005). Her work has appeared in major exhibitions at the Museum of Modern Art, New York (2007); Detroit Institute of Arts (2006); Walker Art Museum, Minneapolis (2003); and Albright-Knox Art Gallery, Buffalo (2003), among others. Mehretu has participated in the Sydney Biennale (2006); Carnegie International (2004); Bienal de São Paulo (2004); Whitney Biennial (2004); and the Istanbul Biennial (2003). Julie Mehretu lives and works in Berlin.

Doris Salcedo

Doris Salcedo was born in 1958 in Bogotá, Colombia. Salcedo earned a BFA at Universidad de Bogotá Jorge Tadeo Lozano (1980) and an MA from New York University (1984). Salcedo's understated sculptures and installations embody the silenced lives of the marginalized, from individual victims of violence to the disempowered of the Third World. Although elegiac in tone, her works are not memorials: Salcedo concretizes absence, oppression, and the gap between the disempowered and powerful. While abstract in form and open to interpretation, her works are essential

Julie Mehretu

Julie Mehretu was born in 1970 in Addis Ababa, Ethiopia. She studied at University Cheik Anta Diop, Dakar (1990–91), earning a BA from Kalamazoo College, Michigan (1992), and an MFA from Rhode Island School of Design, Providence (1997). She was a resident of the CORE

testimonies on behalf of both victims and perpetrators. Even when monumental in scale, her installations achieve a degree of imperceptibility—receding into a wall, burrowed into the ground, or lasting for only a short time. Salcedo's work reflects a collective effort and close collaboration with a team of architects, engineers, and assistants and—as Salcedo says—with the victims of the senseless and brutal acts to which her work refers. Her awards include a commission from Tate Modern, London (2007); the Ordway Prize, from the Penny McCall Foundation (2005, 1993); and a Solomon R. Guggenheim Foundation Grant (1995). Her work has appeared in major exhibitions at Tate Modern, London (2007); Castello de Rivoli, Turin (2005); and Museum Boijmans Van Beuningen, Rotterdam (2002), among others. She has participated in the T1 Triennial of Contemporary Art, Turin (2005); Documenta (2002); and the Liverpool Biennial of Contemporary Art (1999). Her work is included in many museum collections, including the Museum of Modern Art, New York; Art Institute of Chicago; Los Angeles County Museum of Art; and the Museum of Fine Arts, Boston. Doris Salcedo lives and works in Bogotá, Colombia.

Cindy Sherman

Cindy Sherman was born in 1954 in Glen Ridge, New Jersey. Sherman earned a BA from State University College, Buffalo, New York (1976). In self-reflexive photographs and films, Cindy Sherman invents myriad guises, metamorphosing from Hollywood starlet to clown to society matron. Often with the simplest of means—a camera, a wig, makeup, an outfit—Sherman fashions ambiguous but memorable characters that suggest complex lives lived out of frame. Leaving her works untitled, Sherman refuses to impose descriptive language on her images, relying instead on the viewer's ability to develop narratives as an essential component of appreciating the work. While rarely revealing her private intentions, Sherman's investigations have a compelling relationship to public images, from kitsch (*Film Stills* and *Centerfolds*) to art history (Old Masters and Surrealism) to green-screen technology and the latest advances in digital photography. Sherman's exhaustive study of portraiture and self-portraiture—often a playful mixture of camp and horror, heightened by gritty realism—provides a new lens through

which to examine societal assumptions surrounding gender and the valuation of concept over style. Among her awards are the Guild Hall Academy of the Arts Lifetime Achievement Award for Visual Arts (2005); American Academy of Arts and Sciences Award (2003); National Arts Award (2001); a John D. and Catherine T. MacArthur Foundation Award (1995), and others. Her work has appeared in major exhibitions at Sprüth Magers, Berlin (2009); Jeu de Paume, Paris (2006); Museum of Modern Art, New York (1997); and the Museum of Contemporary Art, Los Angeles (1997), among others. Sherman has participated in many international events, including SITE Santa Fe (2004); the Venice Biennale (1982, 1995); and five Whitney Biennials. Cindy Sherman lives and works in New York.

Yinka Shonibare MBE

Yinka Shonibare MBE was born in 1962 in London, England. After growing up in Lagos, Nigeria, Shonibare studied at Byam Shaw School of Art, London (1984–89) and earned an MA from Goldsmiths College, London University (1991). Known for using batik in costumed dioramas that explore race and colonialism, Yinka Shonibare MBE also employs painting, sculpture, photography, and film in work that disrupts and challenges our notions of cultural identity. Taking on the honorific MBE as part of his name in everyday use, Shonibare plays with the ambiguities and contradictions of his attitude toward the Establishment and its legacies of colonialism and class. In multimedia projects that reveal his passion for art history, literature, and philosophy, Shonibare provides a critical tour of Western civilization and its achievements and failures. At the same time, his sensitive use of his own foibles (vanity, for one) and challenges (physical disability) provide an autobiographical perspective through which to navigate the contradictory emotions and paradoxes of his examination of individual and political power. Among his awards are the MBE (Member of the Order of the British Empire) (2005); a fellowship at Goldsmith's College (2003); and the Art for Architecture Award, Royal Society of Arts (1998). Shonibare was nominated for the Turner Prize (2004). His work has appeared in major exhibitions at the

Santa Barbara Museum of Art, California (2009); Cooper-Hewitt National Design Museum, New York, (2005); Fabric Workshop and Museum, Philadelphia (2004); and Museum Boijmans Van Beuningen, Rotterdam (2004), among others. He has participated in international events including Documenta (2003); Spoleto Festival, Charleston (2003); and the Venice Biennale (2001). Yinka Shonibare MBE lives and works in London.

Carrie Mae Weems

Carrie Mae Weems was born in Portland, Oregon, in 1953. Weems earned a BFA from the California Institute of the Arts, Valencia (1981), and an MFA from the University of California, San Diego (1984), continuing her studies in the Graduate Program in Folklore at the University of California, Berkeley (1984–87). With the pitch and timbre of an accomplished storyteller, Carrie Mae Weems uses colloquial forms—jokes, songs, rebukes—in photographic series that scrutinize subjectivity and expose pernicious stereotypes. Weems's vibrant explorations of photography, video, and verse breathe new life into traditional narrative forms—social documentary, tableaux, self-portrait, and oral history. Eliciting epic contexts from individually framed moments, Weems debunks racist and sexist labels, examines the relationship between power and aesthetics, and uses personal biography to articulate broader truths. Whether adapting or appropriating archival images, restaging famous news photographs, or creating altogether new scenes, she traces an indirect history of the depiction of African Americans that spans more than a century. She has received honorary degrees from Colgate University, New York (2007) and California College of the Arts, Oakland (2001). Awards include the Anonymous Was a Woman Award (2007); Skowhegan Medal for Photography (2007); Rome Prize Fellowship (2006); and the Pollack Krasner Foundation Grant in Photography (2002), among others. Weems's work has appeared in major exhibitions at Savannah College of Art and Design (2008); W. E. B. Du Bois Institute for African and African American Research, Harvard University (2007); Williams College Museum of Art, Williamstown (2000); and the Whitney Museum of American Art, New York (1998), among others. Carrie Mae Weems lives and works in Syracuse, New York.

List of Illustrations

Photographic Credits and Copyrights

COMPASSION: pp. 16–19, © William Kentridge, courtesy the artist; pp. 20–21, photos by John Hodgkiss, © William Kentridge, courtesy the artist; p. 22, © William Kentridge, courtesy Marian Goodman Gallery, New York; p. 23, © William Kentridge, courtesy the artist; pp. 23–24, photo by John Hodgkiss, © William Kentridge, courtesy the artist; p. 25, © William Kentridge, courtesy the artist; pp. 26–27, photo by Johan Jacobs, © Johan Jacobs; pp. 28–29, © William Kentridge, courtesy the artist; pp. 30–31, © Doris Salcedo, courtesy the artist and Alexander and Bonin, New York; p. 32, photo by Rita Burmester, © Doris Salcedo, courtesy the artist and Alexander and Bonin, New York; p. 33, photo by Stephen White, © Doris Salcedo, courtesy the artist and Alexander and Bonin, New York; p. 34, photo by Herbert Lotz, © Doris Salcedo, courtesy the artist and Alexander and Bonin, New York; p. 35, photo by David Heald, © Doris Salcedo, courtesy the artist and Alexander and Bonin, New York; p. 36, photo by Bill Orcutt, © Doris Salcedo, courtesy the artist and Alexander and Bonin, New York; p. 37, photo by Muammer Yanmaz, © Doris Salcedo, courtesy the artist and Alexander and Bonin, New York; p. 38, photo by Javier Campano, © Doris Salcedo, courtesy the artist and Alexander and Bonin, New York; p. 39, photo by Robert Pettus, © Doris Salcedo, courtesy the artist and Alexander and Bonin, New York; pp. 40–41, © Doris Salcedo, courtesy the artist and Alexander and Bonin, New York; pp. 42–43, photo by Tate Photography, London, © Doris Salcedo, courtesy the artist and Alexander and Bonin, New York; pp. 44–57, © Carrie Mae Weems, courtesy the artist and Jack Shainman Gallery, New York.

FANTASY: pp. 60–71, © Cao Fei, courtesy the artist and Lombard-Freid Projects, New York; p. 71 (bottom), © Art 21, Inc., New York; pp. 72–73, © Cao Fei, courtesy the artist and Lombard-Freid Projects, New York; pp. 74–86, © Mary Heilmann, courtesy the artist, 303 Gallery, New York, and Hauser & Wirth, Zürich London; p. 87, © Mary Heilmann, courtesy Pace Editions Inc.; pp. 88–99, © Jeff Koons, courtesy the artist; pp. 100–101, photo by Nathan Keay, © Jeff Koons, courtesy the artist and Museum of Contemporary Art, Chicago; pp. 102–115, © Florian Maier-Aichen, courtesy Blum & Poe, Los Angeles, and 303 Gallery, New York.

SYSTEMS: pp. 118–121, © John Baldessari, courtesy Marian Goodman Gallery, New York; p. 122, © John Baldessari, courtesy the artist; p. 123, © John Baldessari, courtesy the artist and Beyer LLC; pp. 124–131, © John Baldessari, courtesy Marian Goodman Gallery, New York; p. 132, photo by Alon Koppel, © Kimsooja Studio, courtesy the artist; p. 133, photo by Luca Campigotto, © Kimsooja Studio, courtesy the artist and the Bevilacque La Masa Foundation; pp. 134–135, photo by Mikäel Falke, © Kimsooja Studio, courtesy the artist, Dijon Consortium, the Centre for Fine Arts, Brussels, and the Ministry of Culture, Sports and Tourism, Korea; p. 136, © Kimsooja Studio, courtesy the artist; p. 137, photo by Lee Jong Soo, © Kimsooja Studio, courtesy the artist and Art & Public, Geneva; p. 138, photo by Jason Schmidt, © Kimsooja Studio, courtesy the artist and Peter Blum Gallery, New York; p. 139 (top), photo by Bill Orcutt, © Kimsooja Studio, courtesy the artist and Peter Blum Gallery, New York; p. 139 (bottom), © Kimsooja Studio, courtesy the artist; p. 140–142, © Kimsooja Studio, courtesy the artist; p. 143, photo by Blaise Adilon, © Kimsooja Studio, courtesy the artist; pp. 144–145, photos by Jaeho Chong, © Kimsooja Studio, courtesy

the artist and Museo Nacional Centro de Arte Reina Sofia, Madrid; pp. 146–48, photo by Eric Baum, © Allan McCollum, courtesy the artist; p. 149, photo by Eva Inkiri, © Allan McCollum, courtesy the artist; pp. 150–51, © Allan McCollum, courtesy the artist; pp. 152–53, photo by Fred Scruton, © Allan McCollum, courtesy the artist; pp. 154–55, photo by Shigeto Mihata, © Allan McCollum, courtesy the artist; pp. 156–59, photo by Lamay Photo, © Allan McCollum, courtesy Friedrich Petzel Gallery, New York; p. 160, photo by Erma Estwick, © Julie Mehretu, courtesy the artist and The Project, New York; p. 161, photo by Steven Gerlich, © Julie Mehretu, courtesy the artist and The Project, New York; pp. 162–65, photo by Erma Estwick, © Julie Mehretu, courtesy the artist and The Project, New York; p. 165 (bottom), © Julie Mehretu, courtesy the artist and The Project, New York; pp. 166–67, photo by Erma Estwick, © Julie Mehretu, courtesy the artist and The Project, New York; pp. 168–69, photo by Richard Stoner, © Julie Mehretu, courtesy the artist and The Project, New York; p. 170, photo by Tim Thayer, © Julie Mehretu, courtesy the artist and The Project, New York; p. 171, photo by Erma Estwick, © Julie Mehretu, courtesy the artist and The Project, New York; pp. 172–73, photo by Tim Thayer, © Julie Mehretu, courtesy the artist and The Project, New York.

TRANSFORMATION: pp. 176–77, photo by Ann-Marie Rounkle, © Paul McCarthy, courtesy the artist and Hauser & Wirth, Zürich London; pp. 178–82, © Paul McCarthy, courtesy Paul McCarthy and Hauser & Wirth, Zürich London; p. 183–85, photo by Ann-Marie Rounkle, © Paul McCarthy, courtesy the artist and Hauser & Wirth, Zürich London; p. 186 (left), photo by Uwe Walter, © Paul McCarthy, courtesy the artist and Hauser & Wirth, Zürich London; p. 186 (right) and p.187 (left), photo by Ron Amstutz, © Paul McCarthy, courtesy the artist and Hauser & Wirth, Zürich London; p. 187 (right), photo by Ann-Marie Rounkle, © Paul McCarthy, courtesy the artist and Hauser & Wirth, Zürich London; p. 188, photo by Gerrit Schreurs, © Paul McCarthy, courtesy the artist and Hauser & Wirth, Zürich London; p. 189, © Paul McCarthy, courtesy the artist and Hauser & Wirth, Zürich London; pp. 190–203, © Cindy Sherman, courtesy the artist and Metro Pictures, New York; pp. 204–05, © Yinka Shonibare MBE, courtesy the artist, James Cohan Gallery, New York, and Stephen Friedman Gallery, London; p. 206, photo by Stephen White, © Yinka Shonibare MBE, courtesy the artist, James Cohan Gallery, New York, and Stephen Friedman Gallery, London; p. 207, photo by Christopher Burke, © Yinka Shonibare MBE, courtesy the artist, James Cohan Gallery, New York, and Stephen Friedman Gallery, London; pp. 208–09, photo by Werner Maschmann, © Yinka Shonibare MBE, courtesy the artist, James Cohan Gallery, New York, and Stephen Friedman Gallery, London; pp. 210–11, photo by Stephen White, © Yinka Shonibare MBE, courtesy the artist, James Cohan Gallery, New York, and Stephen Friedman Gallery, London; pp. 212–13, © Yinka Shonibare MBE, courtesy the artist, James Cohan Gallery, New York, and Stephen Friedman Gallery, London; p. 214, photo by Jason Mandella, © Yinka Shonibare MBE, courtesy the artist, James Cohan Gallery, New York, and Stephen Friedman Gallery, London; p. 215, photo by Ahlburg Keate, © Yinka Shonibare MBE, courtesy the artist, James Cohan Gallery, New York, and Stephen Friedman Gallery, London; pp. 216–15, photo by Patrick Gries for Musée du Quai Branly, © Yinka Shonibare MBE, courtesy the artist, James Cohan Gallery, New York, and Stephen Friedman Gallery, London.

PRODUCTION STILLS: pp. 14–15, 58–59, 116–117, 174–75. © Art21, Inc.

JACKET FRONT, TOP: Jeff Koons, *Balloon Dog (Yellow)*, 1994–2000. Installation view of *Jeff Koons on the Roof*, April 22–October 26, 2008, Metropolitan Museum of Art, New York. High-chromium stainless steel with transparent color coating, 121 x 143 x 45 inches. © Jeff Koons, courtesy the artist.

ENDPAPERS: Florian Maier-Aichen, *Untitled*, 2005. C-print, 72 x 90½ inches. © Florian Maier-Aichen, Courtesy Blum & Poe, Los Angeles and 303 Gallery, New York.

TITLE PAGE: Paul McCarthy, *Piggies*, 2007. Installation view at Middelheim Museum, Antwerp, Belgium. Vinyl-coated nylon fabric, fans, and rigging, 507⅞ x 960⅝ x 1023⅝ inches. Photo by Philip de Gobert, © Paul McCarthy, courtesy the artist and Hauser & Wirth, Zürich London.

TABLE OF CONTENTS: William Kentridge, *Black Box / Chambre Noire*, 2005. Model theatre with drawings (charcoal, pastel, collage, and colored pencil on paper), mechanical puppets, and 35mm film transferred to video, 22 min, 141¾ x 78¾ x 55 inches. Photo by John Hodgkiss, © William Kentridge, courtesy the artist.

Editor: Marybeth Sollins
Associate Curator: Wesley Miller
Designer: Russell Hassell
Publication Coordinator: Jennifer Lee

Printed in the United States by The Studley Press, Dalton, Massachusetts

Library of Congress Control Number: 2009907964
ISBN: 978-0-6153-0836-4

Art21, Inc.
286 Spring Street
New York, NY 10113
www.art21.org